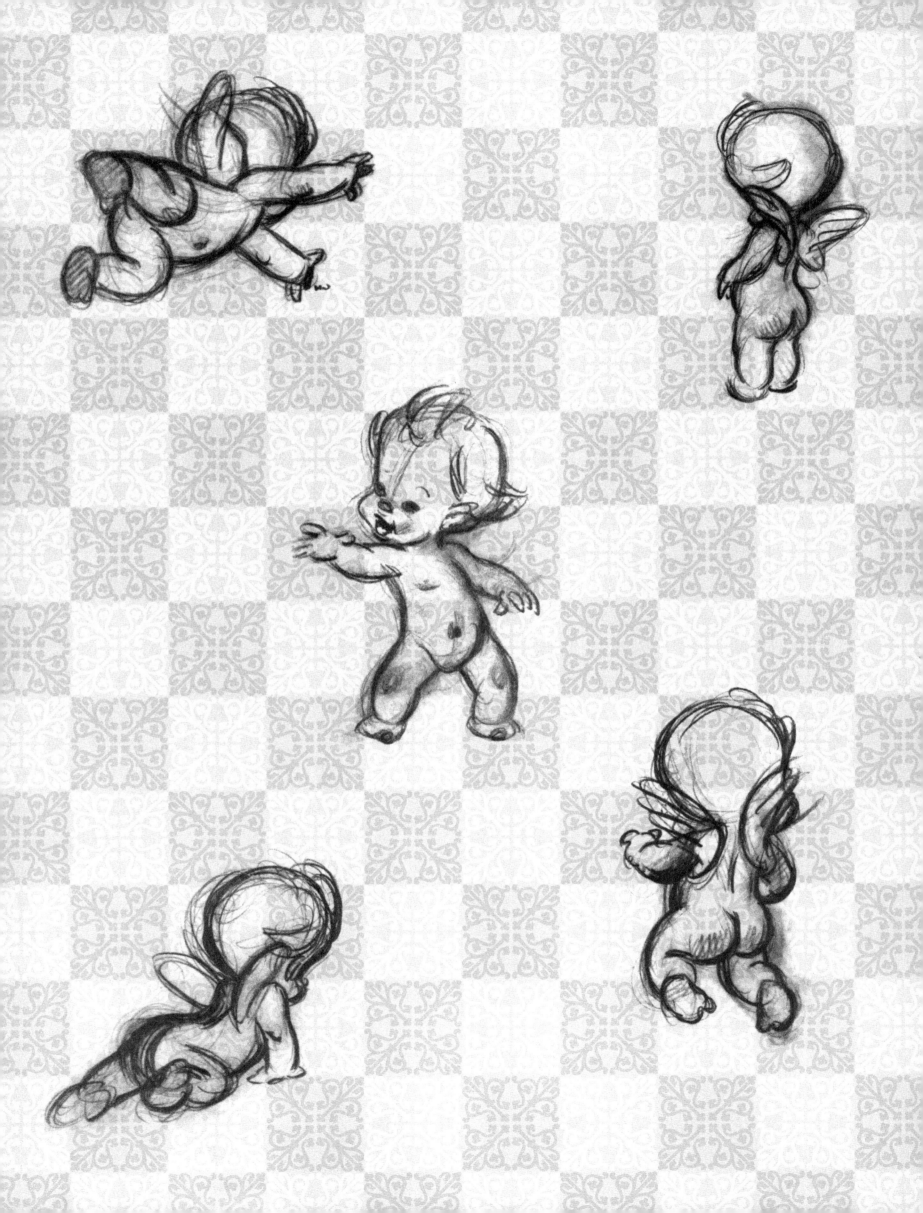

A
DISNEY
SKETCHBOOK

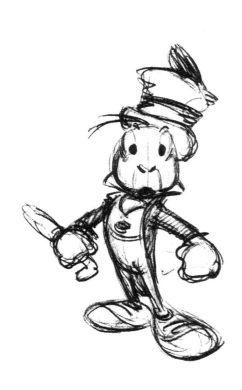

Designed by Tim Palin and Alfred Giuliani

For information address Disney Editions, 1101 Flower Street, Glendale, California 91201.
Editorial Director: Wendy Lefkon
Associate Editor: Jessica Ward

ISBN 978-1-4231-6569-9
Printed in China
Fourth Edition
10 9 8 7 6 5
FAC-005376-18113

The Official Disney Fan Club

Disney.com/D23

A
DISNEY
SKETCHBOOK

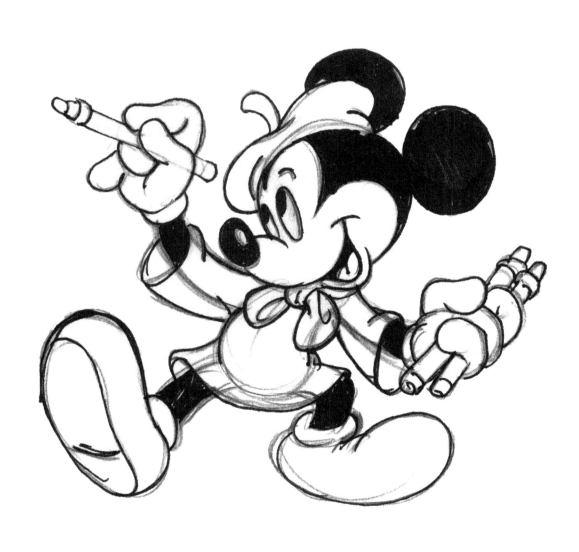

EDITIONS

NEW YORK

FOREWORD

Hand-drawn Disney animation holds a unique place in the history of modern art and popular culture. The work showcased in this book comes from Disney artists and animators who brought great performances to the screen by drawing with emotion, sincerity, and intensity. Knowing full-well that many of these sketches would be seen only in pencil tests and preliminary screenings—or never at all—the artists "drew from within themselves" onto a sheet of paper or a digital tablet. In the process, they created incredible works of art in their own right.

While reviewing a few of his own rough animation drawings made for *Peter Pan*, Frank Thomas, one of Walt Disney's original "Nine Old Men," once explained to me that he and his colleagues never thought of their drawings as final works of art. "We were working to communicate the story," he said, "and we were thinking about what the character was thinking and feeling not only in this moment, but in the one before it and the one after it. We weren't thinking about making drawings. We were thinking about telling a story."

Unprocessed, uninked, unpainted, and un-rendered, a selection of Disney drawings is reproduced here as if drawn into a sketchbook. This *Sketchbook* celebrates the very early stages of Disney filmmaking, in which the human touch defines both a character's performance and its role in telling a story. Drawings used for story and visual development, animation thumbnails, rough animation drawings, layout drawings, and other works have been organized in a rough chronological order, with the knowledge that many of these films and their production stages often overlapped.

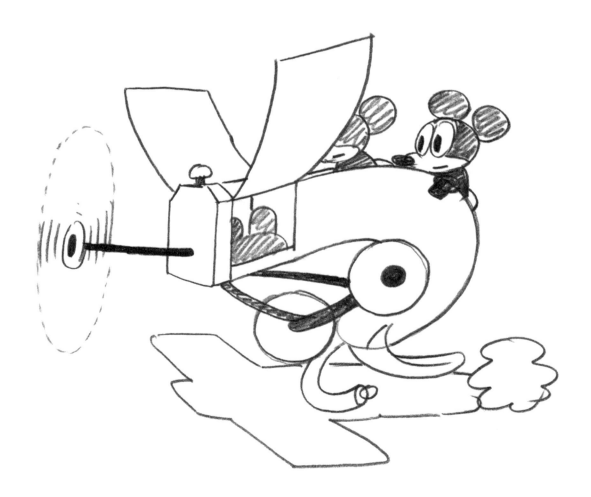

Works from known Disney artists representing each major period of the Studio's output so far have been included. Here are drawings by Ub Iwerks, Joe Grant, Frank Thomas, Ollie Johnston, Marc Davis, and Milt Kahl, as well as those from contemporary animators Andreas Deja, Eric Goldberg, and Glen Keane. Also included are Studio drawings by many other Disney artists, and some by unknown artists.

The concept for this publishing project was to build an artifact—a sketchbook that may have been passed around The Walt Disney Studios lot, one in which artists have studied each other's work over very different periods of time, and then added their own sketches and ideas to inform succeeding generations of visual storytellers. We haven't found such a sketchbook yet, so we made one of our own until we do. Here it is, assembled with loving care by Disney Editions Associate Editor Jessie Ward and Senior Designer Al Giuliani from our Disney Publishing offices. Also on hand to provide expert production guidance for this project were Donna Kerley, Nisha Panchal, and Jennifer Eastwood.

Without the support of Andreas Deja, who generously shared his collection, Eric Goldberg, and Lella Smith (and her expert, hardworking team at the Walt Disney Animation Research Library), this would have been a much lesser project indeed.

This is a book intended to be more of a visual "romp" than a "read." It celebrates the art of drawing, and we hope it inspires artists and fans everywhere.

Ken Shue
Vice President, Disney Publishing Global Art Development
Glendale, California

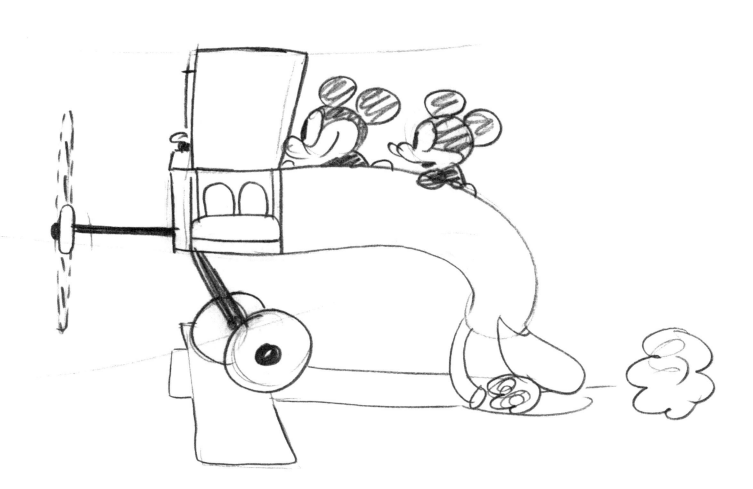

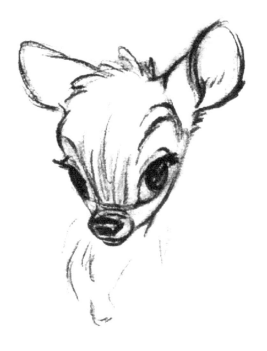

INTRODUCTION

Every drawing in this collection represents a step in a process of discovery. Like other fine artists, the Disney animators, designers, and story artists whose work appears in this anthology didn't know exactly what their drawings would look like until they were finished, but they knew what those drawings had to do and say. The rough, often tentative, lines show the artists exploring and discovering the best way to present a character at a specific moment in a story.

The storyboard panel by Bill Peet from *The Jungle Book* is one of many, perhaps dozens, the great story artist drew trying to find the poses for Mowgli and the monkeys that communicated the key information in the scene most clearly. In earlier versions, Mowgli's expression would have been different. The monkeys and branches would have been in different positions. Peet drew and redrew until he had gotten all the entertainment potential out of the moment that he could. Other artists and Walt Disney would have examined Peet's storyboards and made suggestions that led to new drawings, which were clearer or more dramatic or funnier.

Looking back over the sketches he made when he was designing Beast, Glen Keane commented, "When you design a character for a Disney fairy tale, it's going to become the definitive design for that character, so you don't want to hack something out. I needed to put in the kind of care I felt it warranted if it's going to live on in history as the Beast."

As there was no model for what Beast should look like, Keane initially experimented with funny horns and ears. But they made the character look like an alien who didn't fit into Belle's world. He started over, studying animals in a zoo, and combining elements of a gorilla, bison, wolf, lion, bear, and wild boar into the Beast that Belle learns to love.

Animators find inspiration everywhere. Ollie Johnston realized how Fauna in *Sleeping Beauty* would act when he watched a little old lady on vacation in a hotel agree with everything her friends said—even when they contradicted each other. For *One Hundred and One Dalmatians*, Marc Davis wanted to make Cruella De Vil move "like someone you wouldn't like."

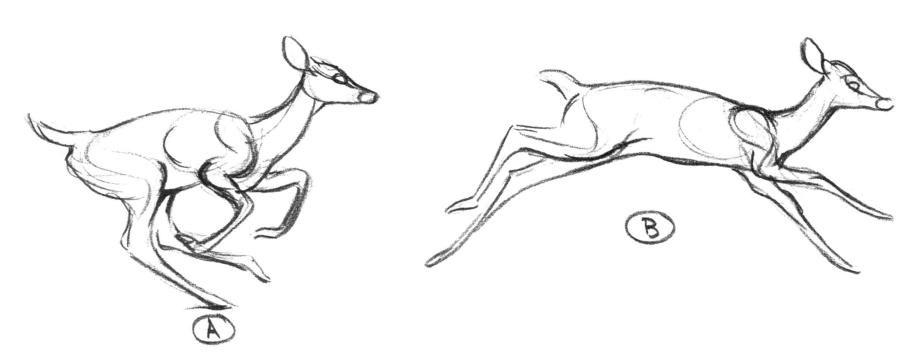

But translating an inspiration into drawings that come to life on the screen involves work, exploration, experimentation, frustration, and more work. As a young artist, Brad Bird observed how Milt Kahl approached the animation of Madame Medusa in *The Rescuers*. "He would draw a page of slight variations on a single pose. If you just glanced at the page, there might be twelve or fifteen poses that looked identical," Bird recalls. "But if you examined them closely, you'd see all these little shifts: the shoulder would be a little higher, the twist of the body would be a little more pronounced, then a little less; fingers on the lips, knuckles on the lips, wrist on the lips; head propped up, head propped down. He would explore, pick one pose, then move on to the next one, which might occur a second later, and do the same thing. He was constantly searching for the best possible graphic statement."

Walt Disney advanced the art of animation by giving his animators the time they needed to explore and experiment. Grim Natwick, who animated Snow White, said, "They allowed me two months of experimental animation before they ever asked me to animate one scene in the picture. Disney had only one rule: whatever we did had to be better than anybody else could do it, even if you had to animate it nine times, as I once did."

More than eighty years after Mickey Mouse whistled and danced his way into audience's hearts in *Steamboat Willie*, the artists at the Disney Studio continue to explore and experiment, working to find the best way to present the story they're telling. They may now use pencils or digital tablets, but the process remains the same. Work and rework each image until it's as perfect as it can be, then make it better. The drawings in this collection offer readers who love the Disney films insights into the process of the creation of their favorite characters.

Charles Solomon
Animation critic and historian

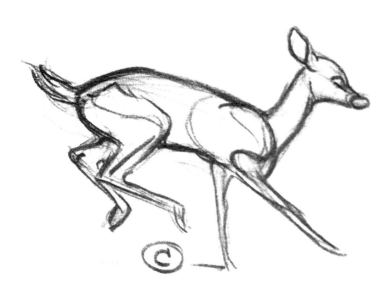

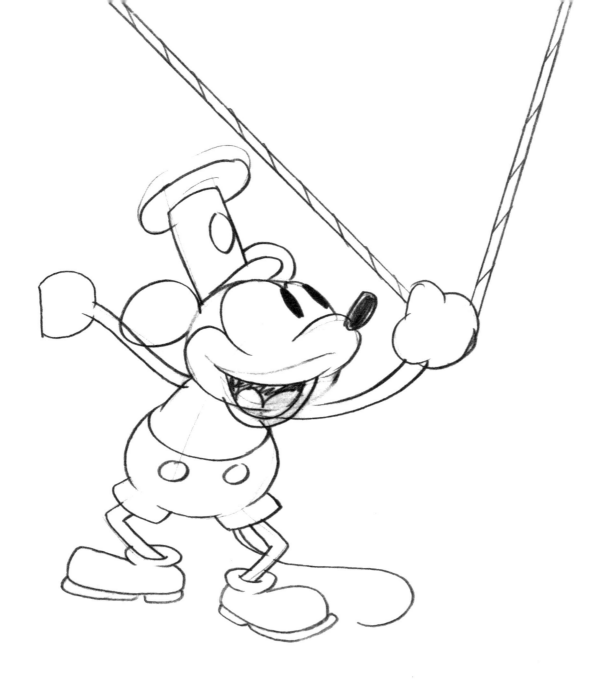

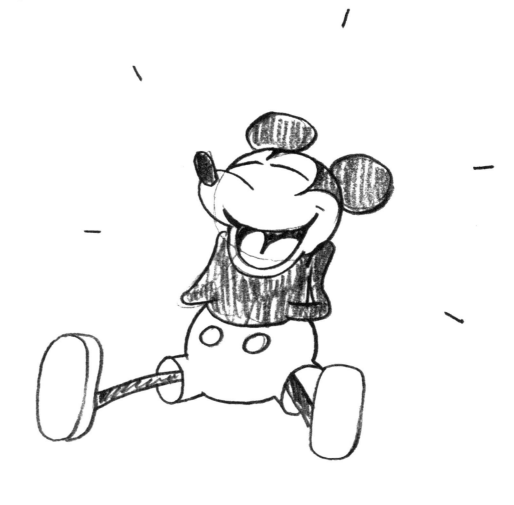

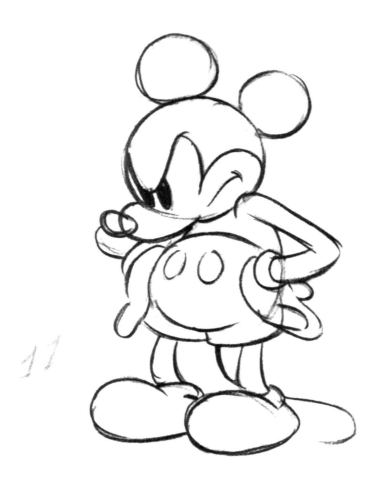

NARROW
SHOULDERS
MAKE HIM

SYMPATHETIC →

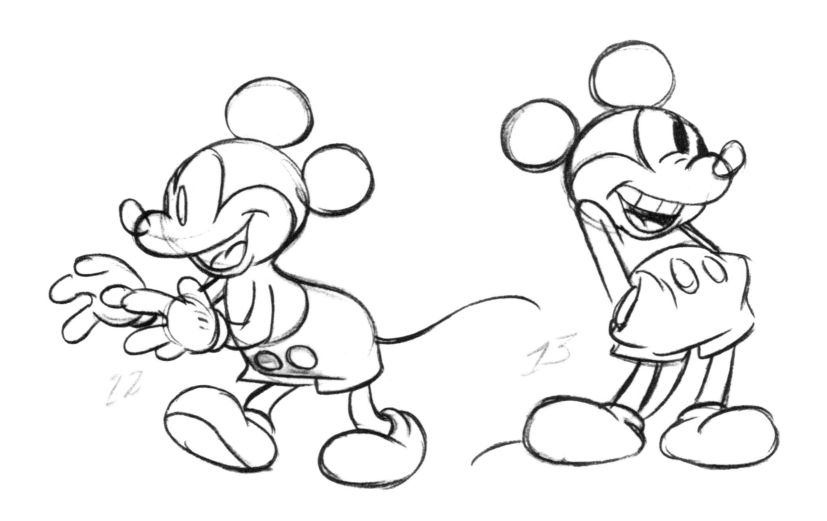

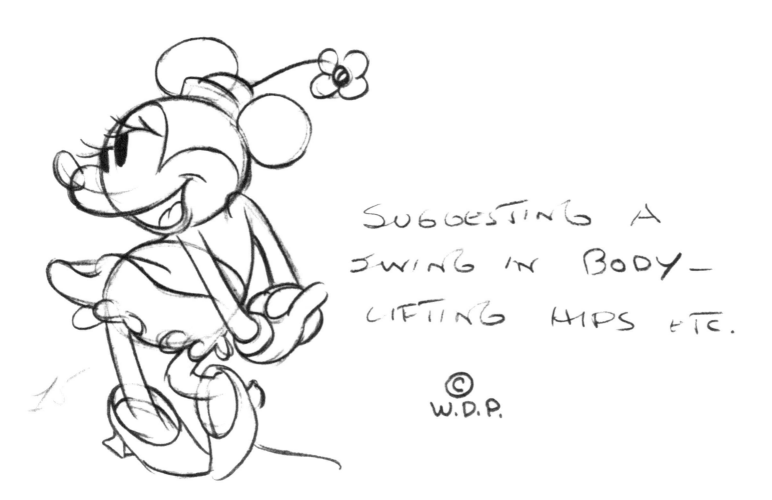

SUGGESTING A
SWING IN BODY—
LIFTING HIPS ETC.

© W.D.P.

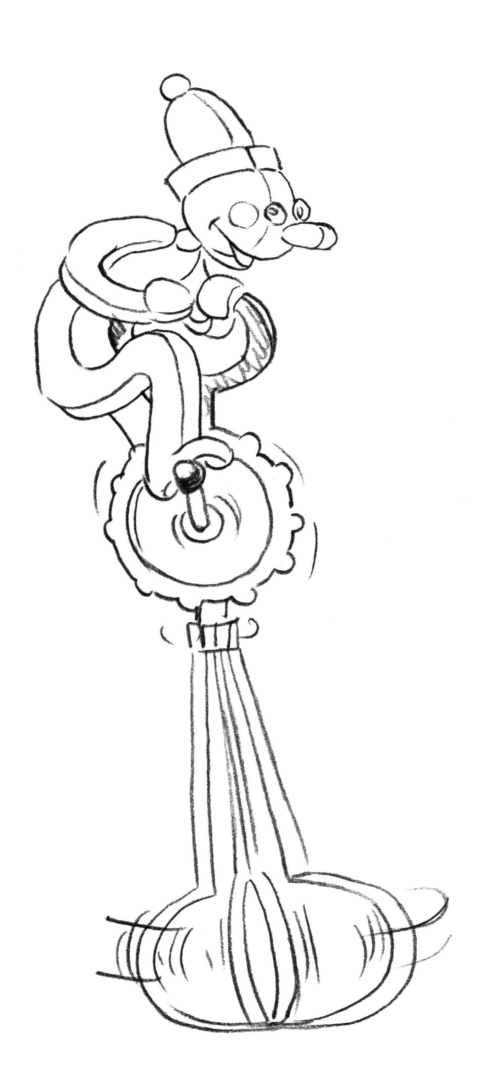

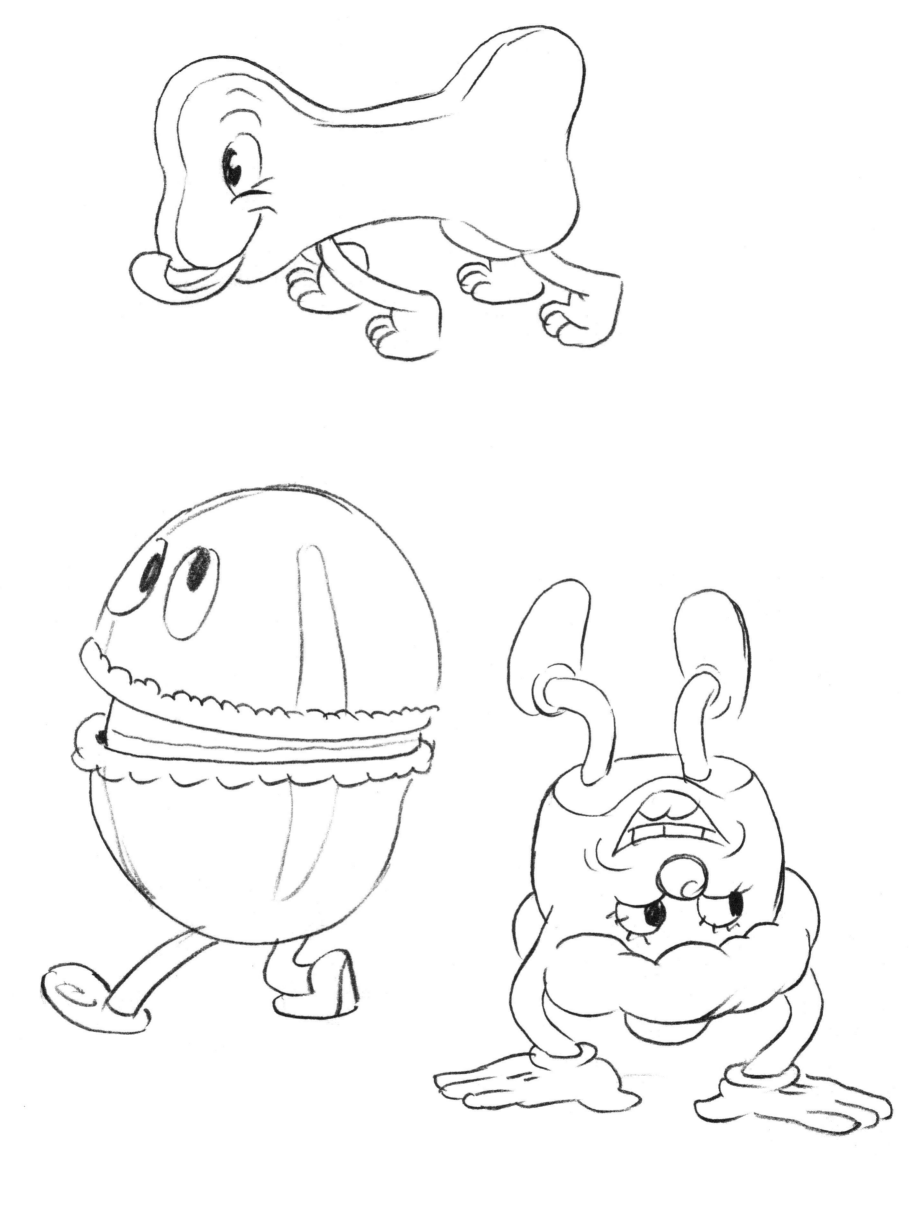

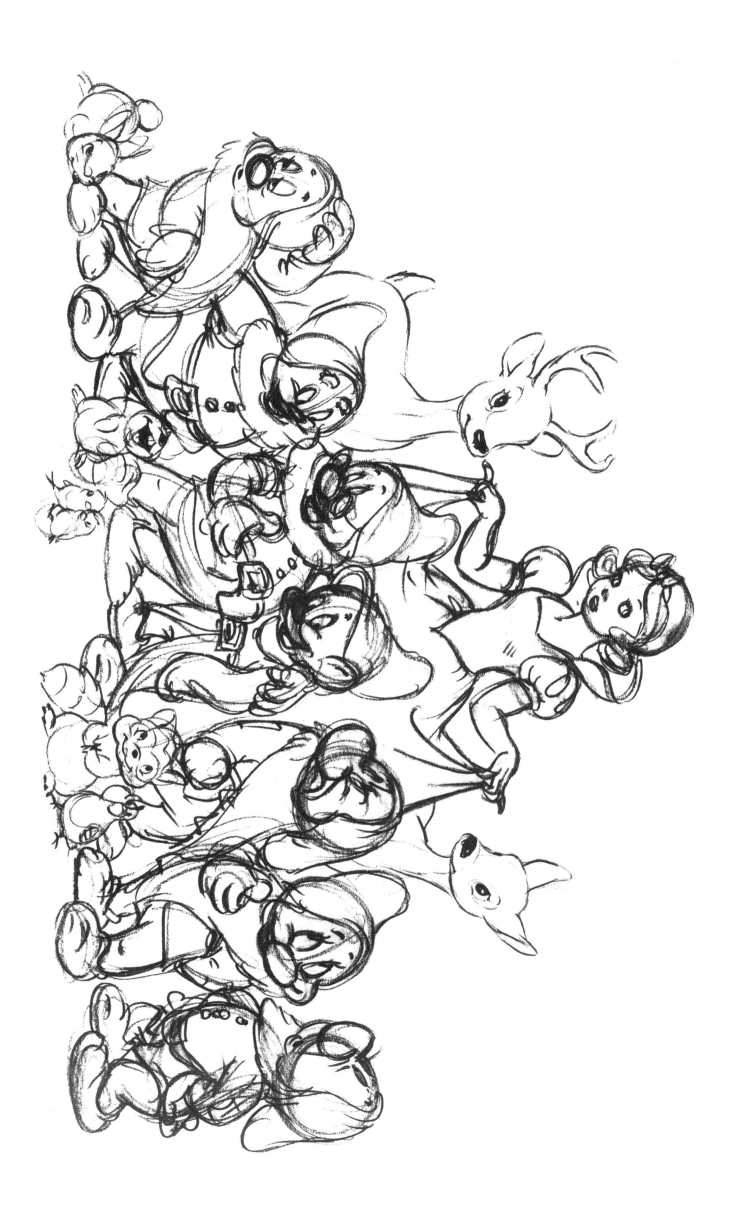

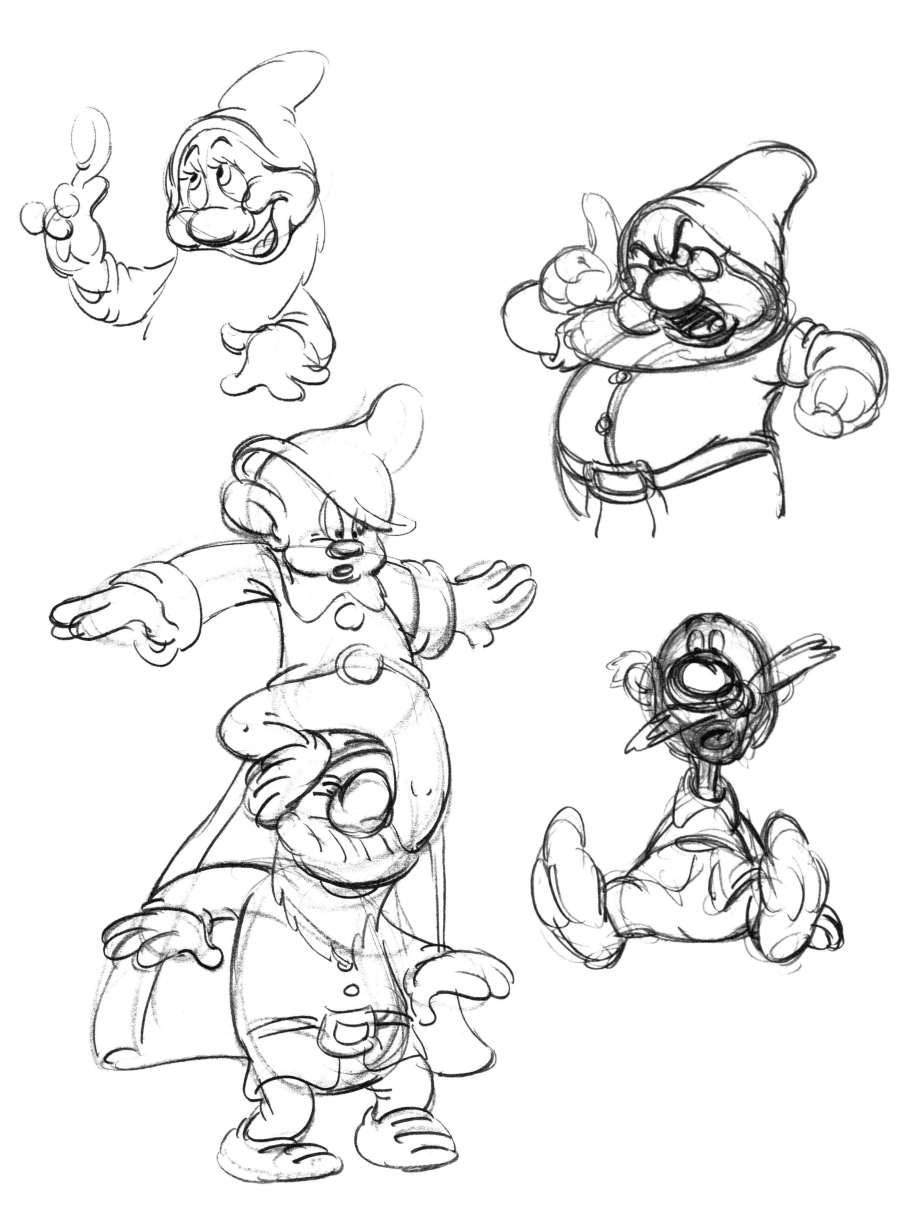

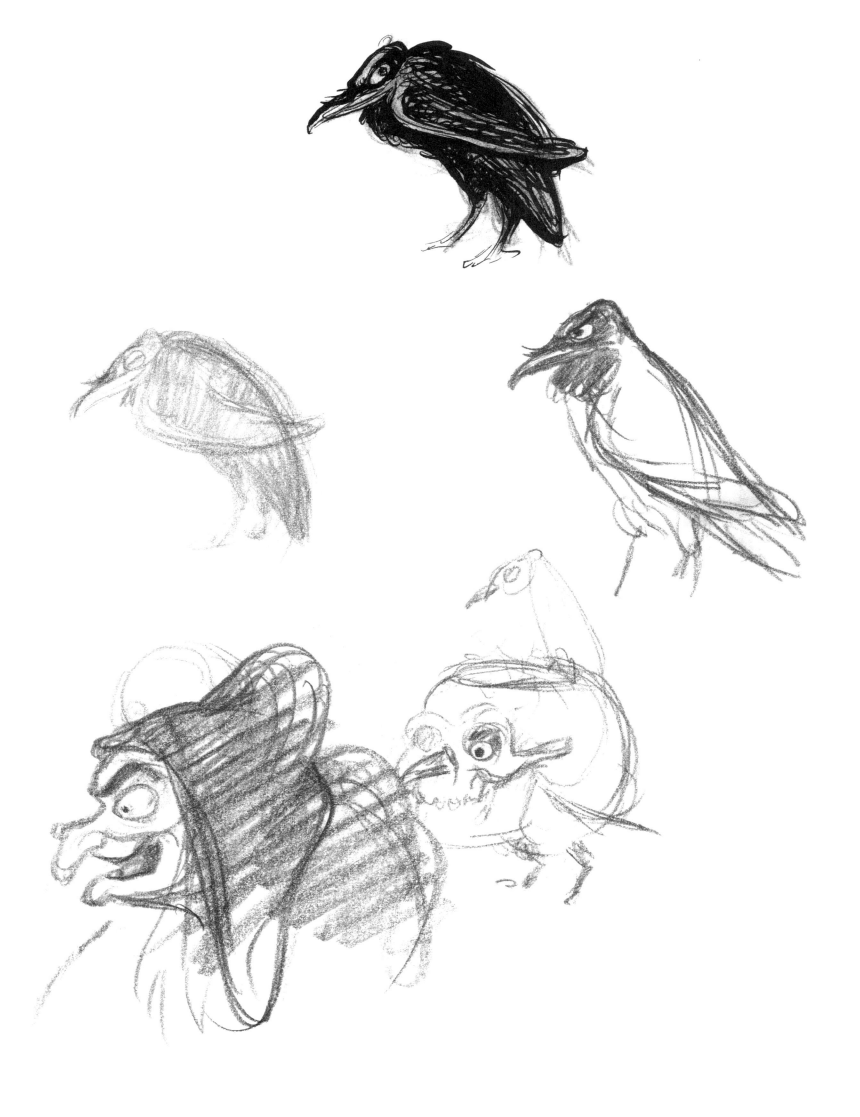

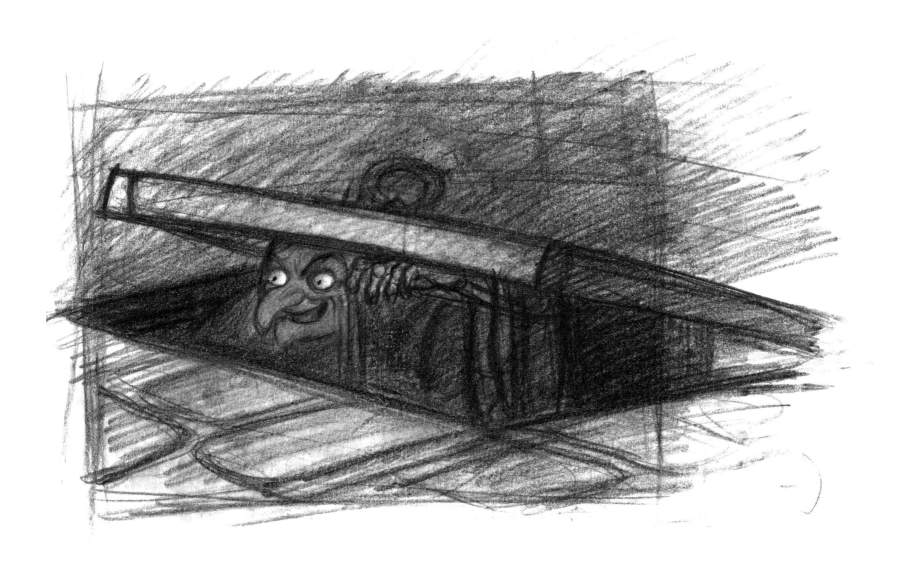

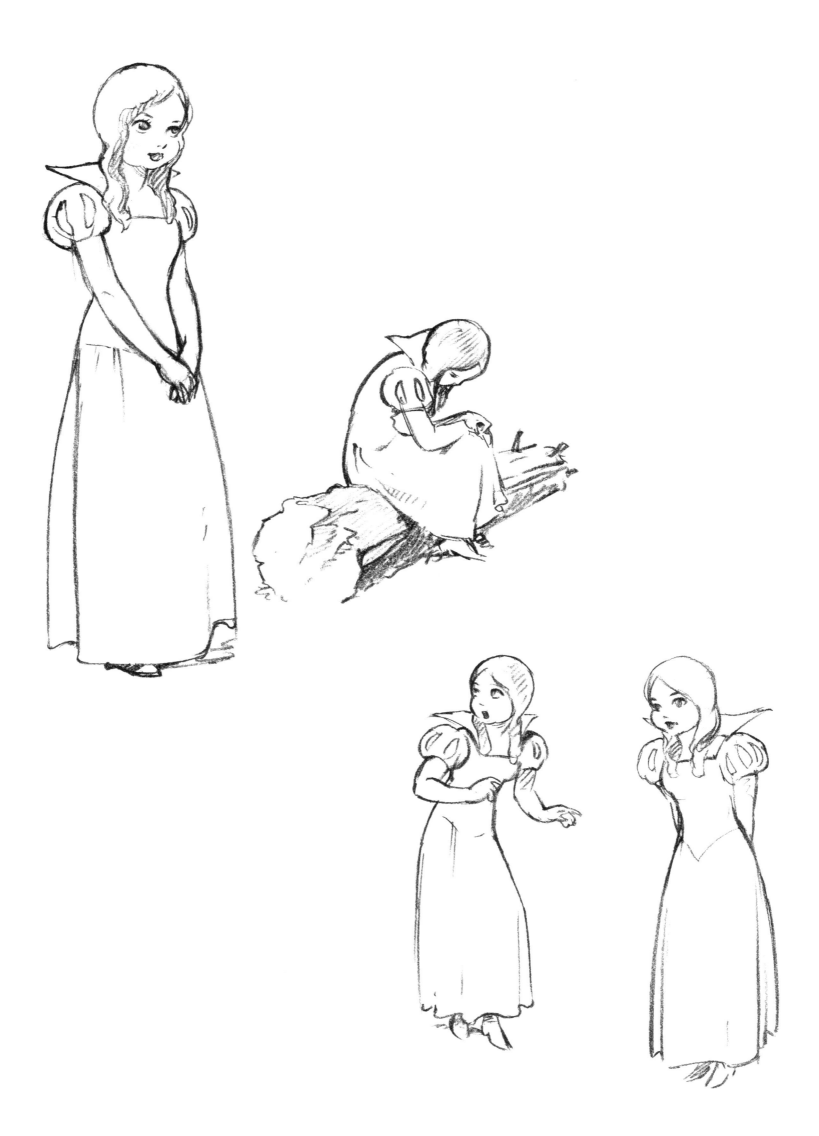

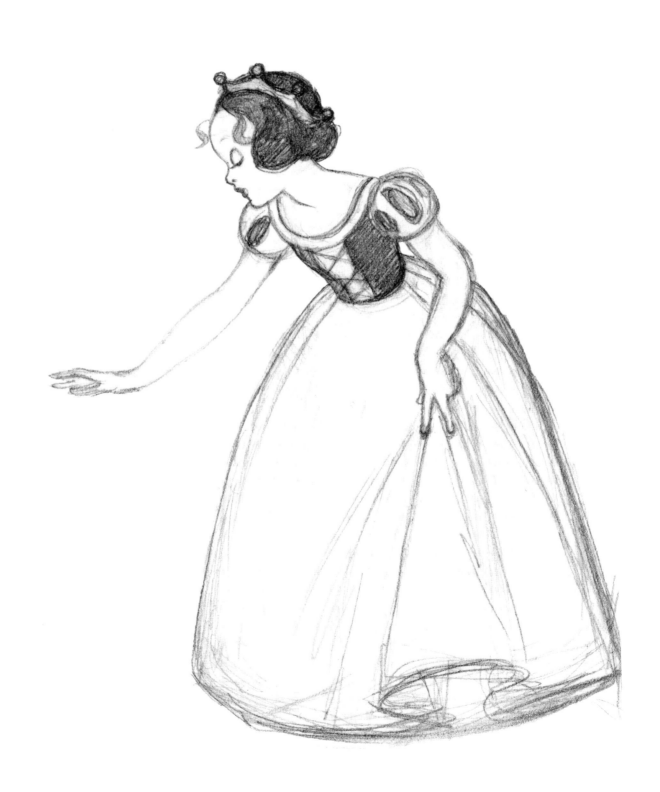

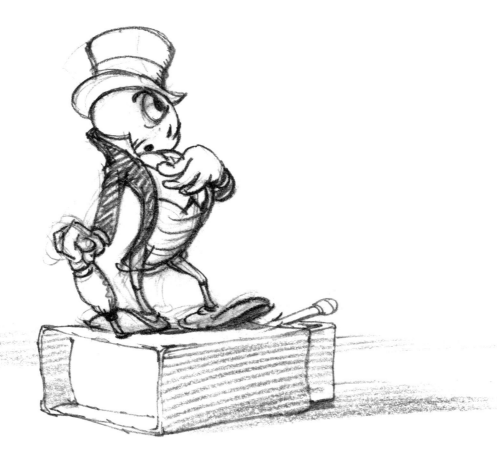

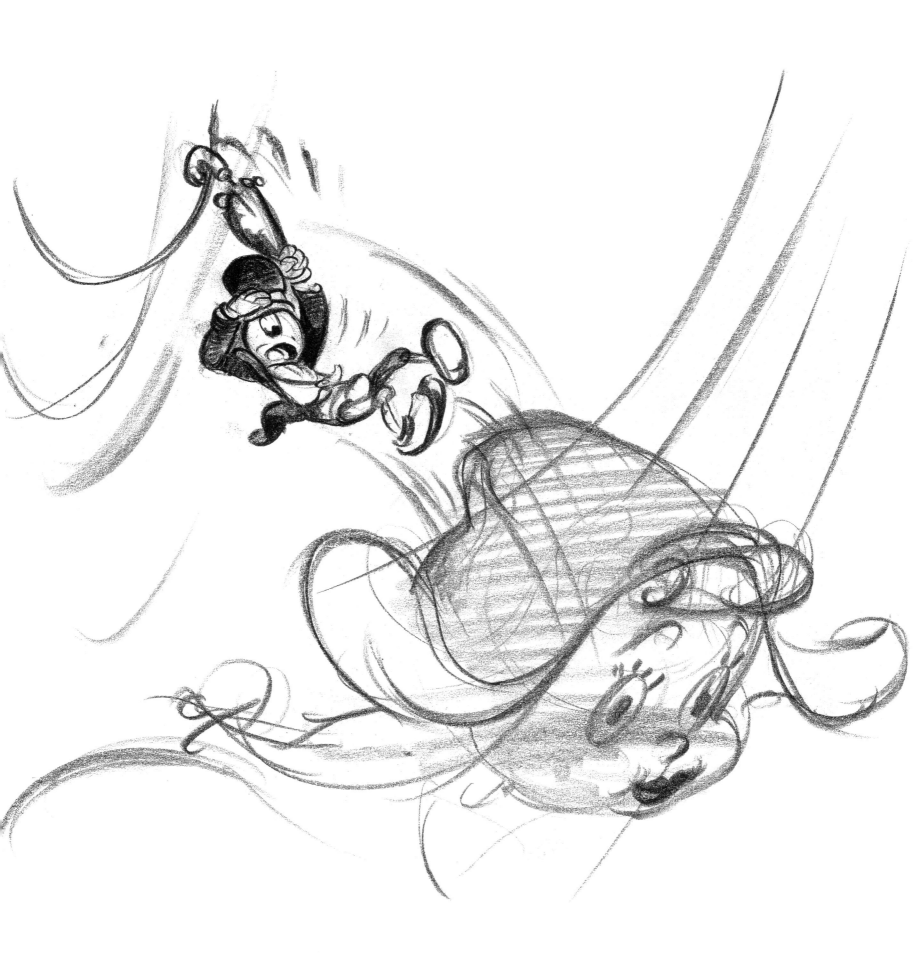

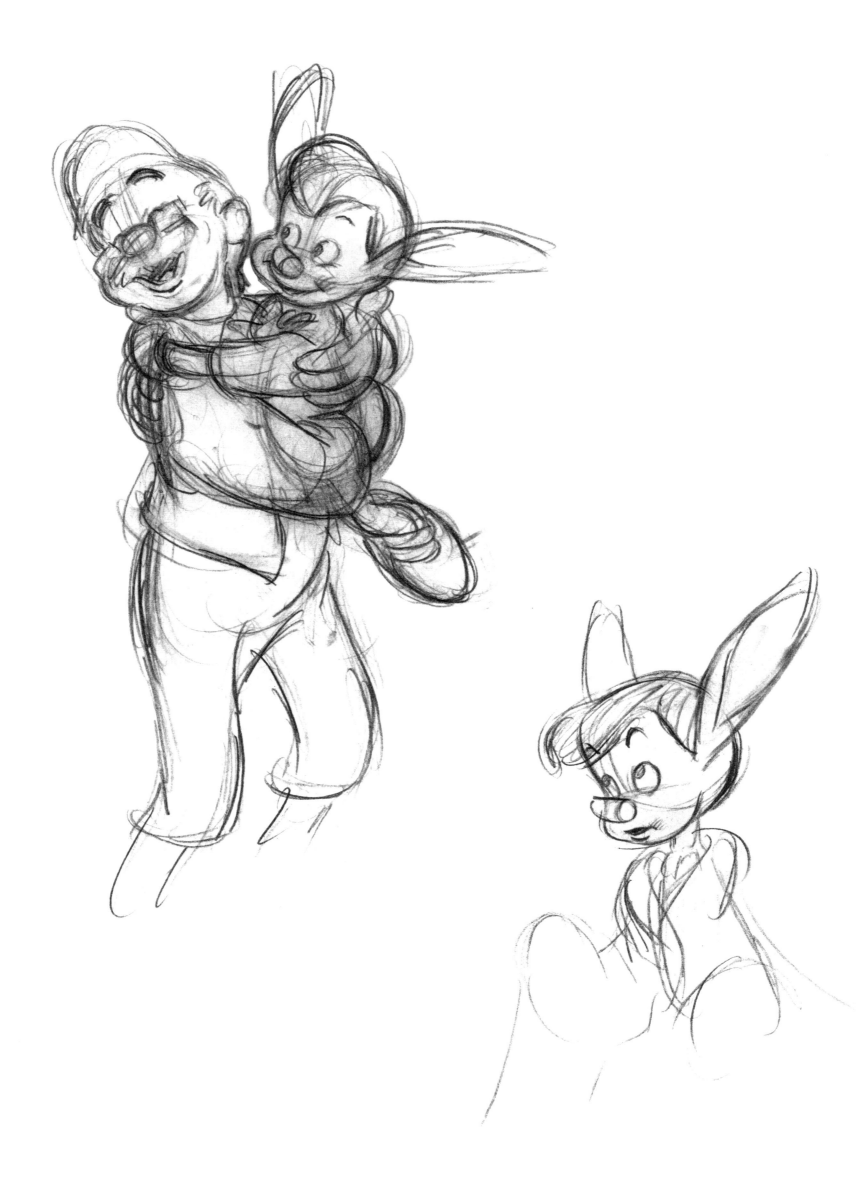

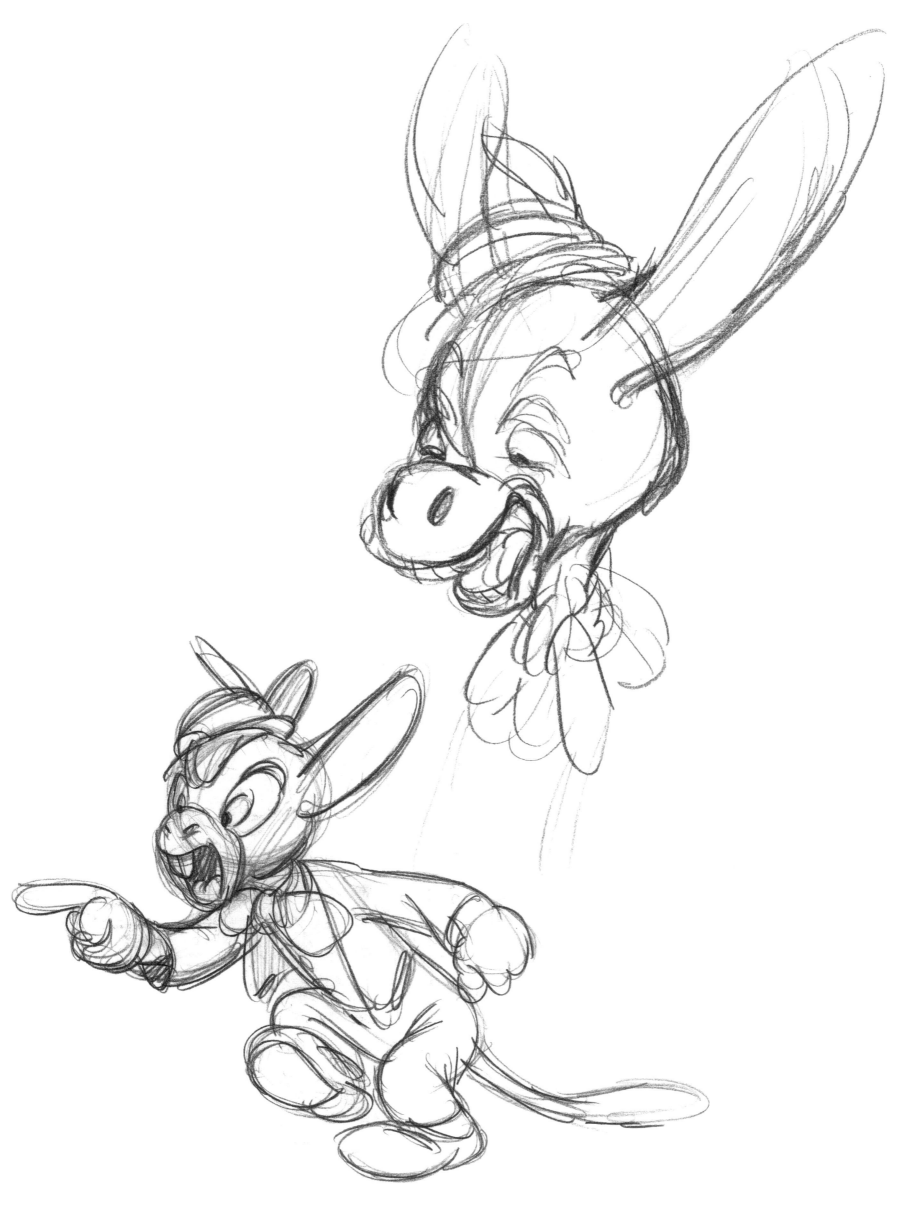

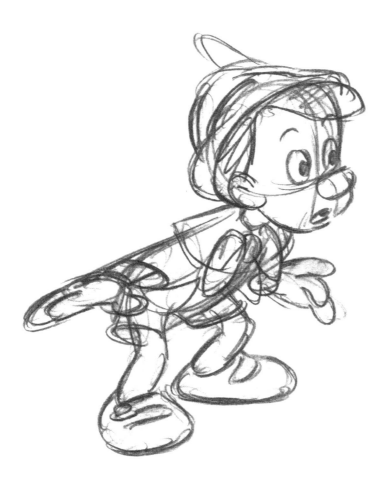

"GOT TO GET THEM BEFORE THEY GO DOWN THERE!"

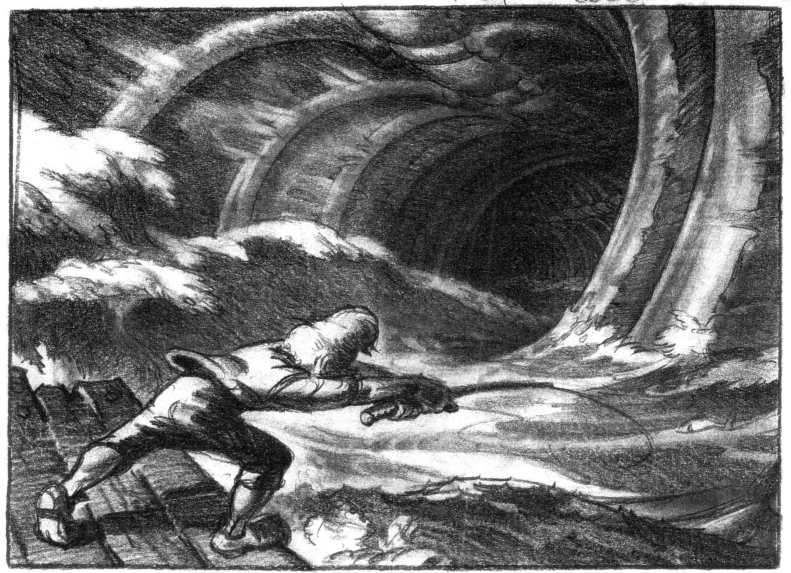

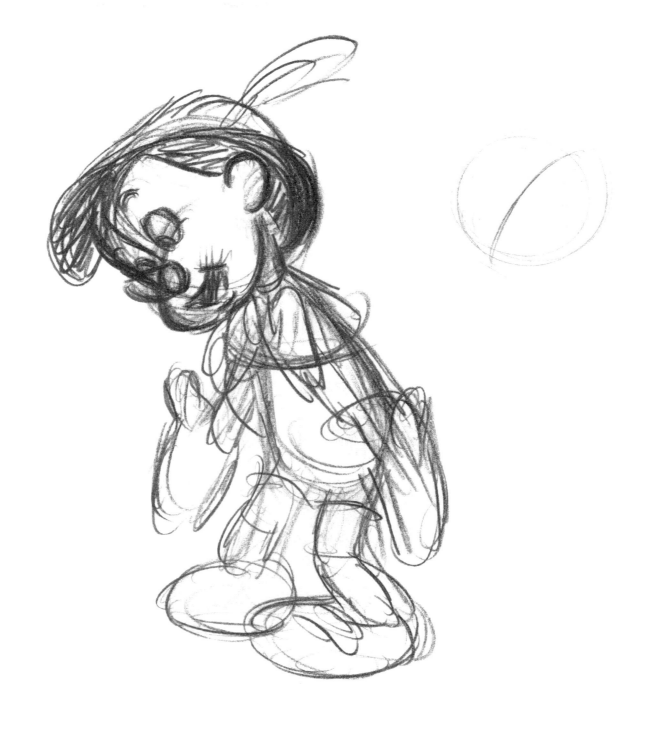

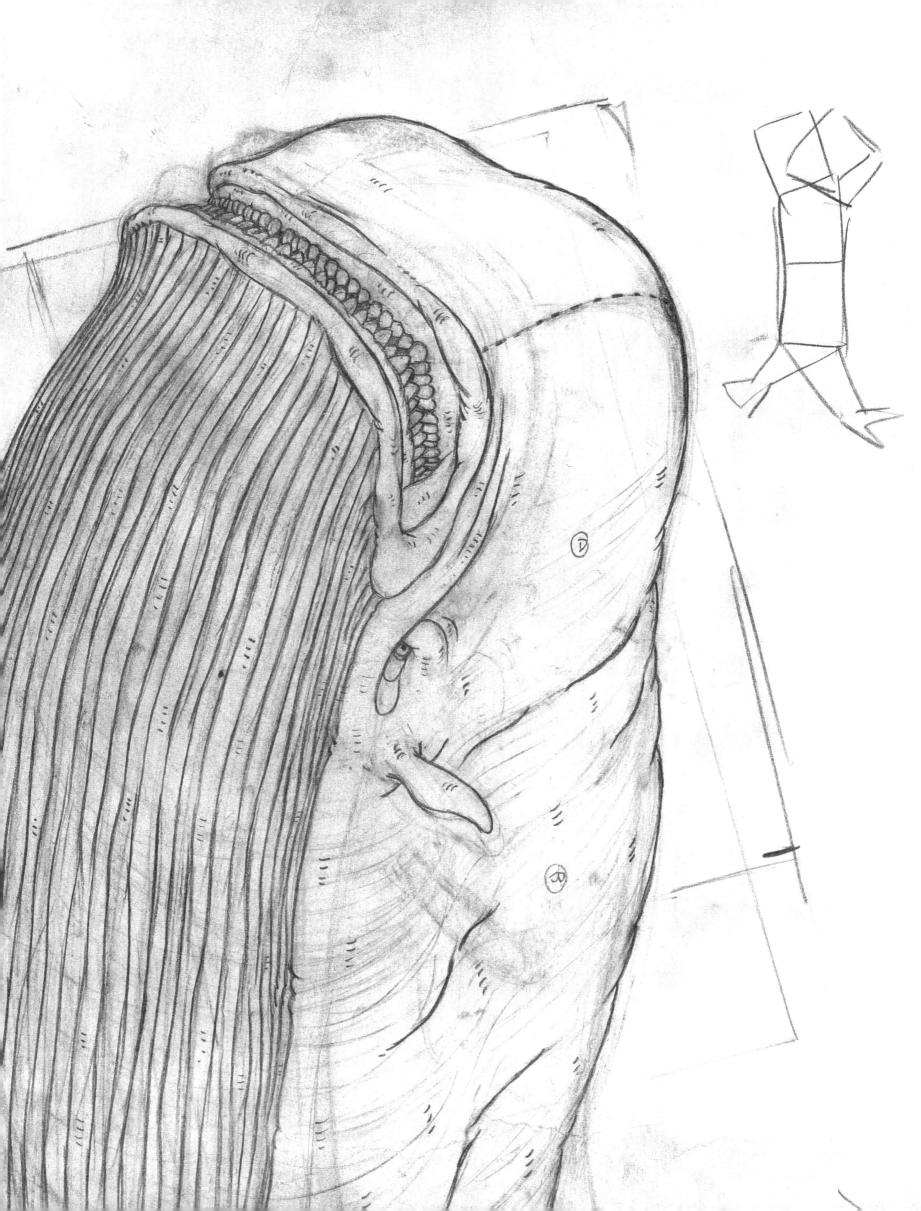

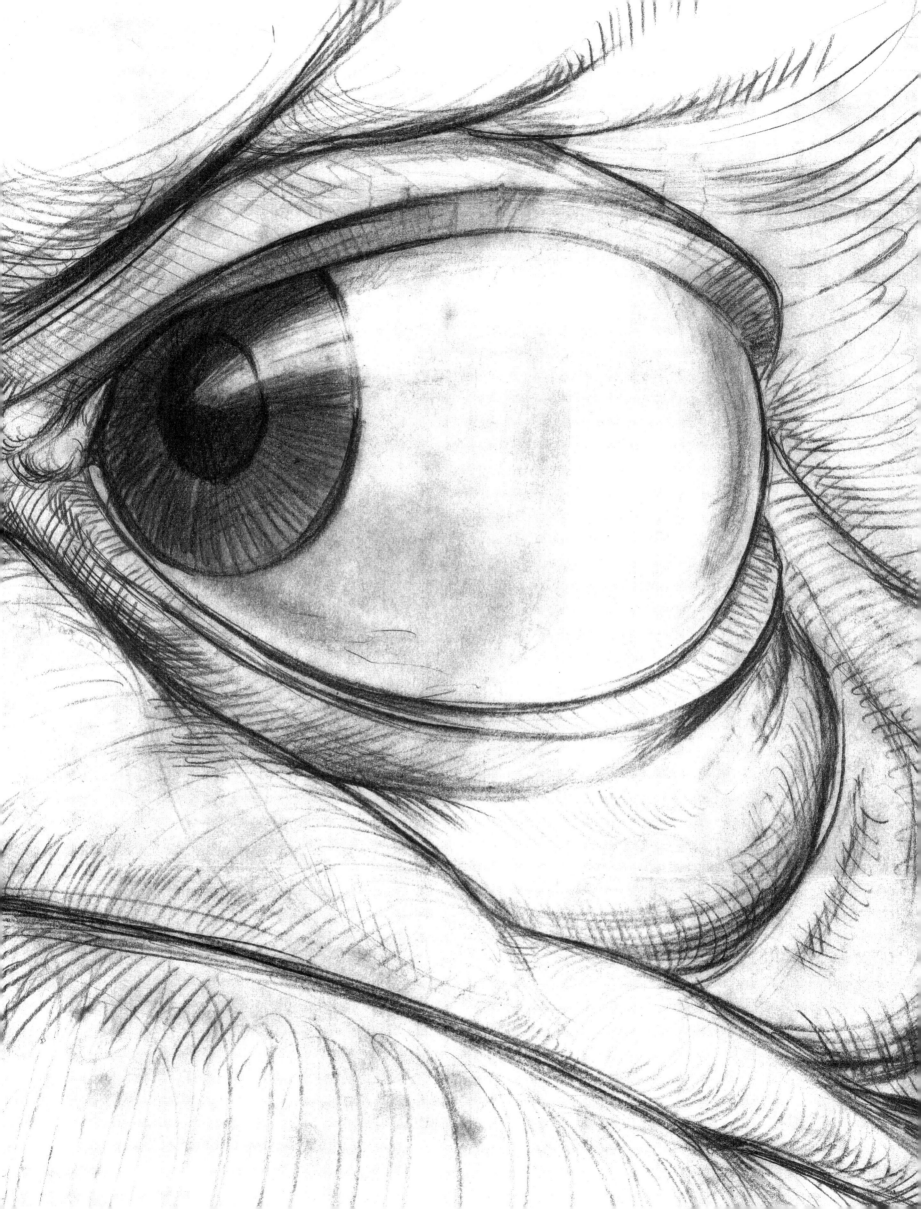

THE HEAD IS CONSTRUCTED FROM A SLIGHTLY "FLATTENED CIRCLE" — SO ARE THE EARS

IN A FRONT VIEW WRINKLES HELP THE PERSPECTIVE OF THE SNOUT

CHEEKS BULDGE SLIGHTLY

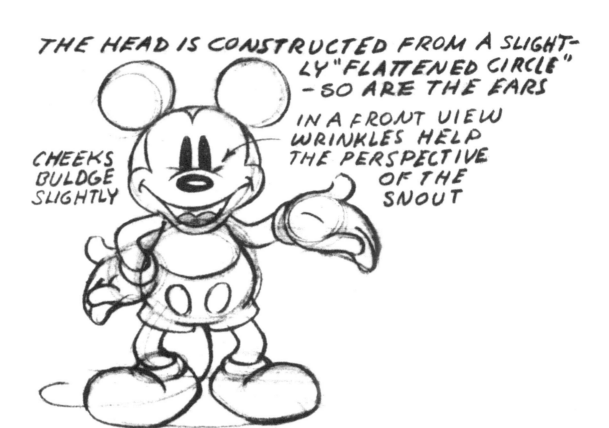

THE EYES FIT THE ROUNDNESS OF THE HEAD BY FOLLOWING THE CENTER LINE OF THE FACE

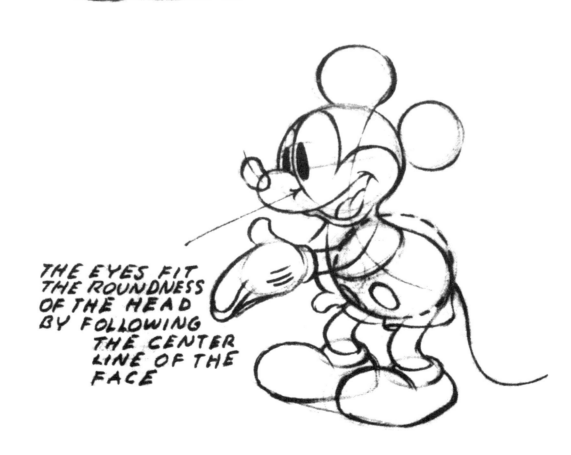

THE NOSE IS PART OF
THE SNOUT AND SHOULD
BE ON A LINE WITH IT

EARS WELL
BACK ON THE
HEAD

SNOUT BELOW
CENTER OF
HEAD

ALWAYS USE
EXPRESSION
LINES AT THE
CORNER OF
THE MOUTH

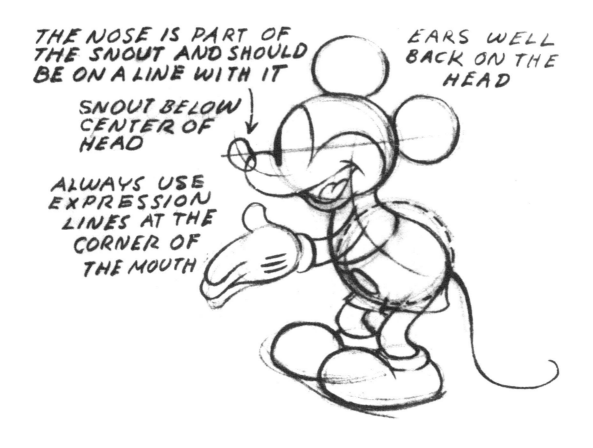

SHOES FLAT ON THE BOTTOM
TO SHOW WEIGHT

EARS WIDEST APART
IN FRONT AND REAR
VIEWS

BUTTONS
FIT ROUND-
NESS OF
BODY

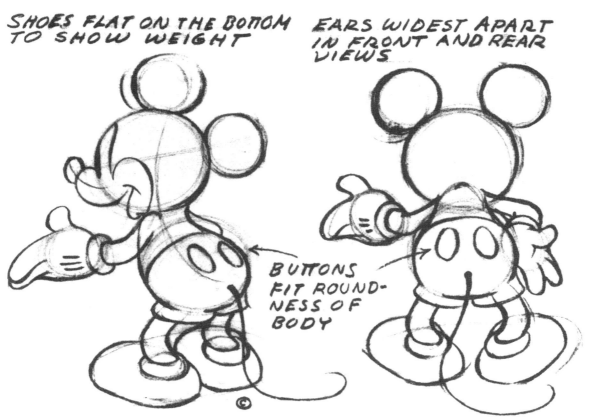

ARMS AND LEGS TAPER SLIGHTLY - KNEES
BREAK BELOW HALF. LEGS HEAVIER THAN ARMS

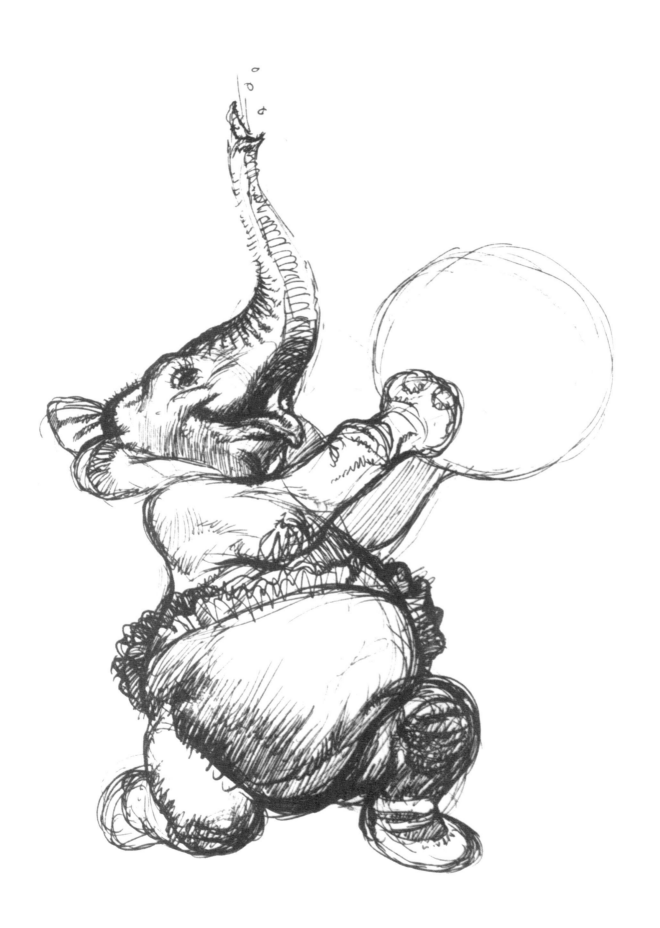

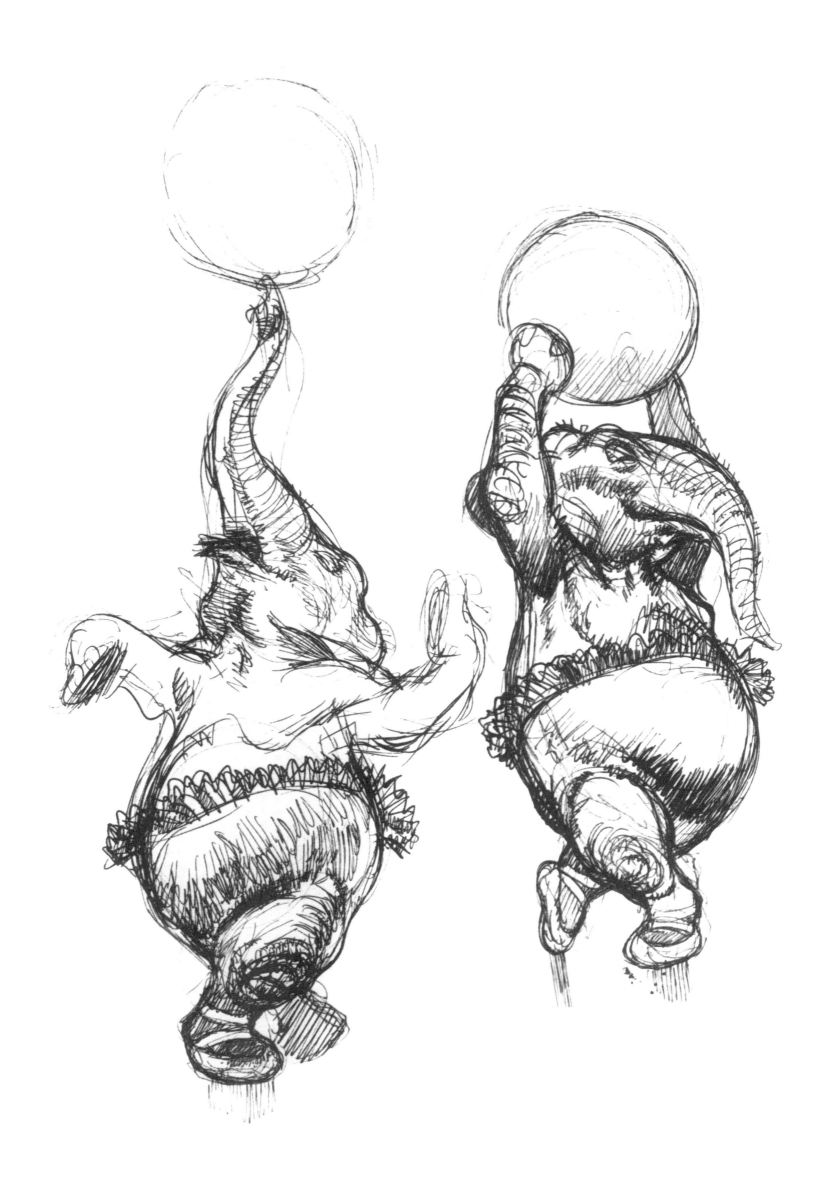

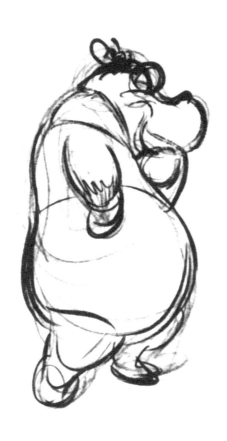
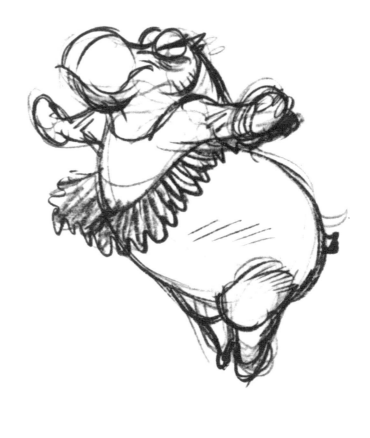
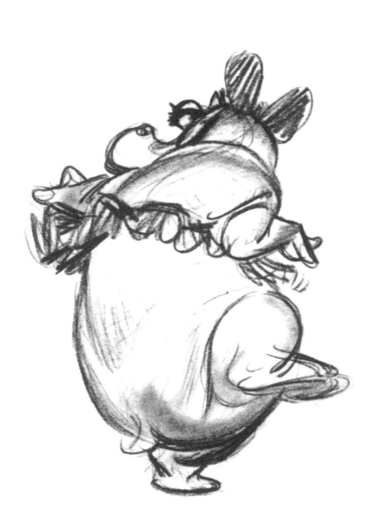
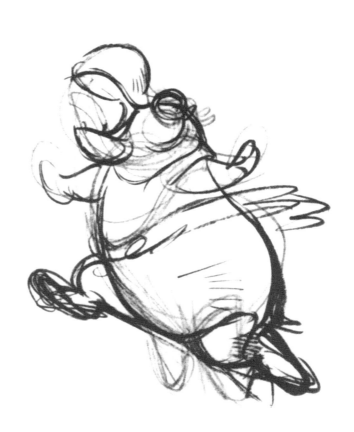

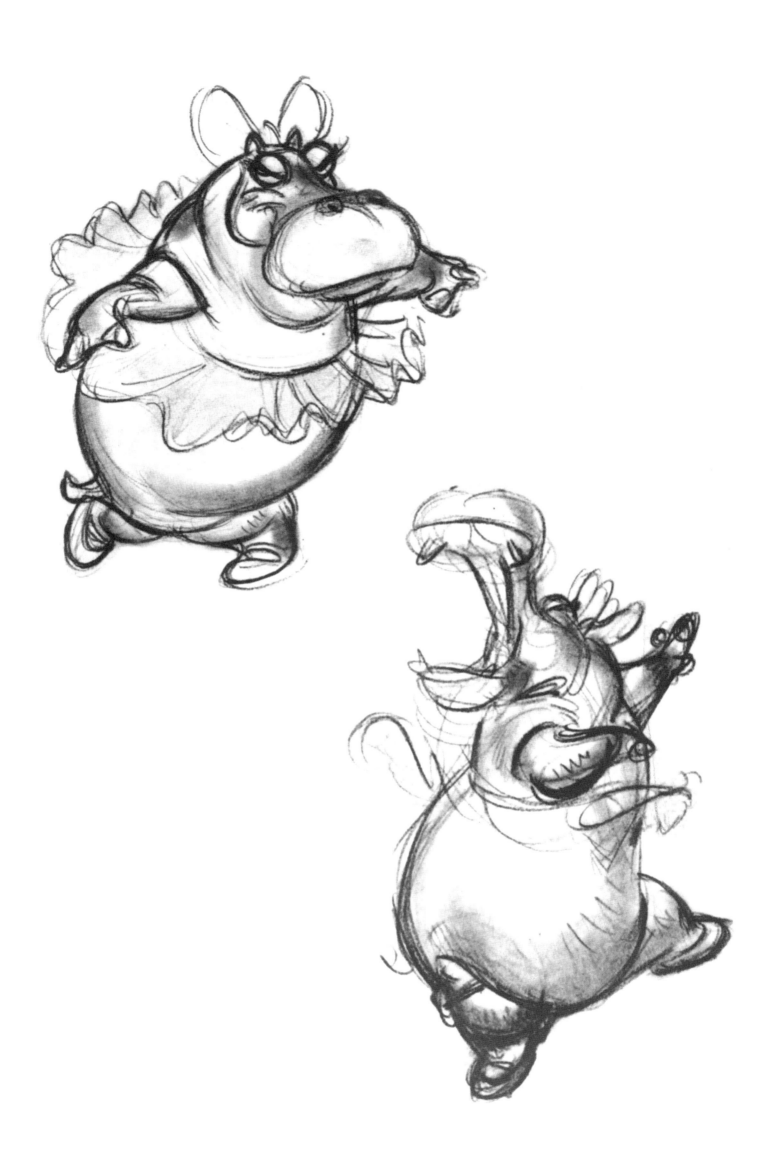

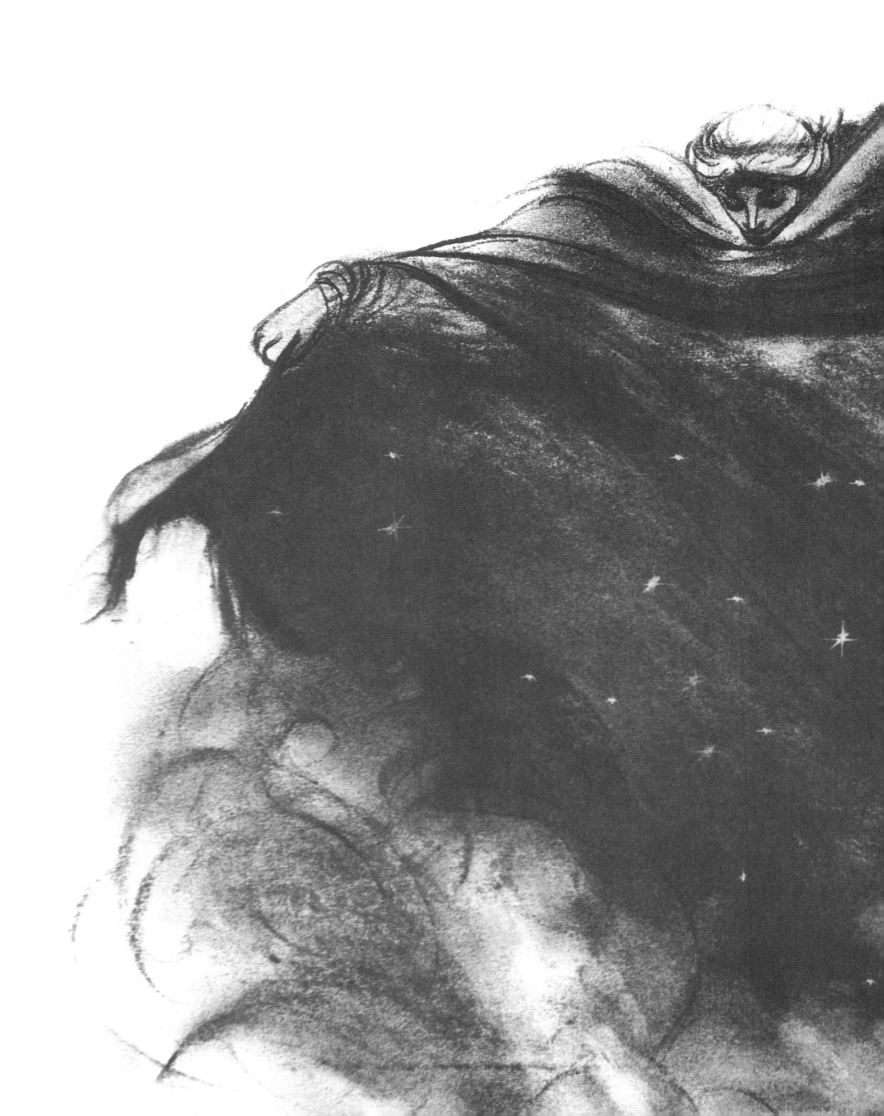

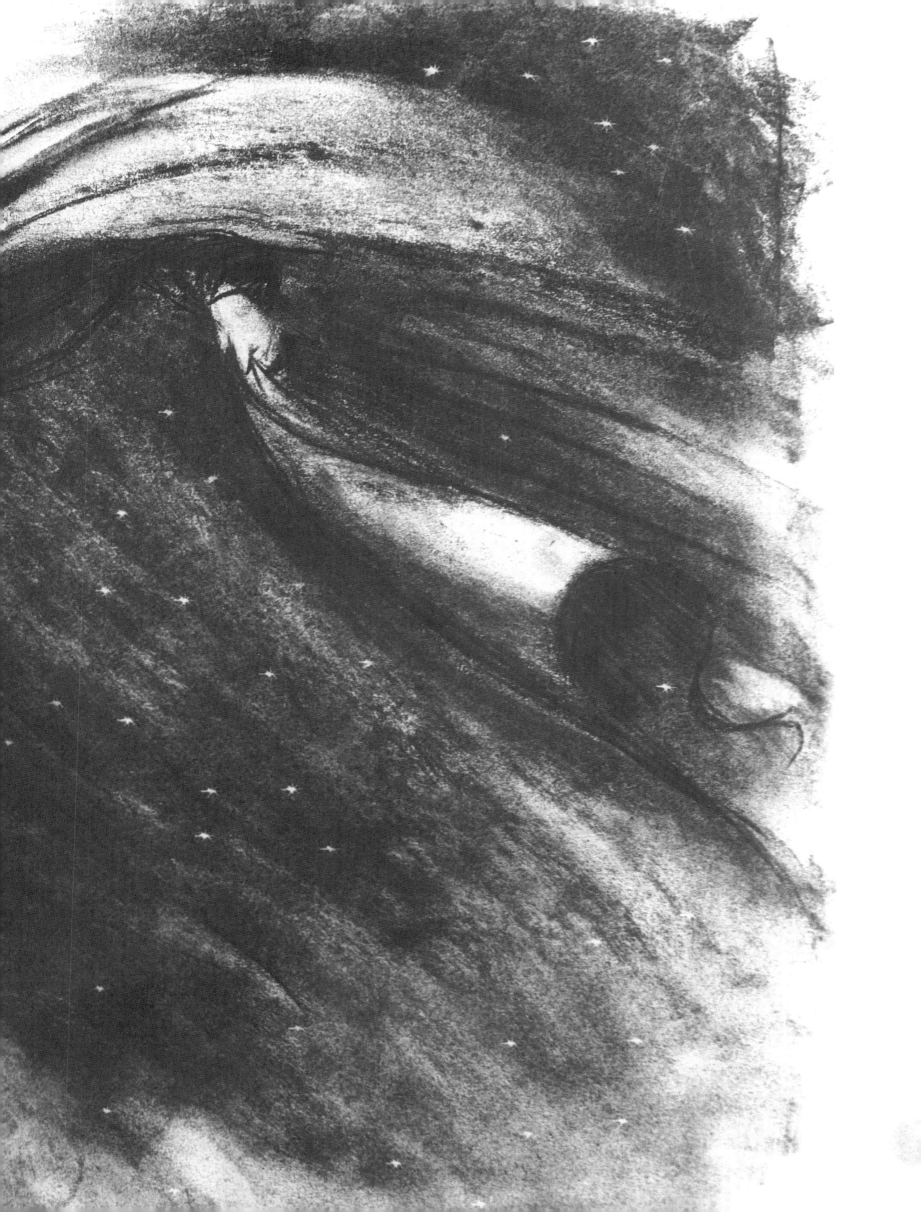

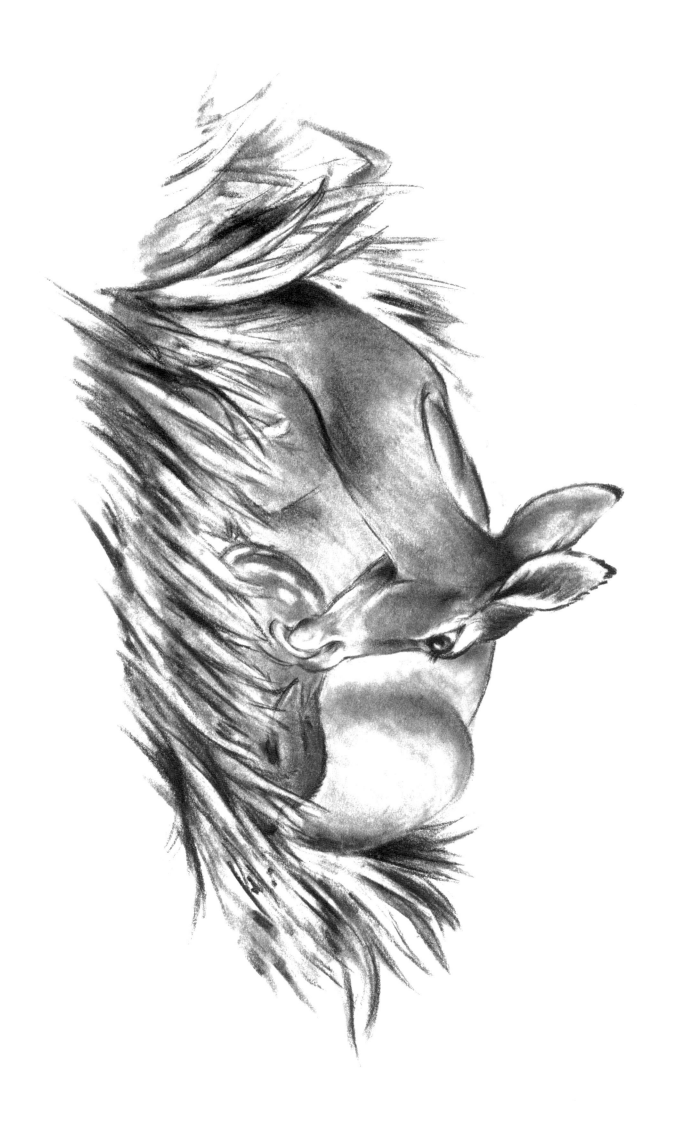

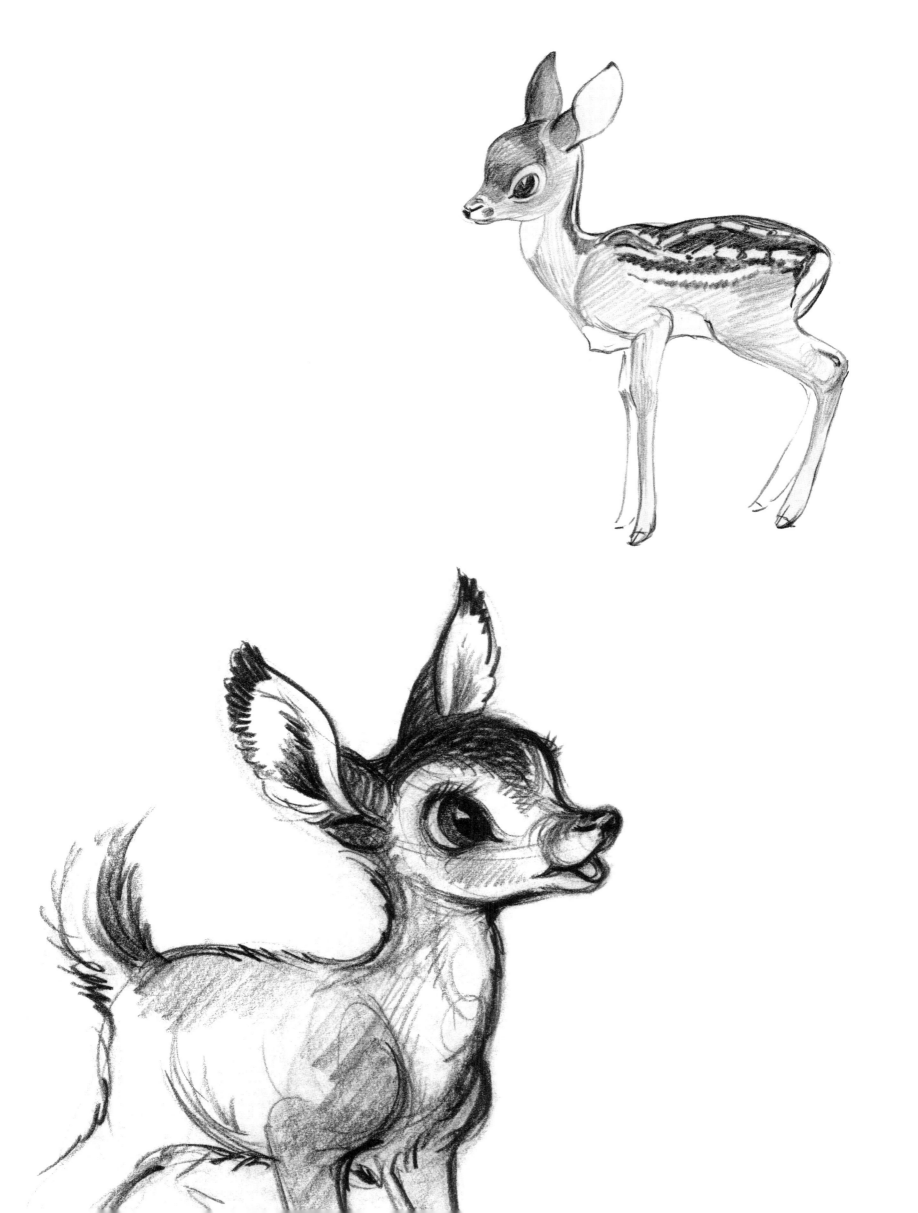

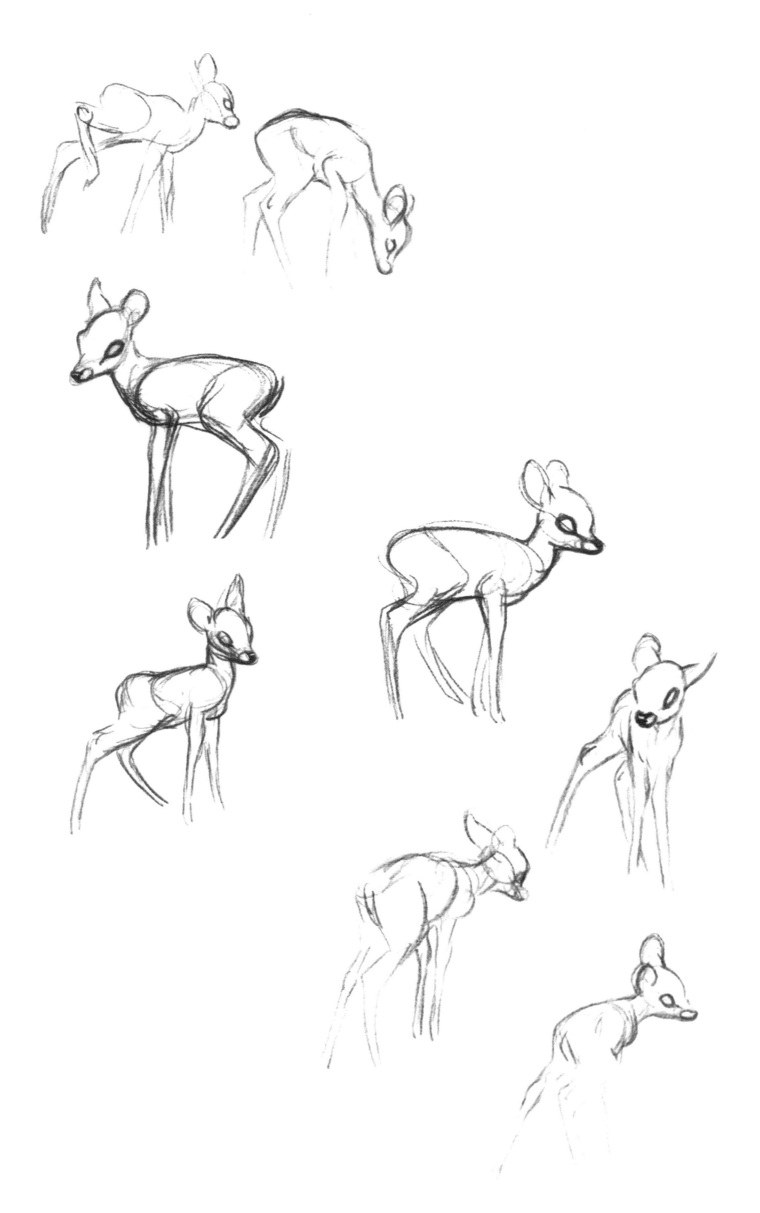

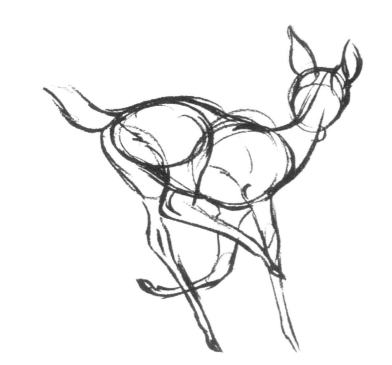

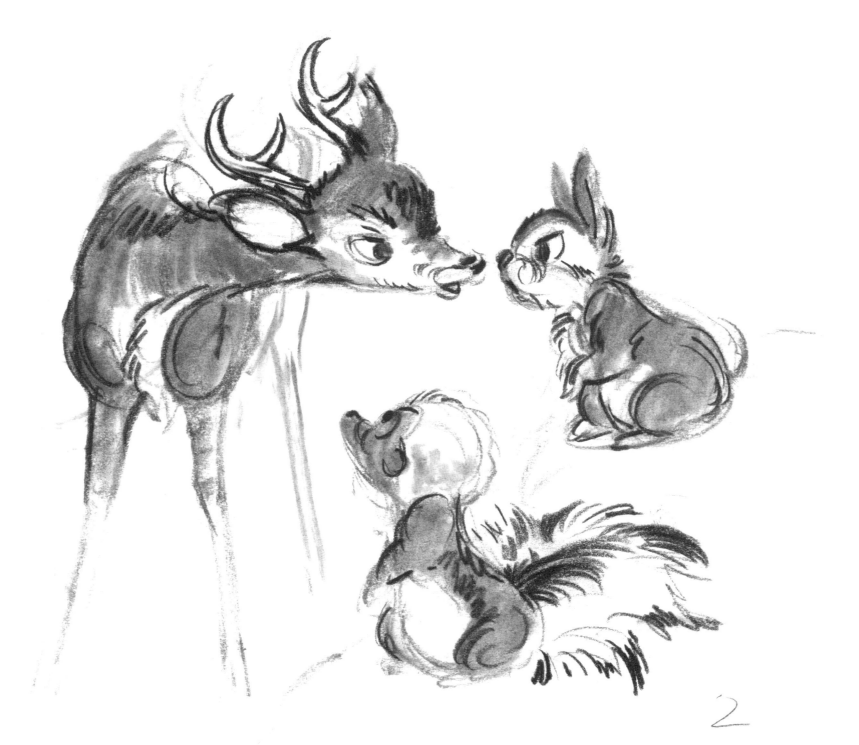

2

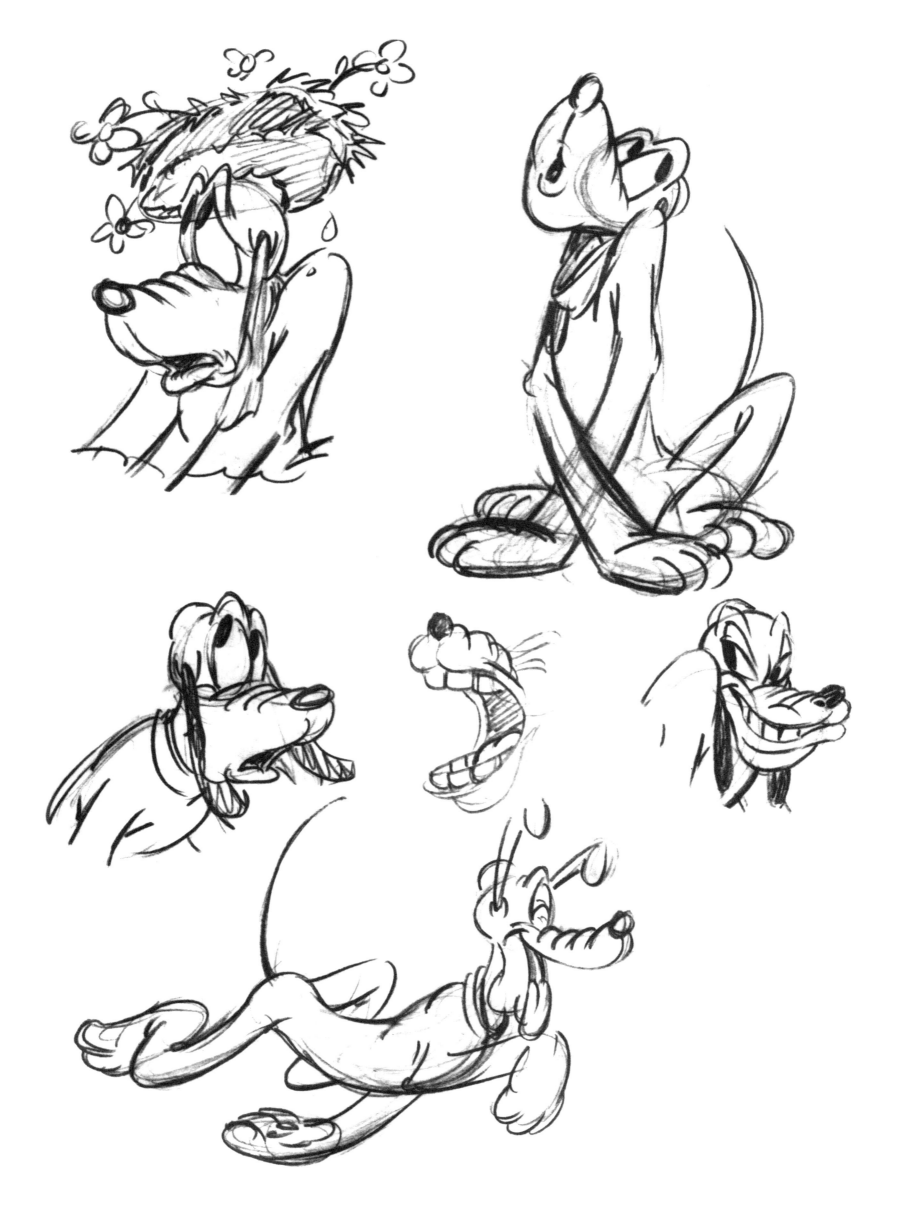

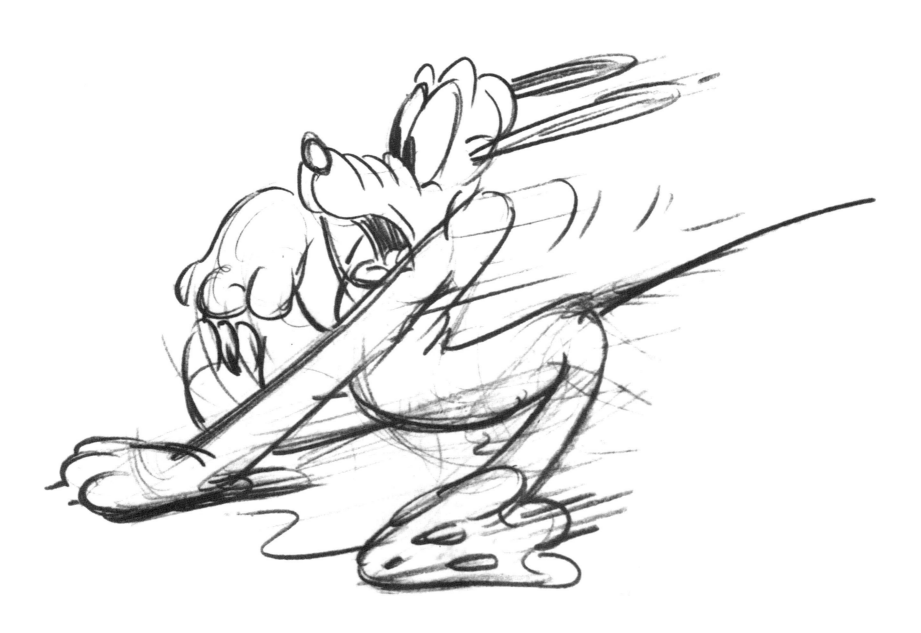

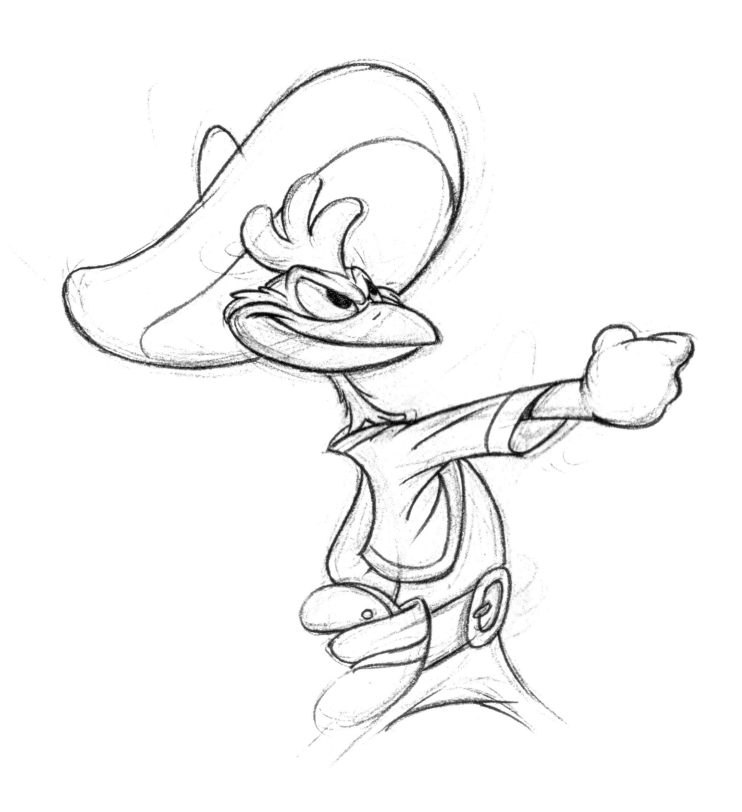

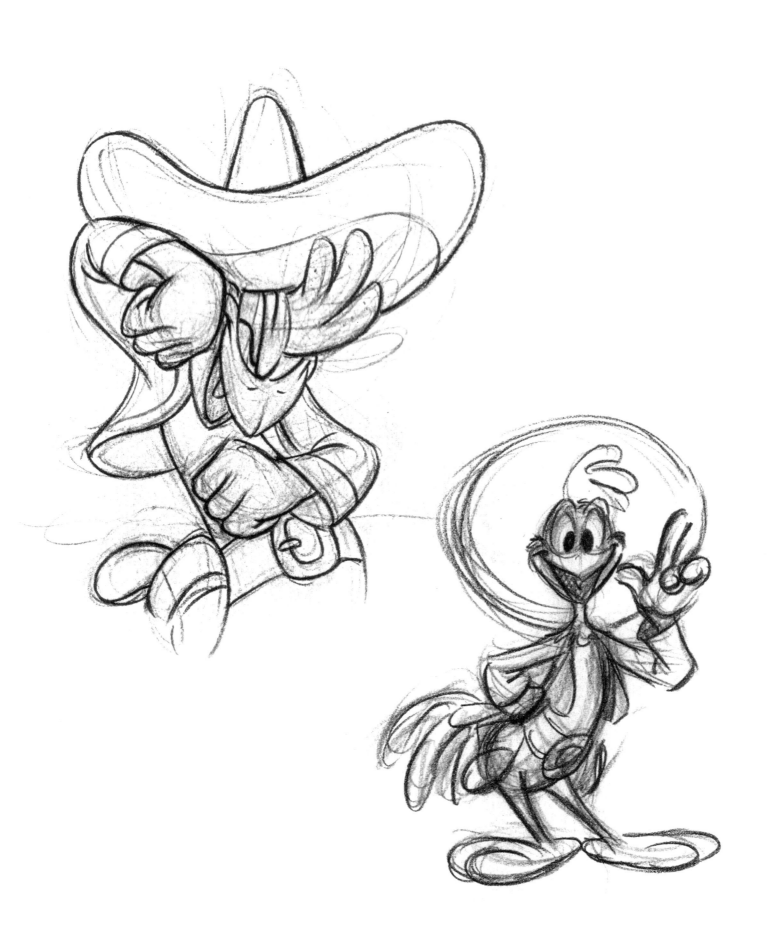

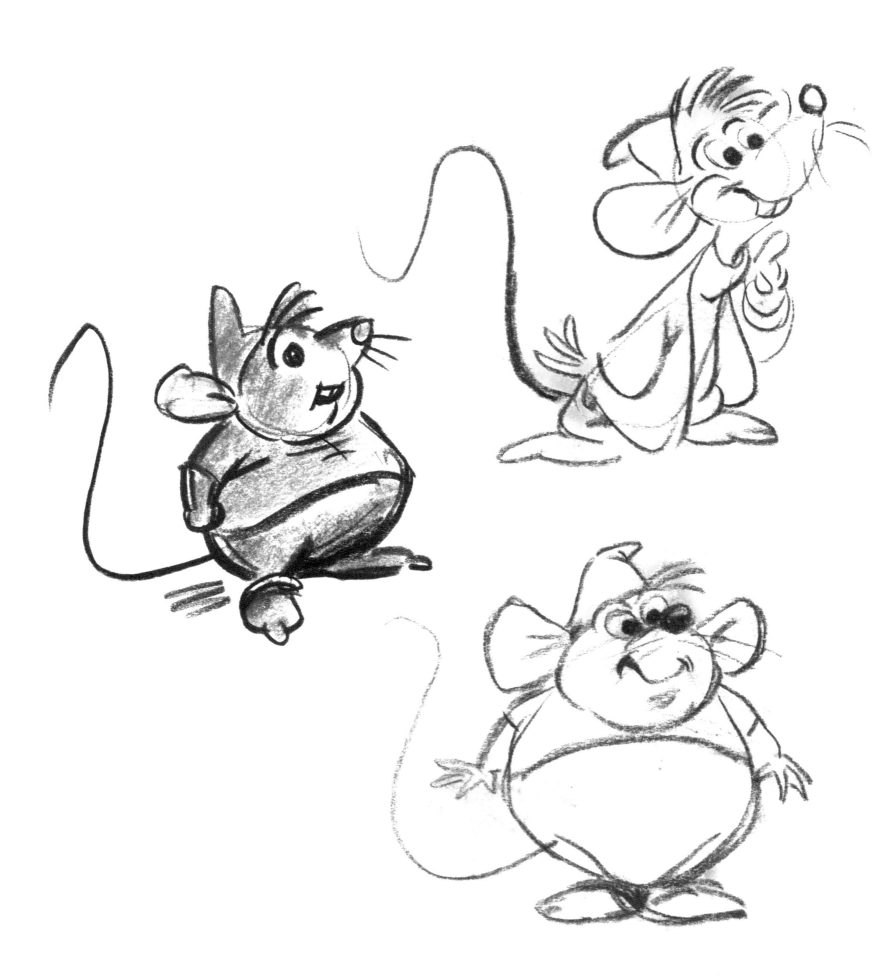

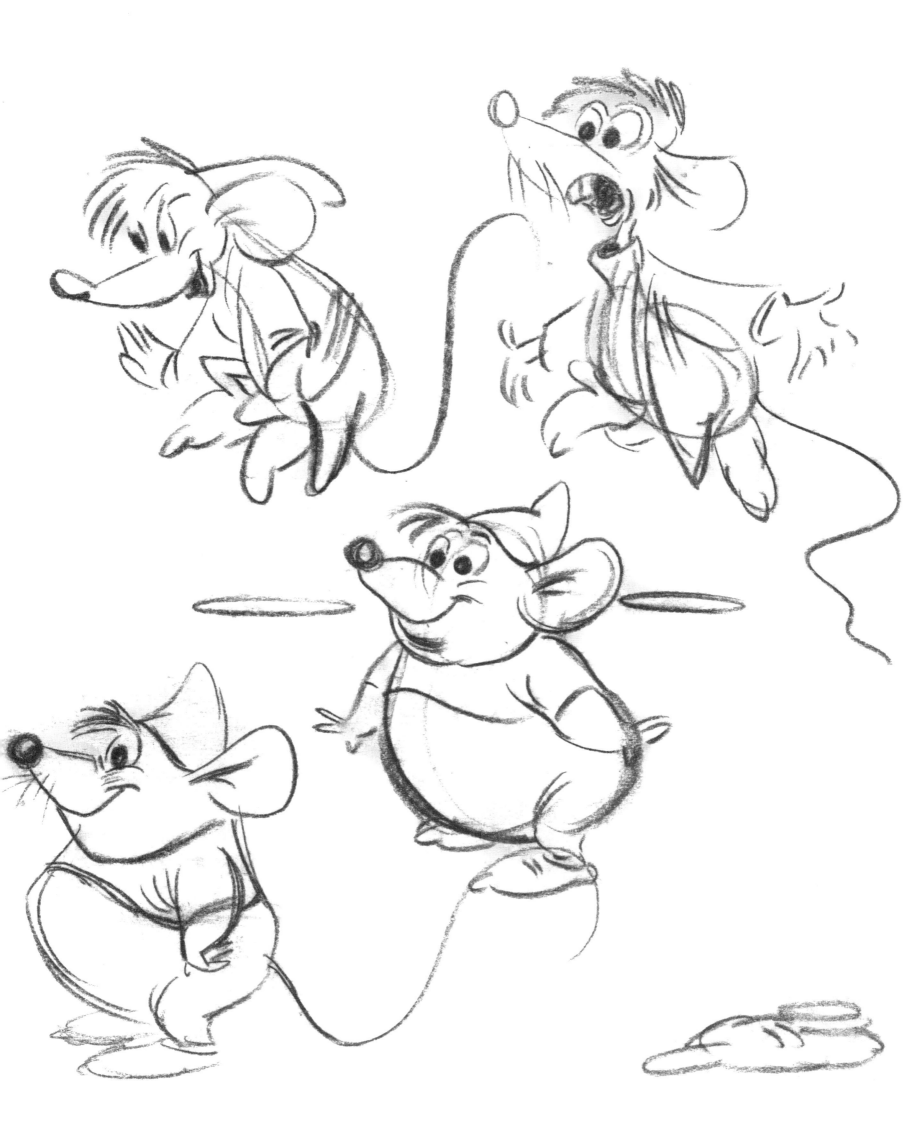

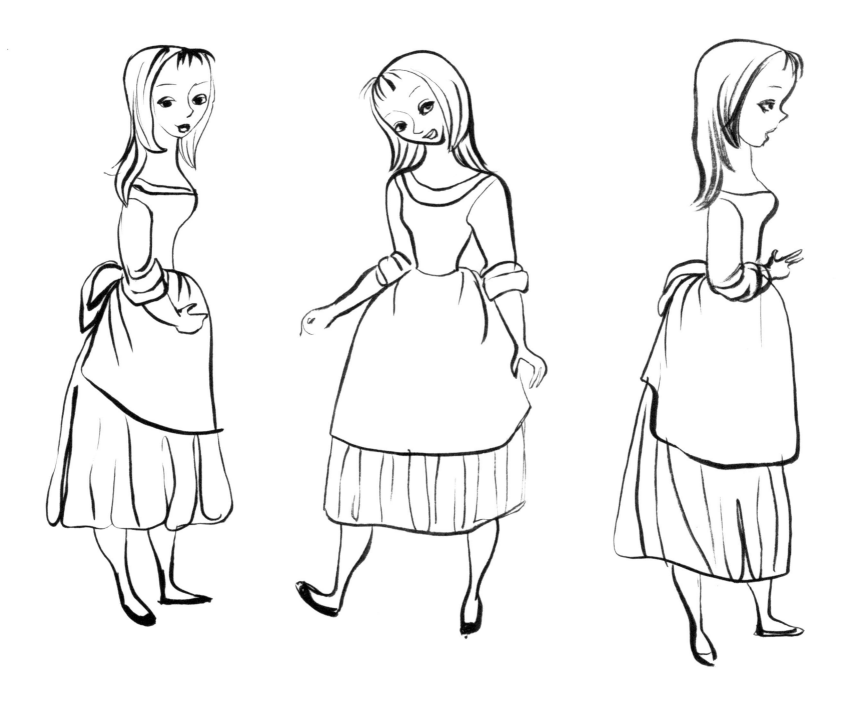

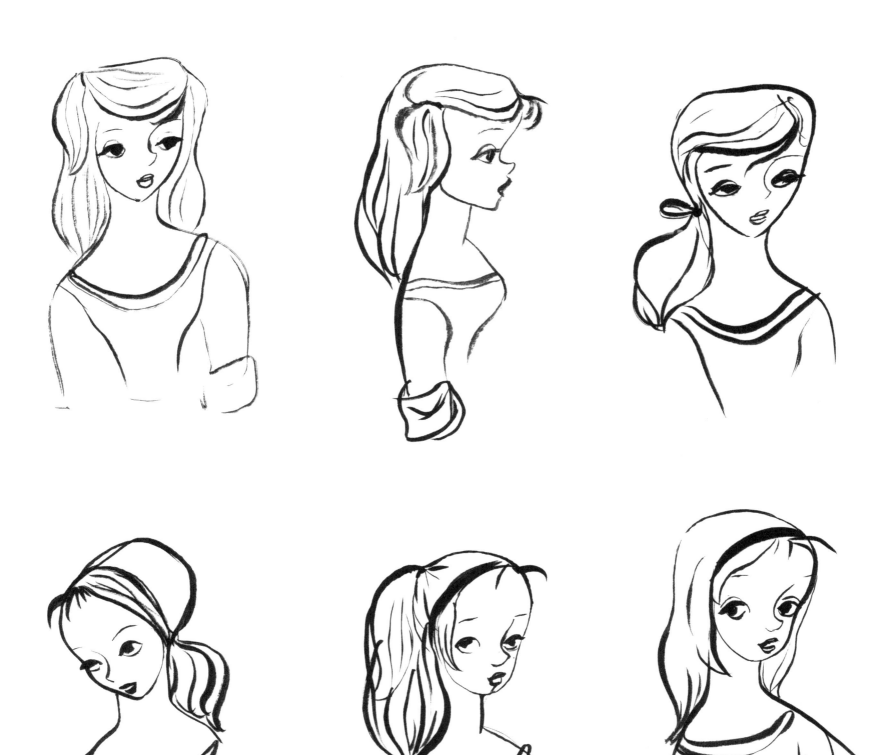

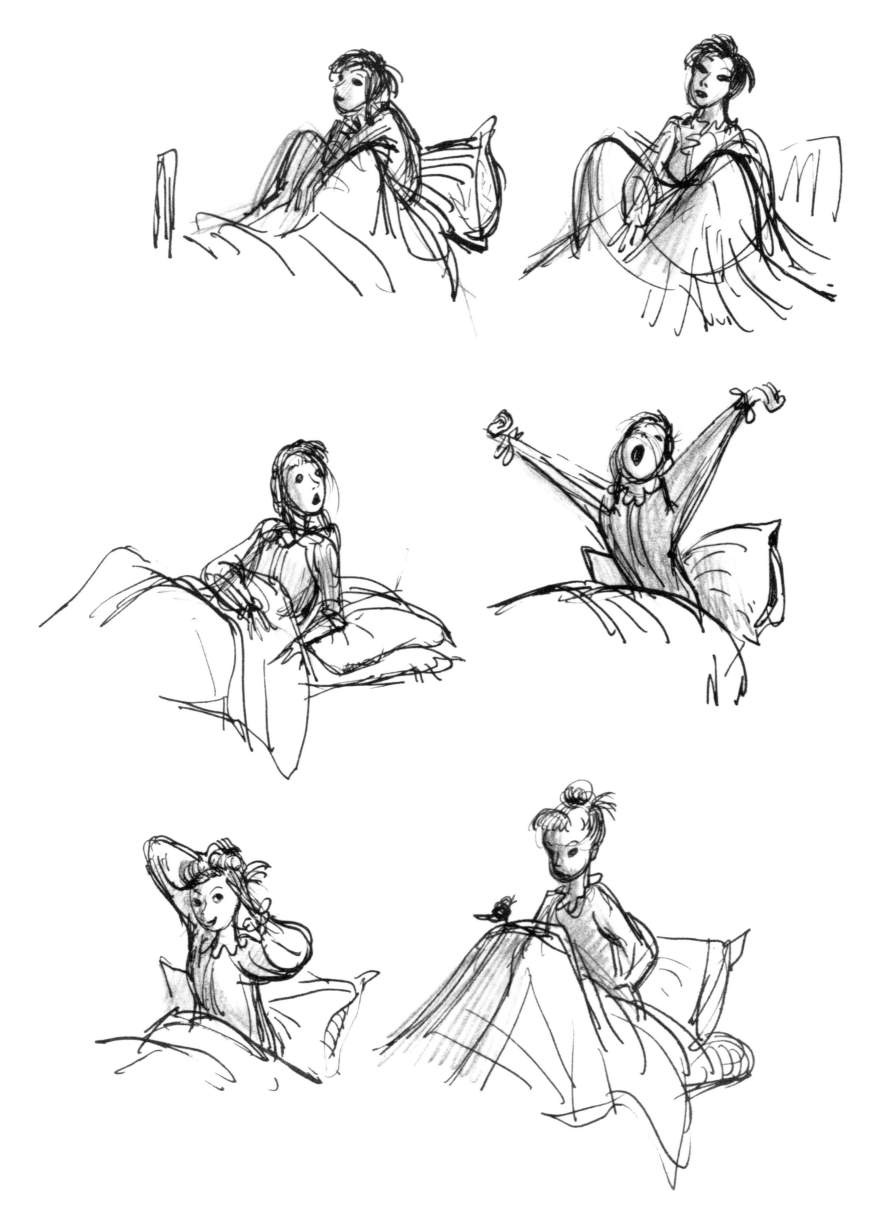

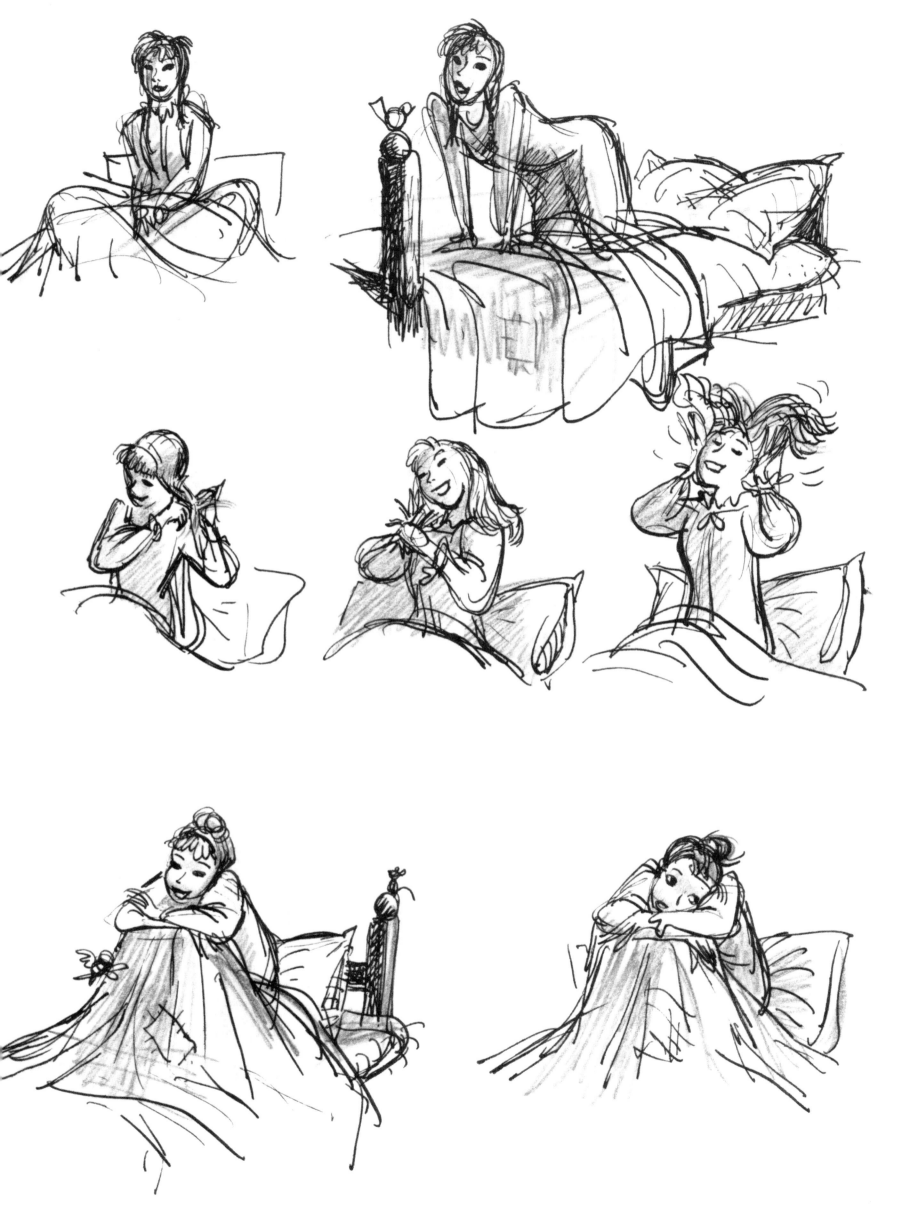

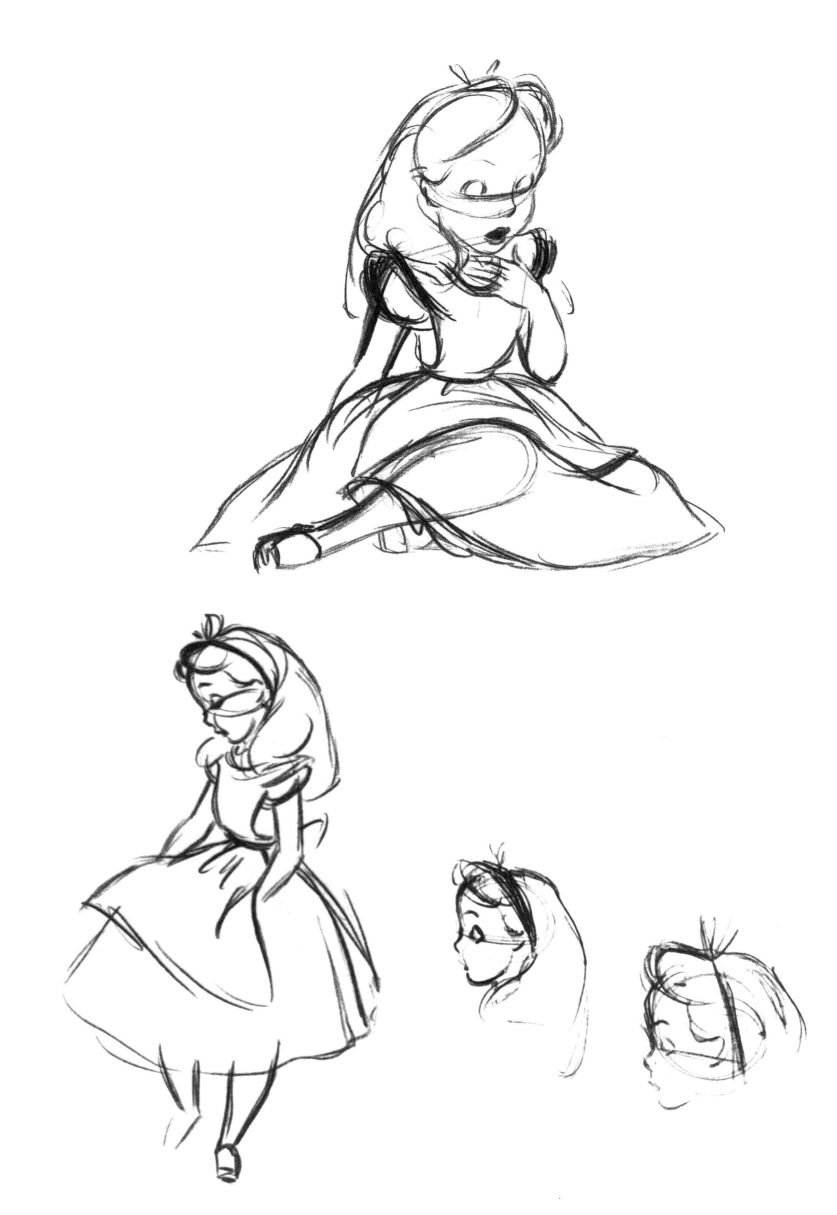

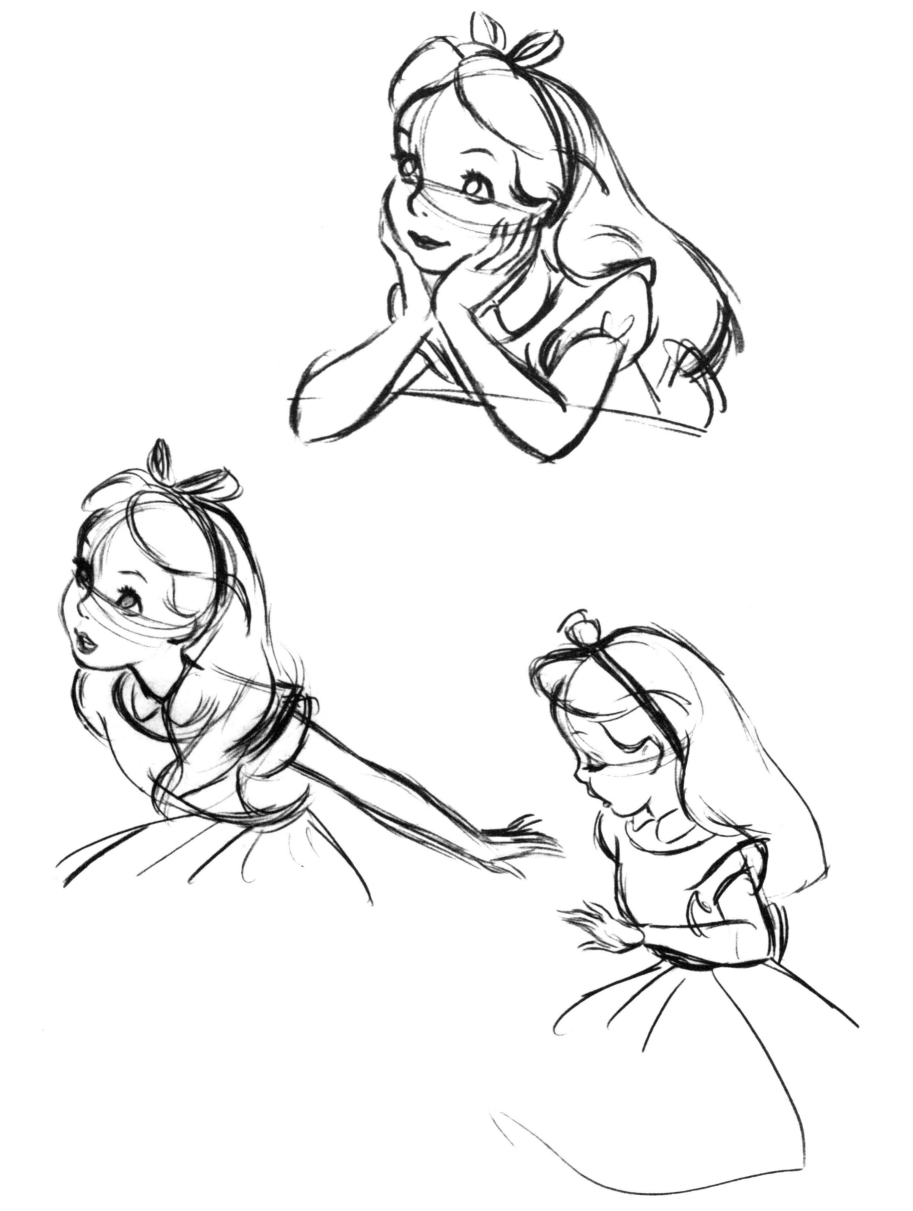

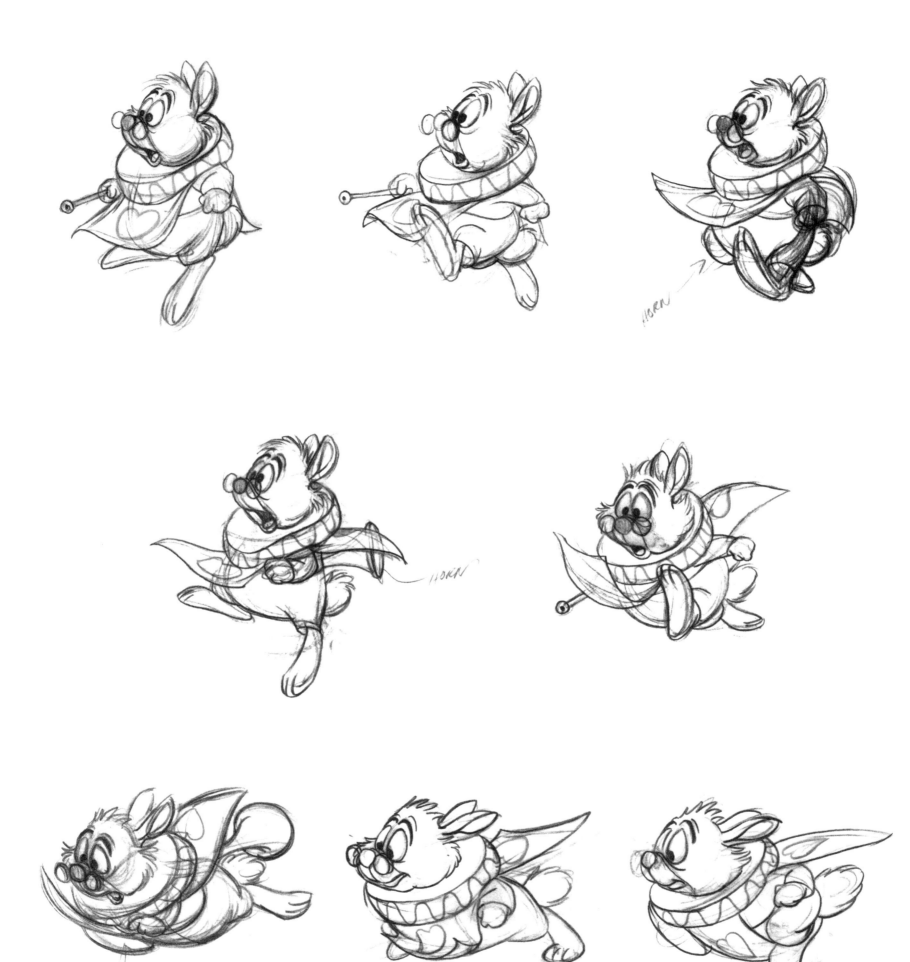

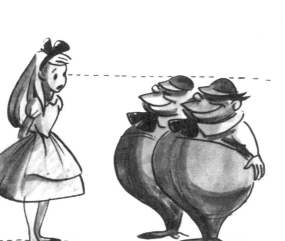

COMPARATIVE SIZES

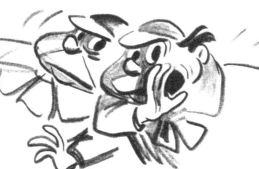

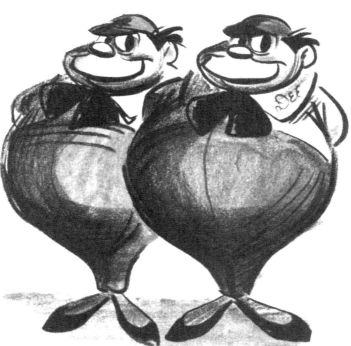

POOR THINGS

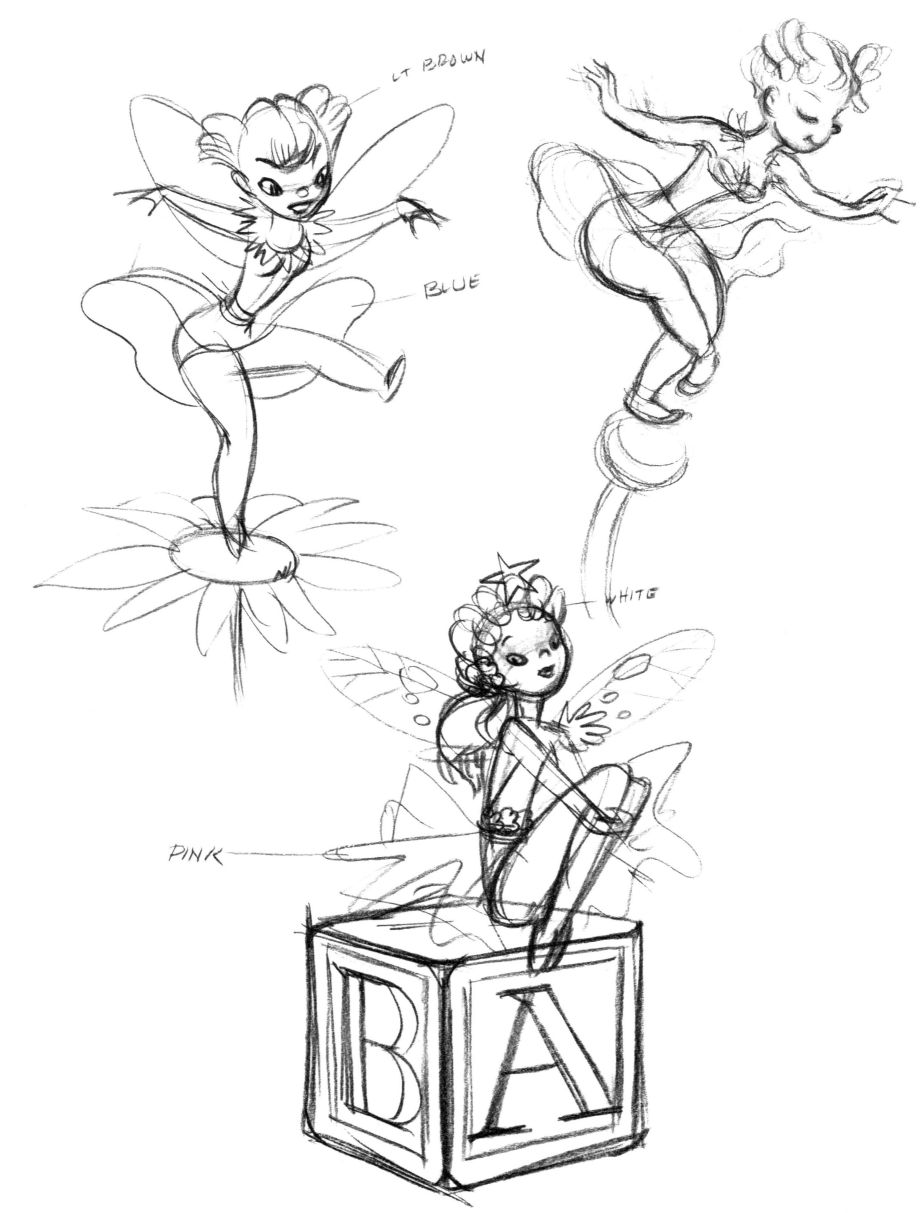

LT BROWN

BLUE

WHITE

PINK

B A

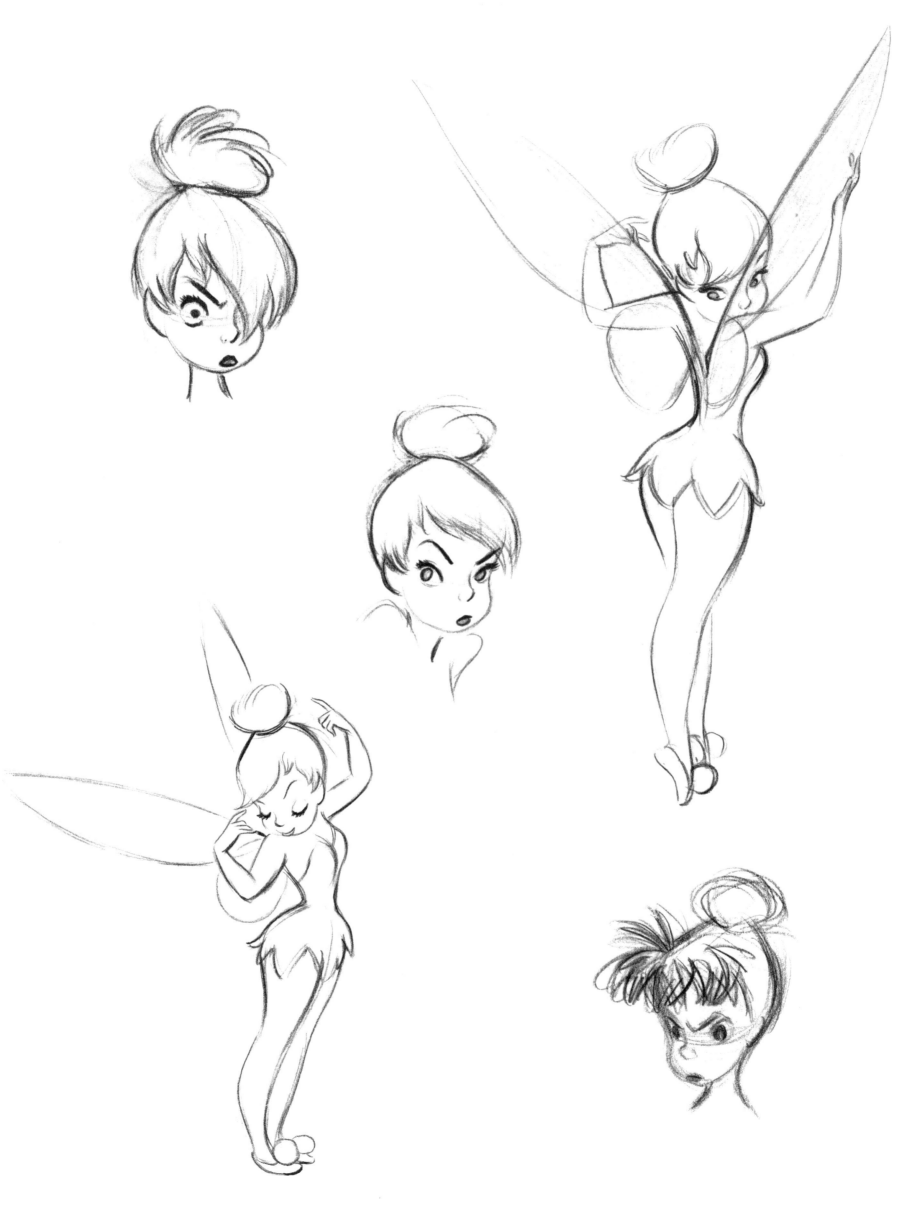

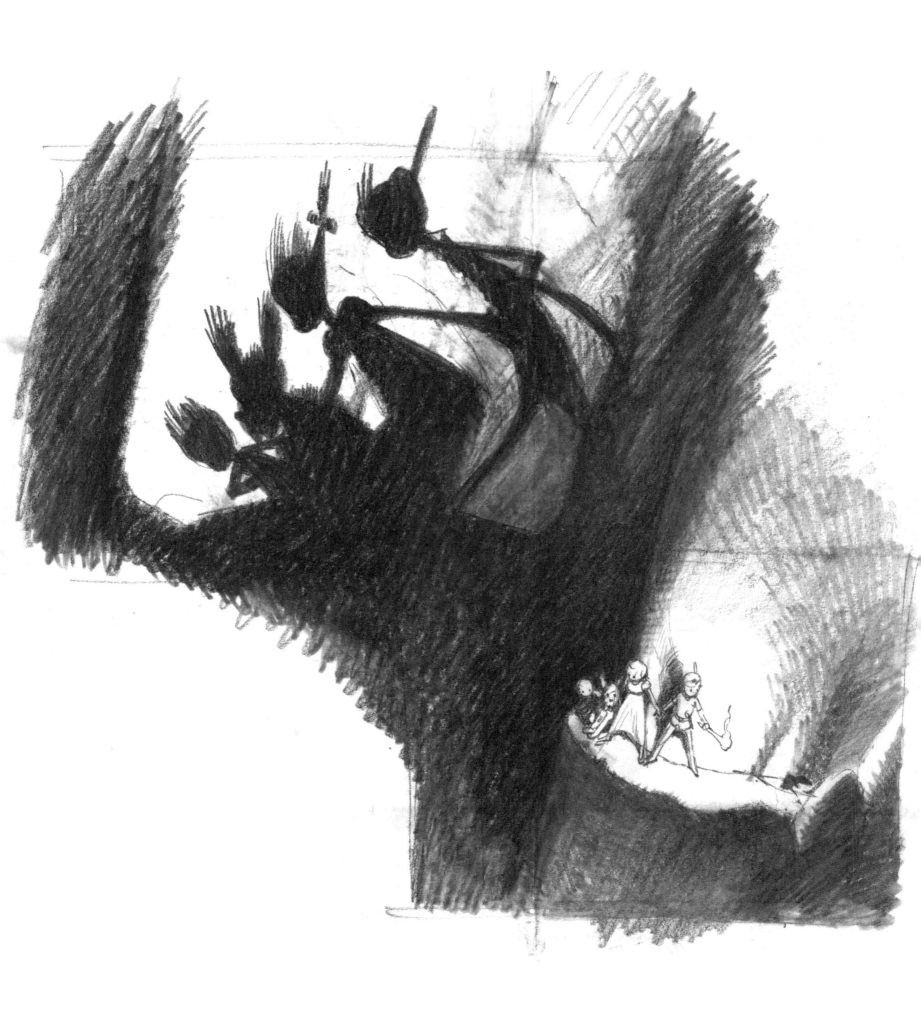

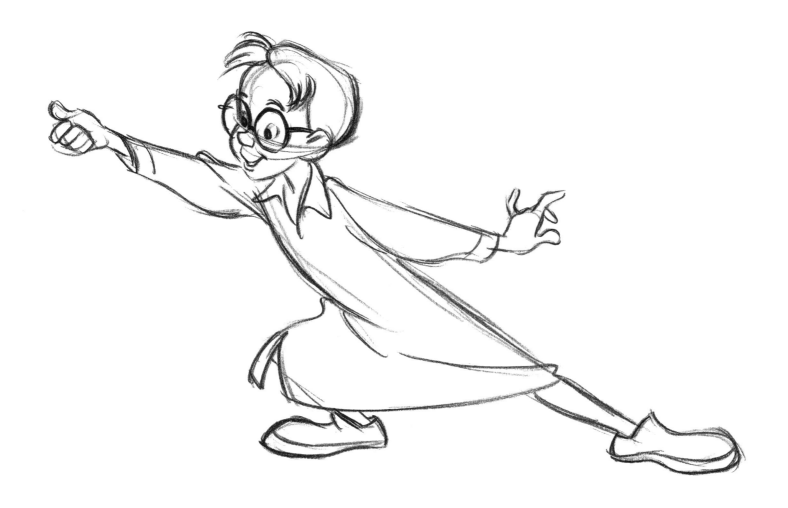

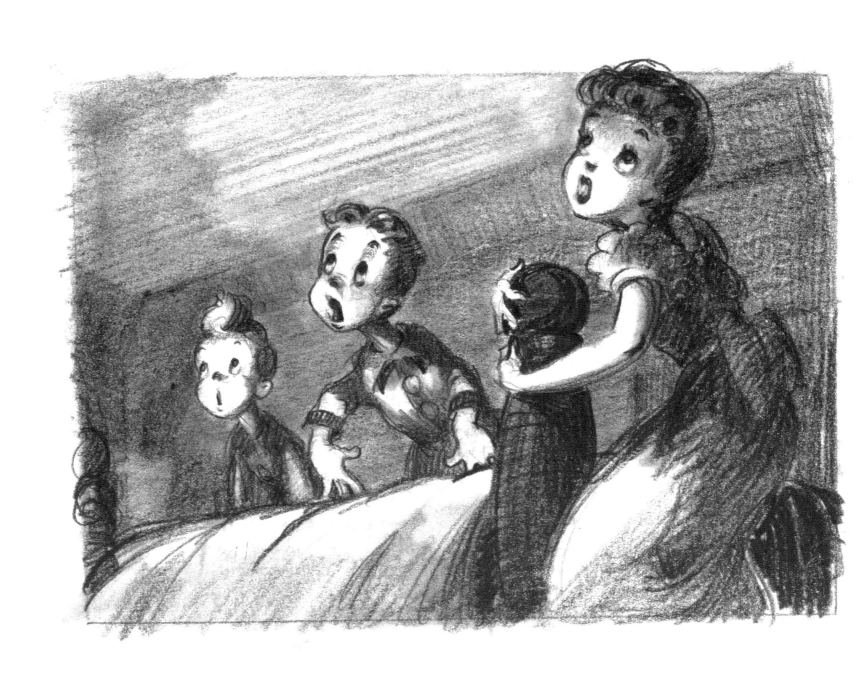

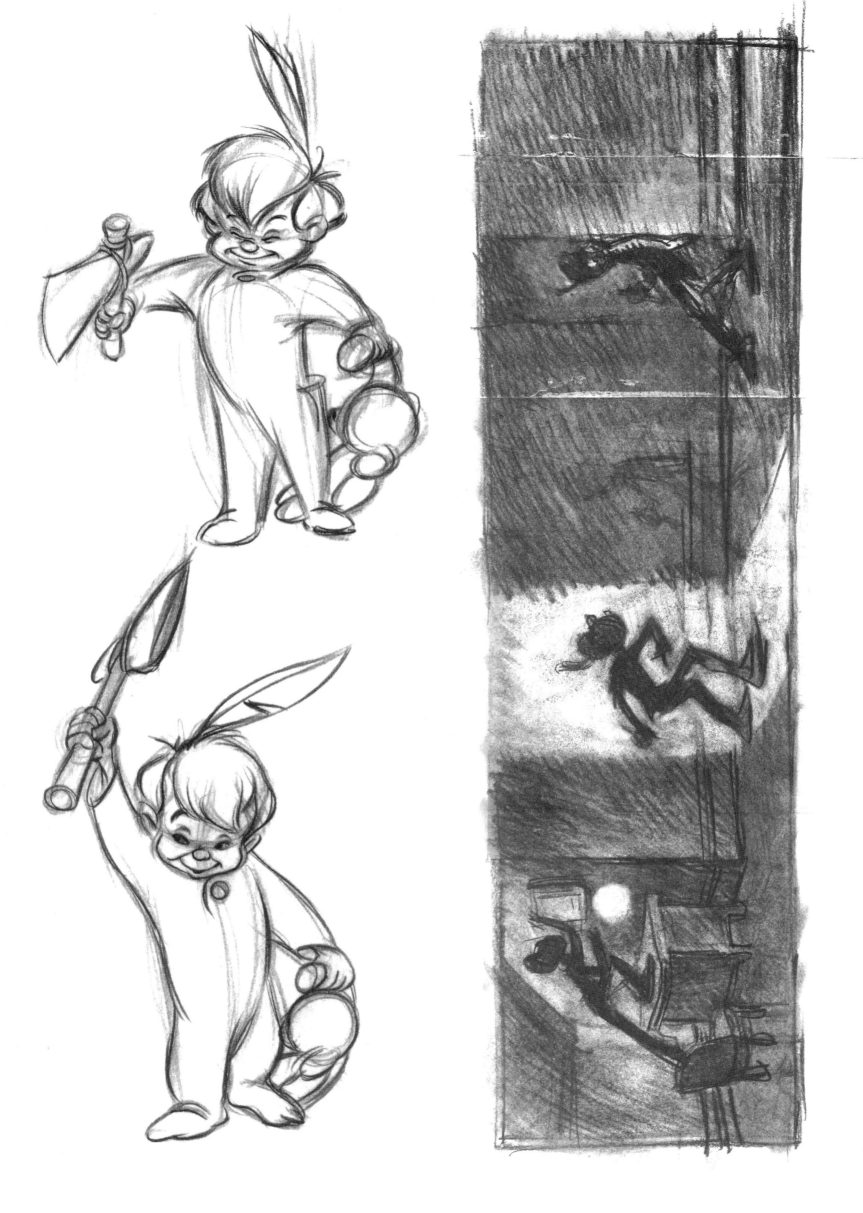

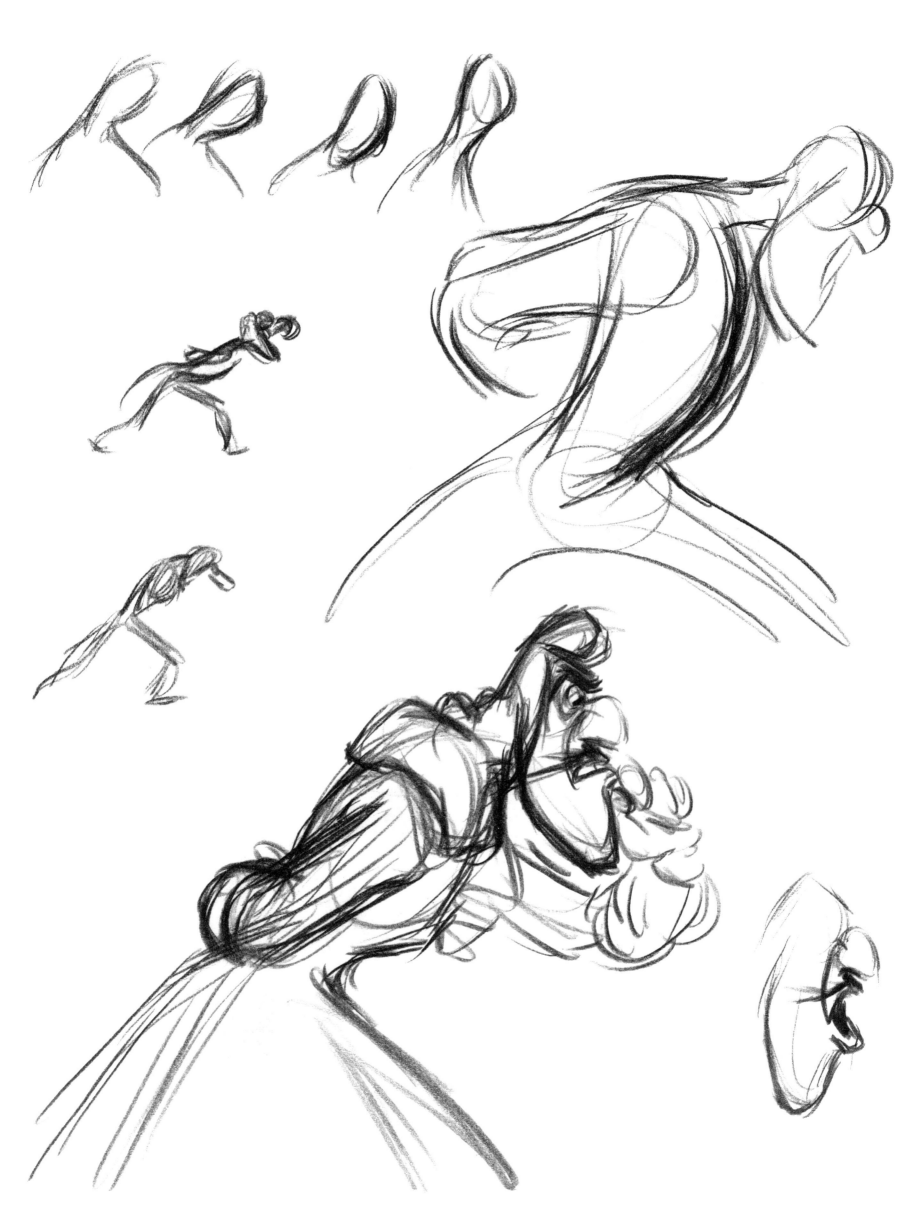

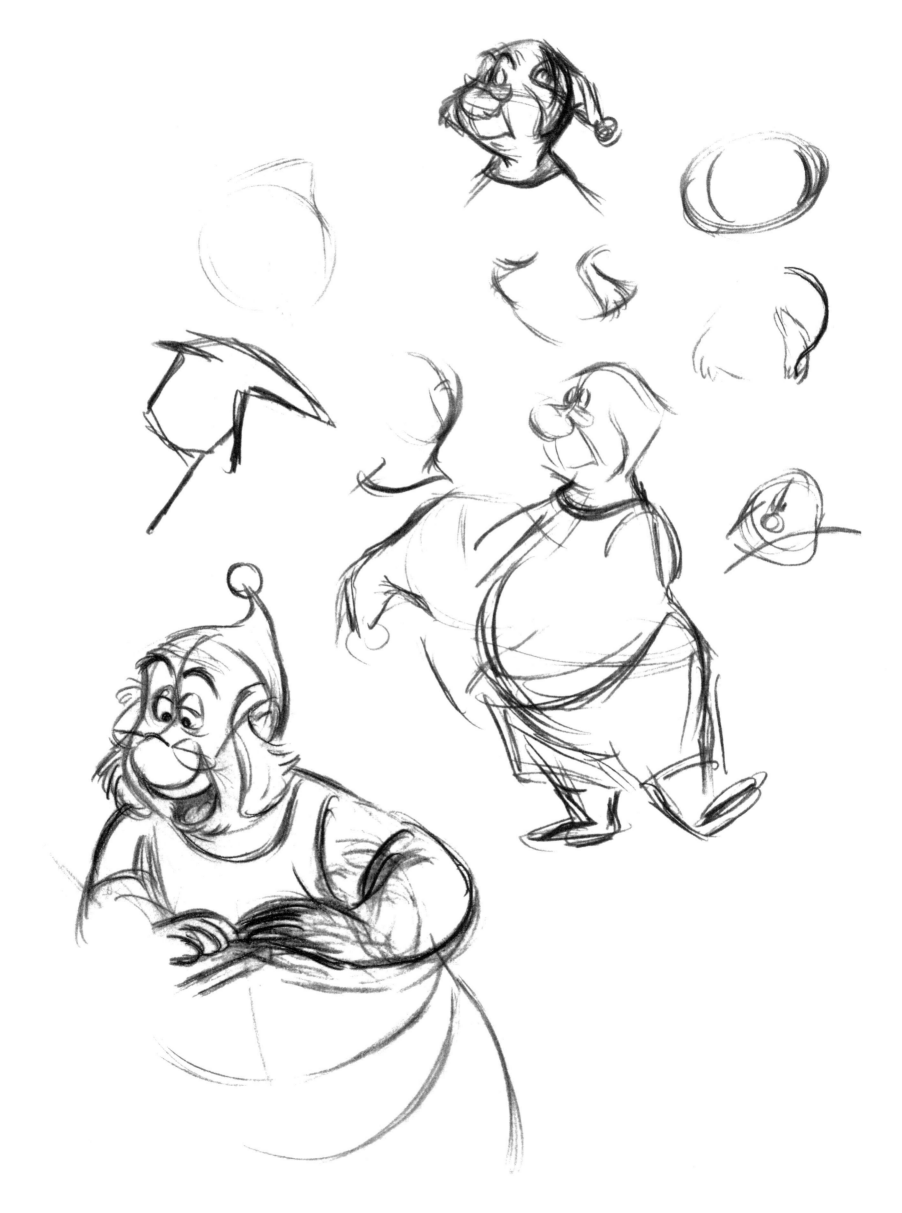

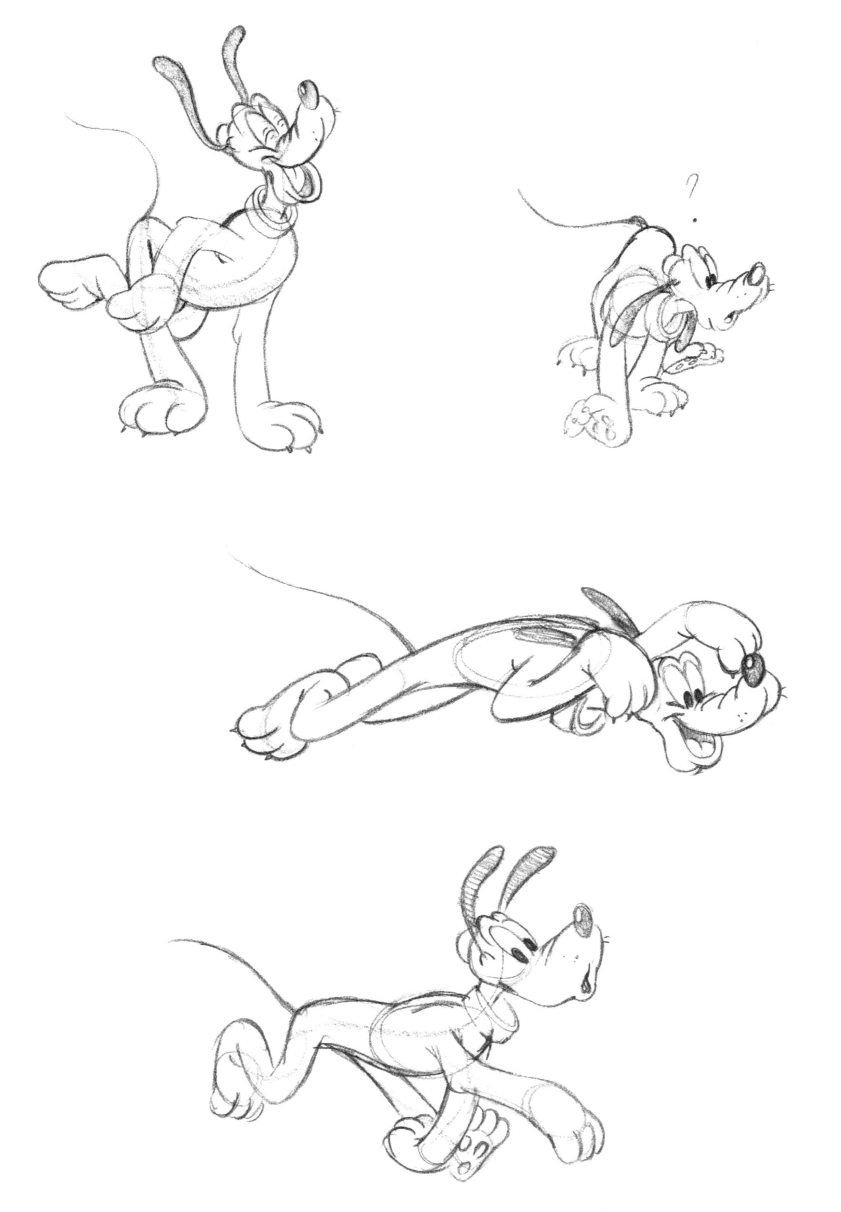

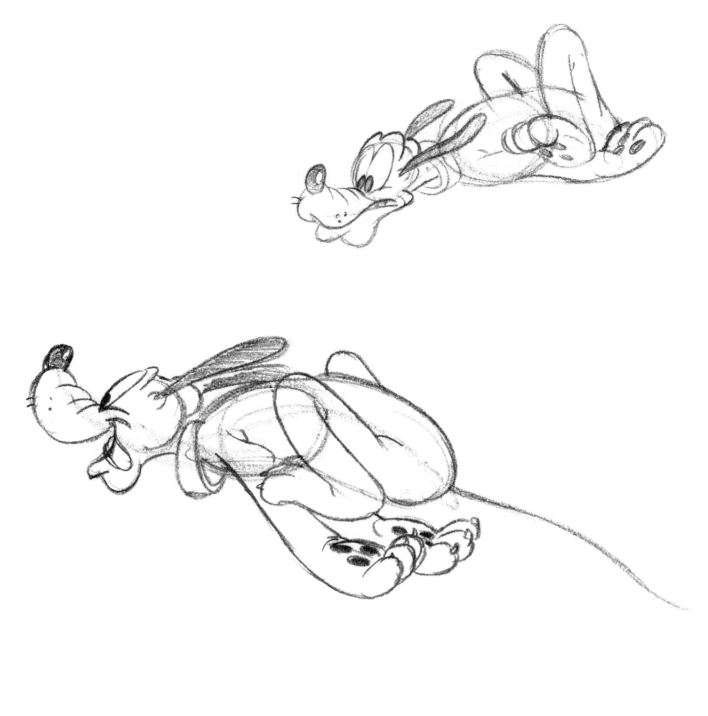
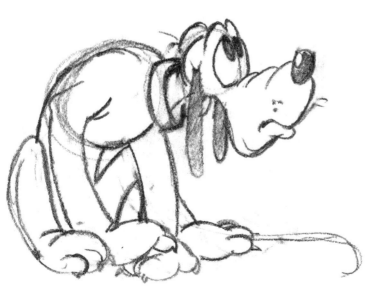
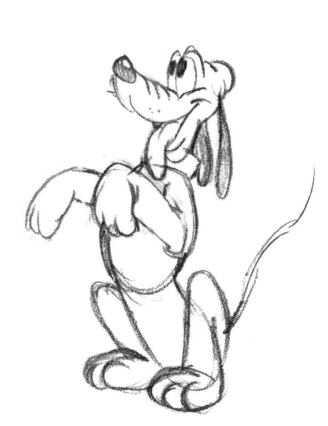

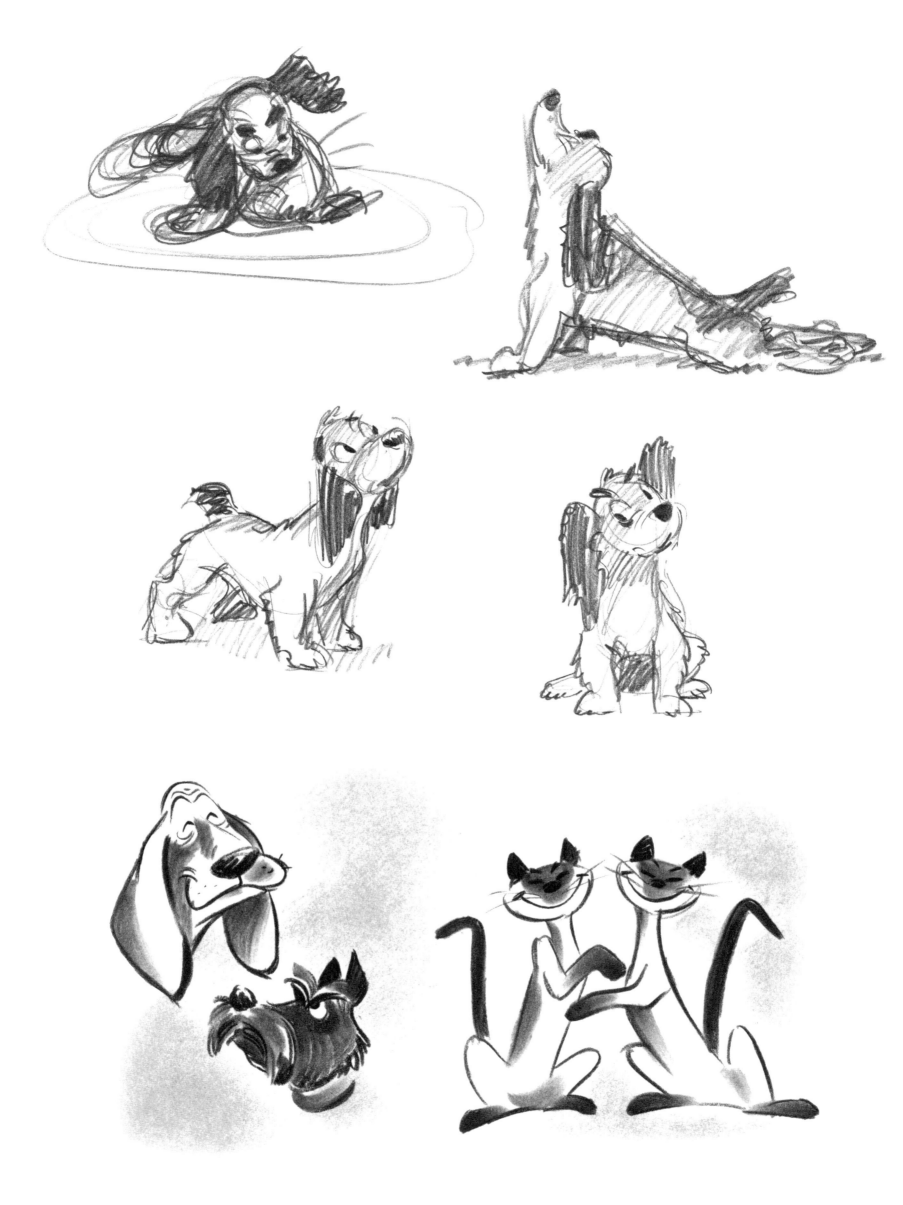

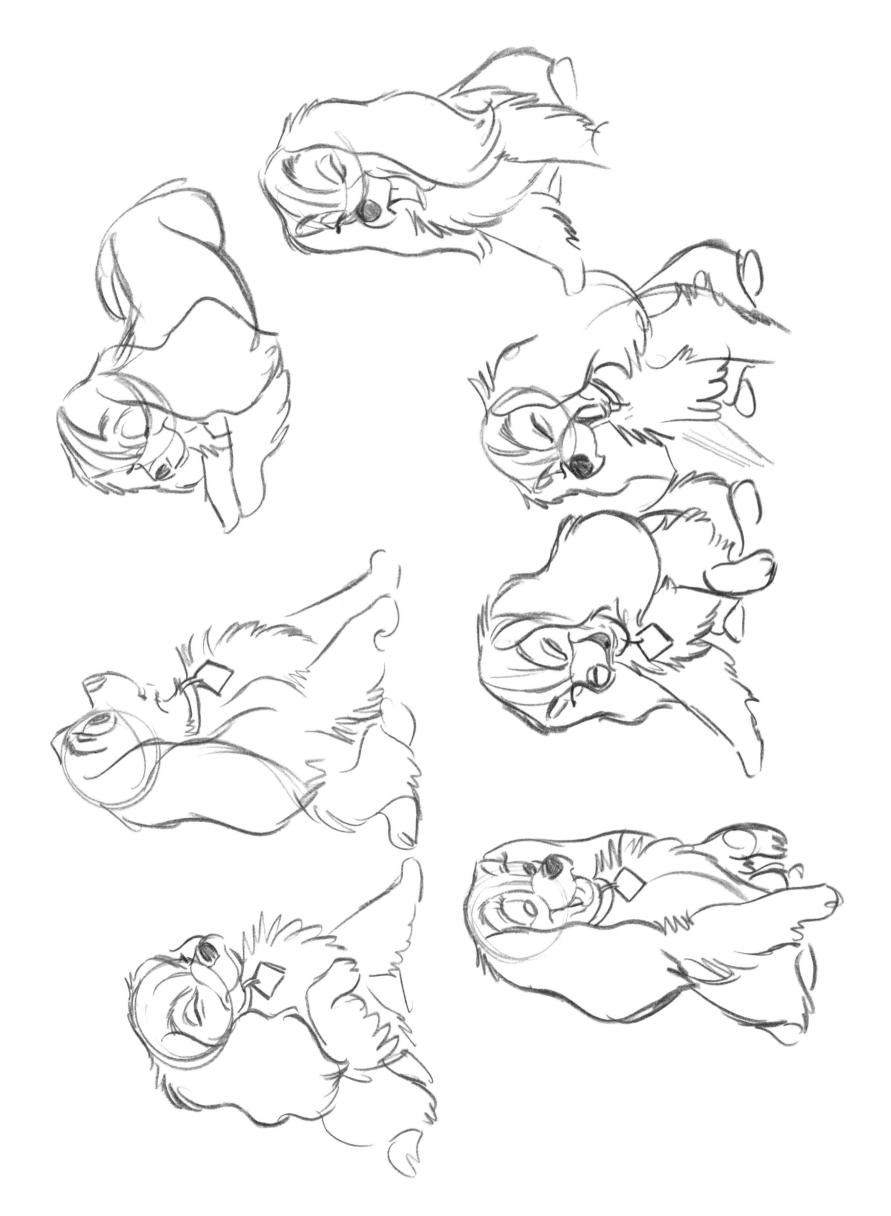

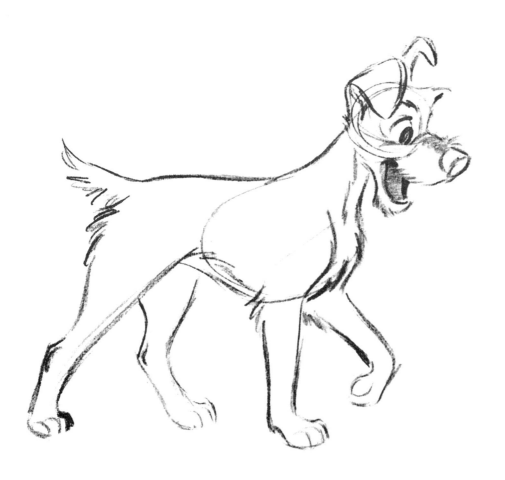

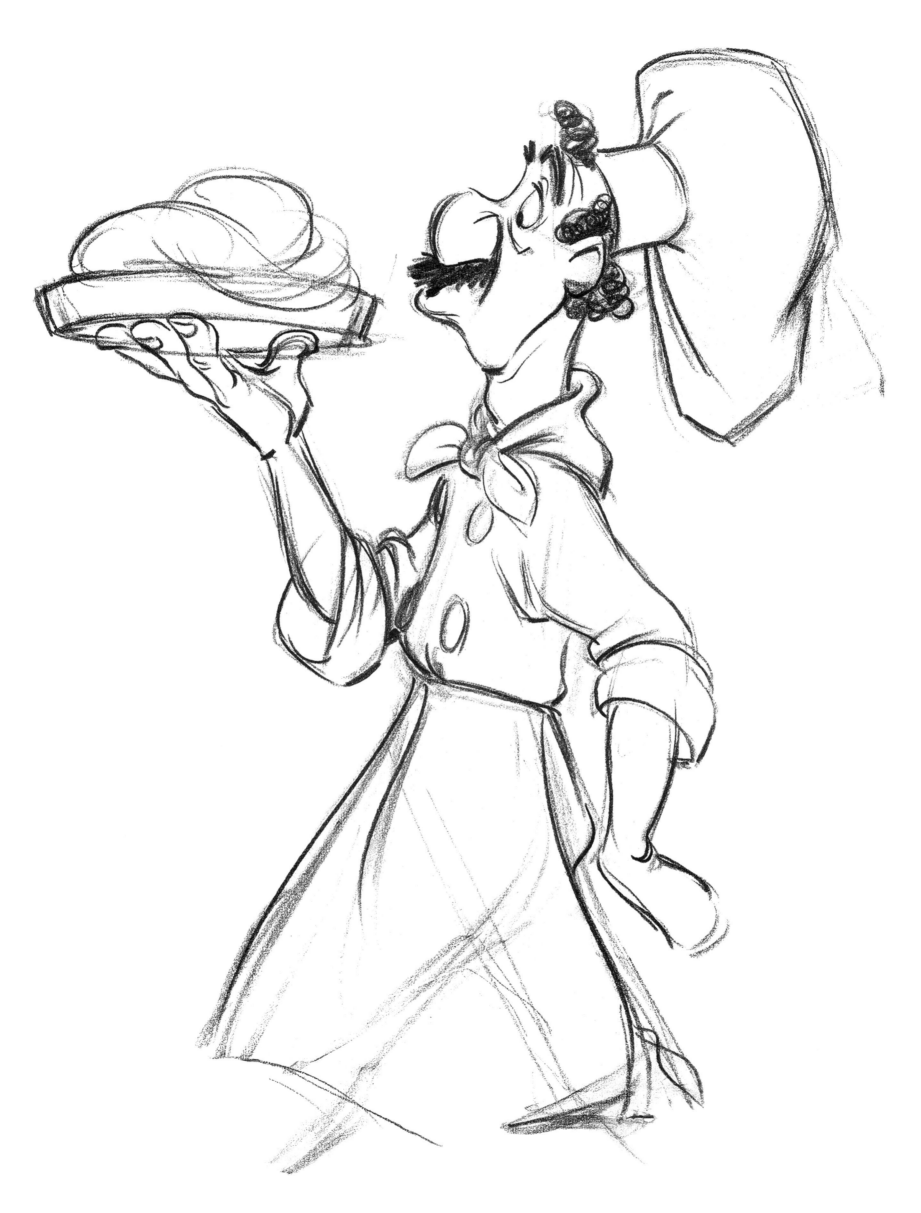

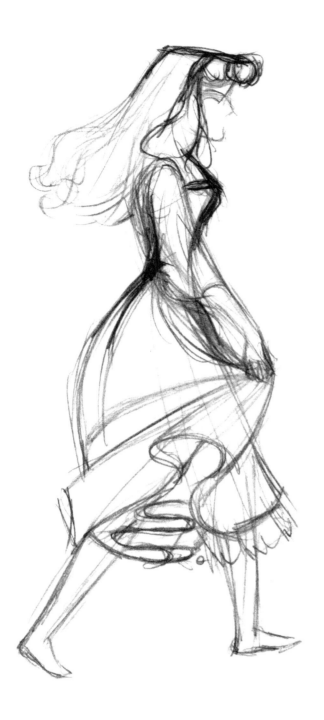
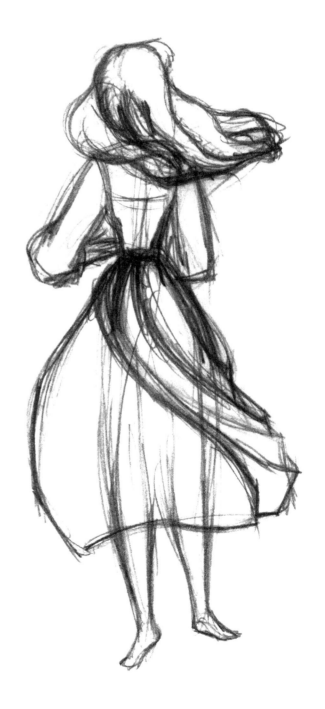

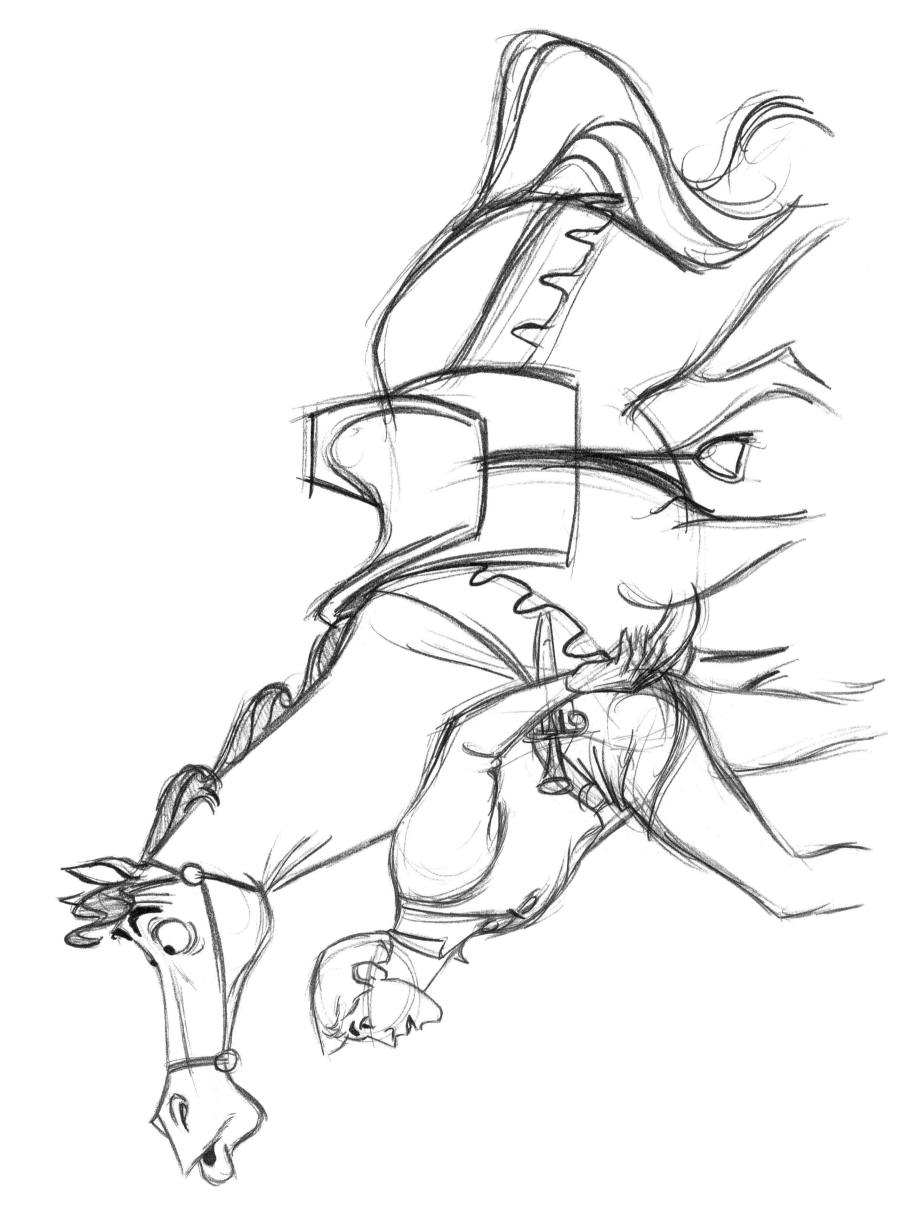

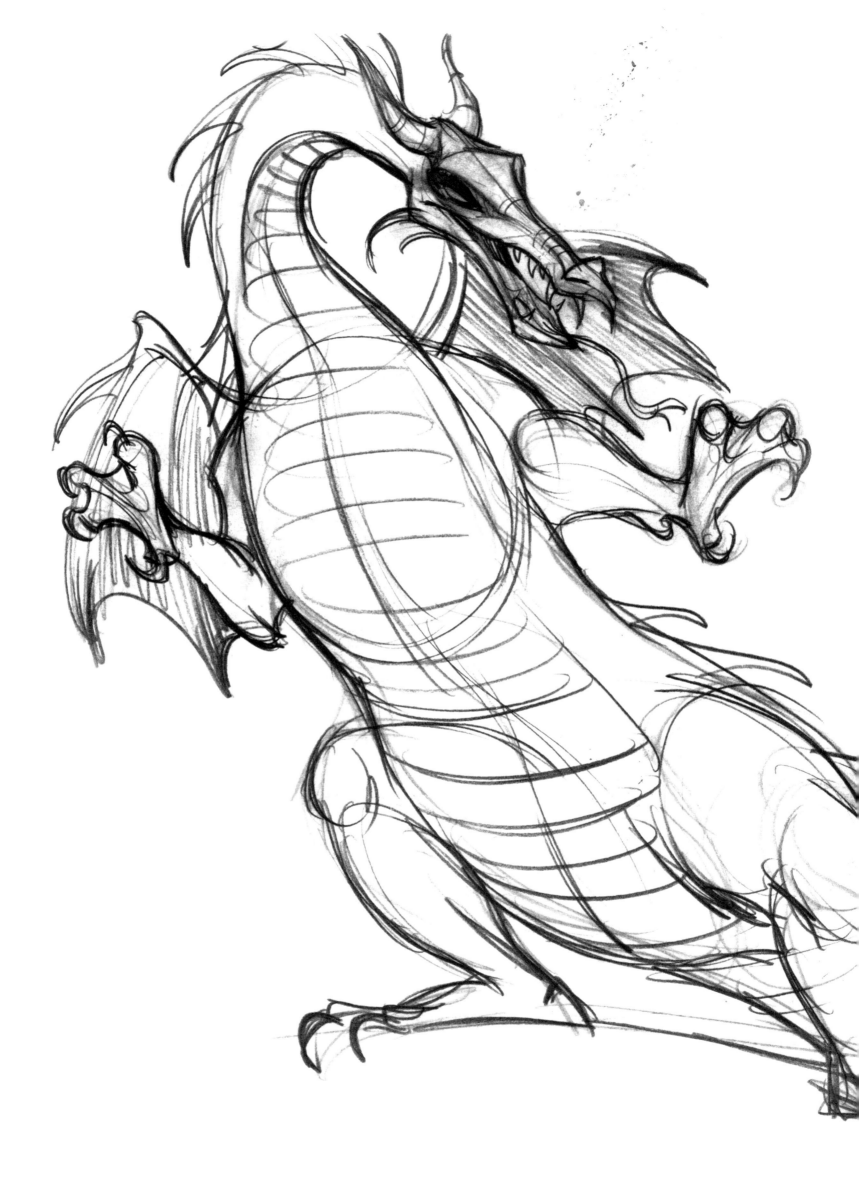

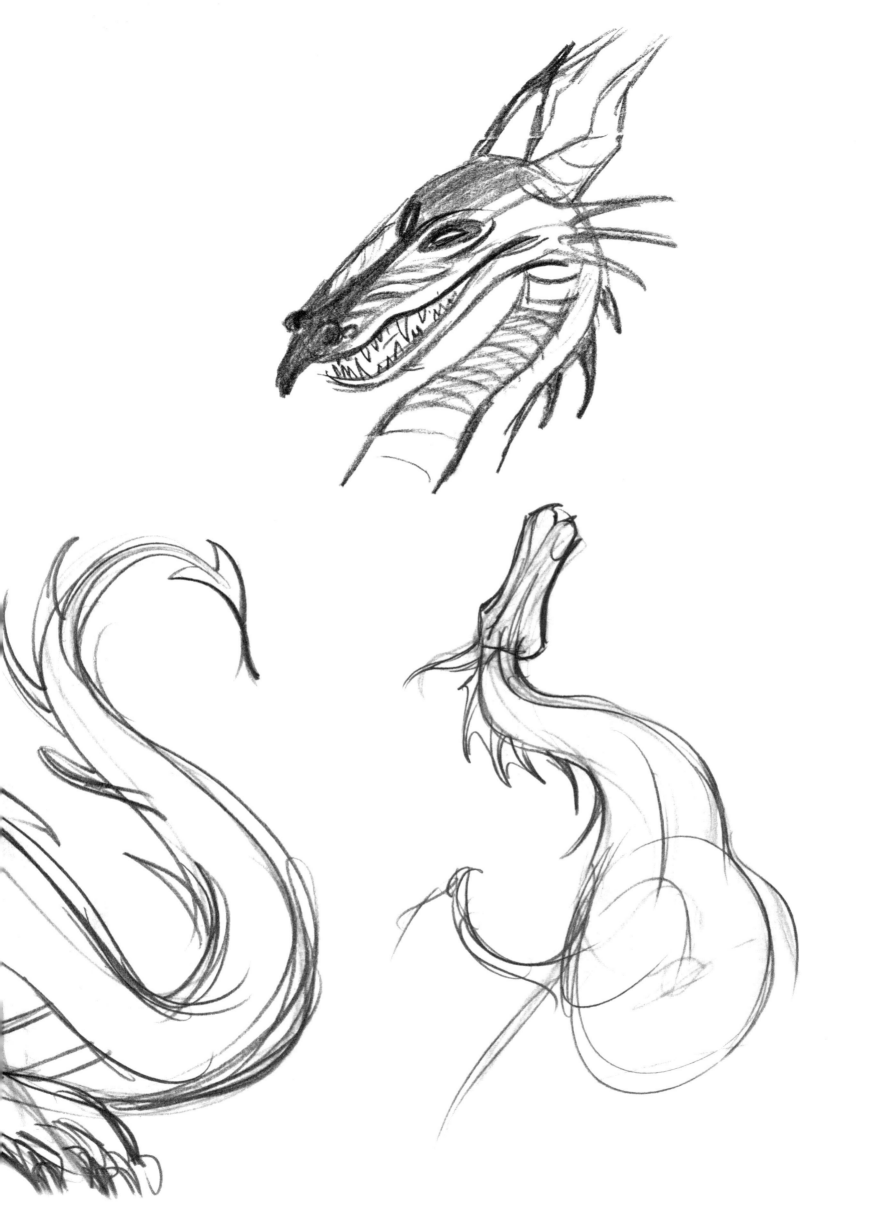

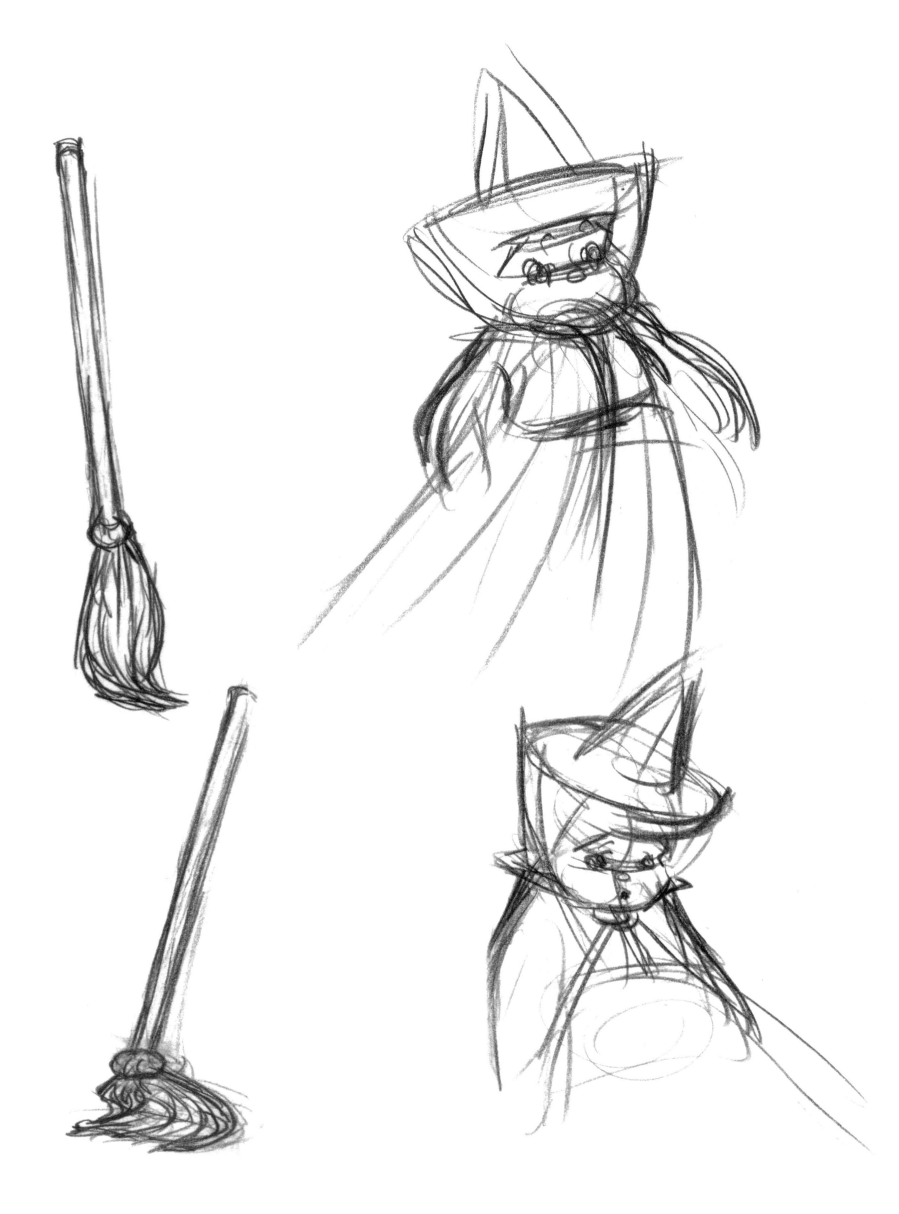

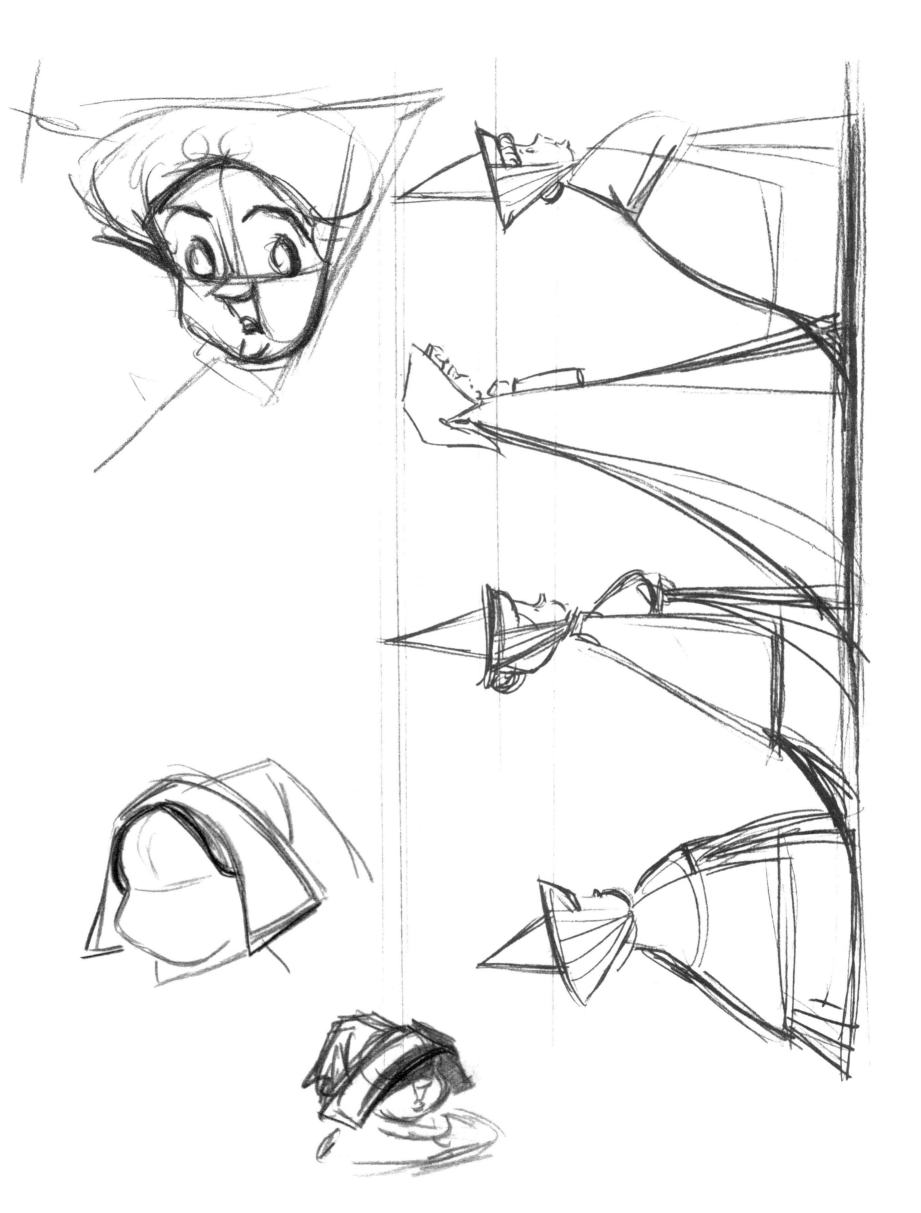

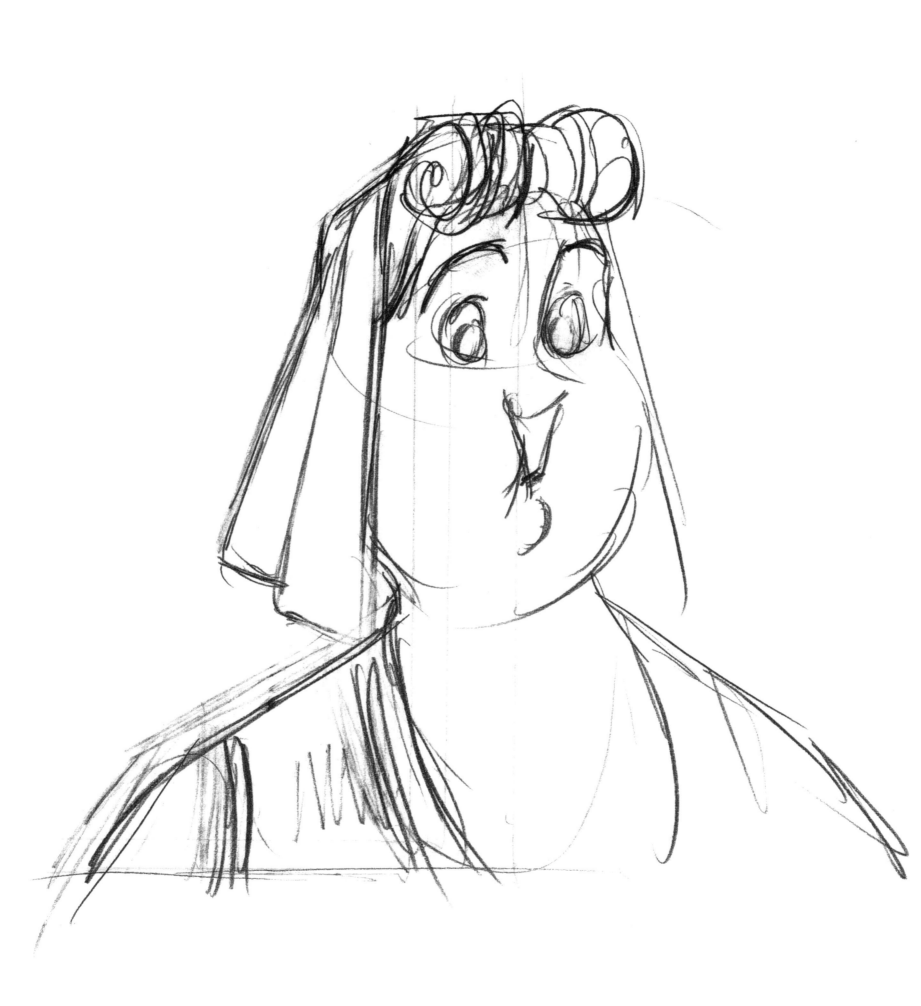

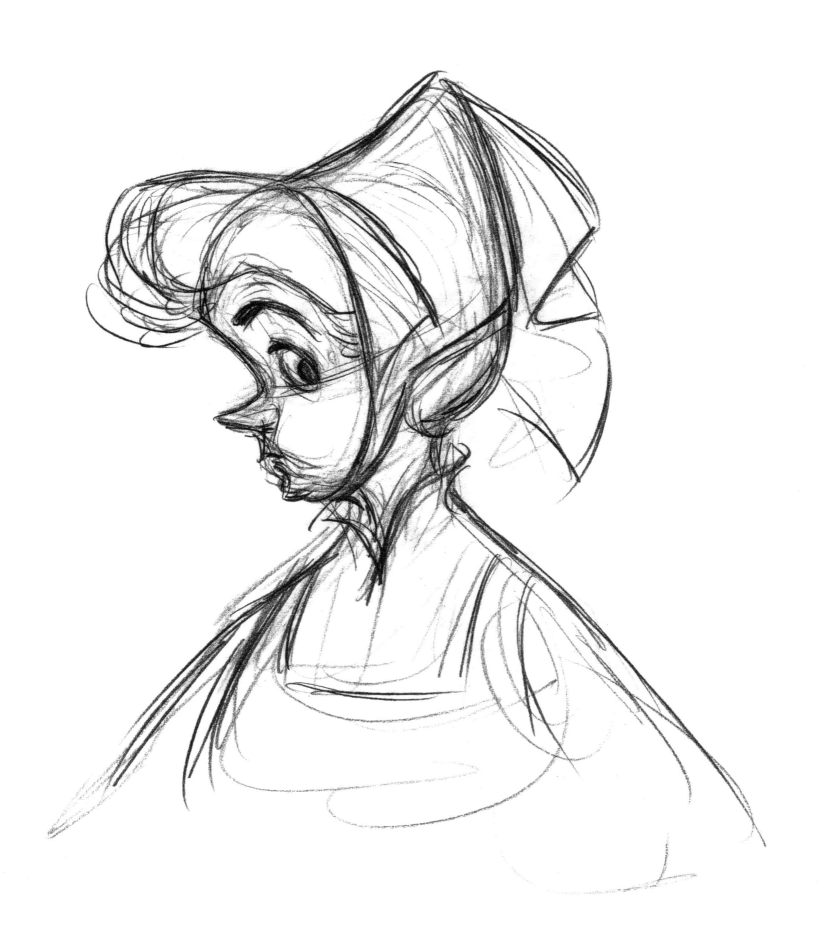

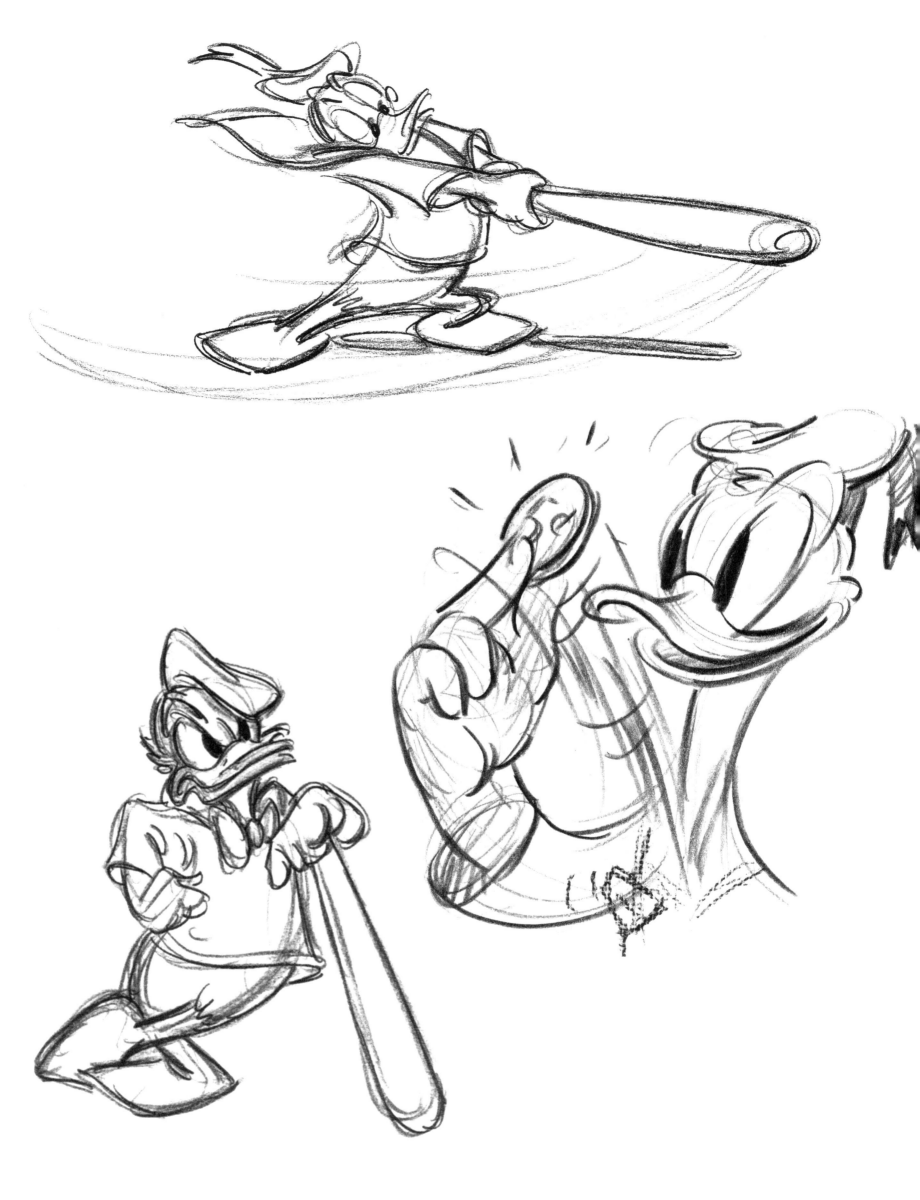

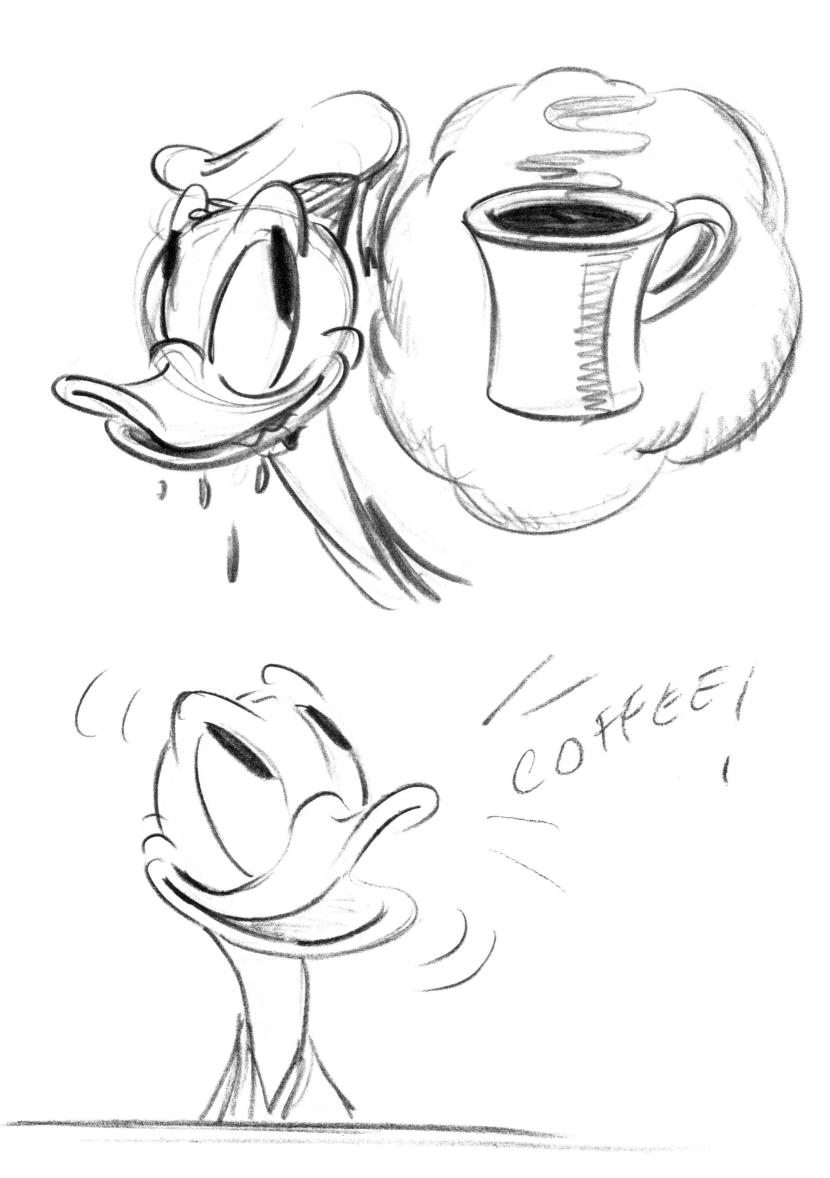

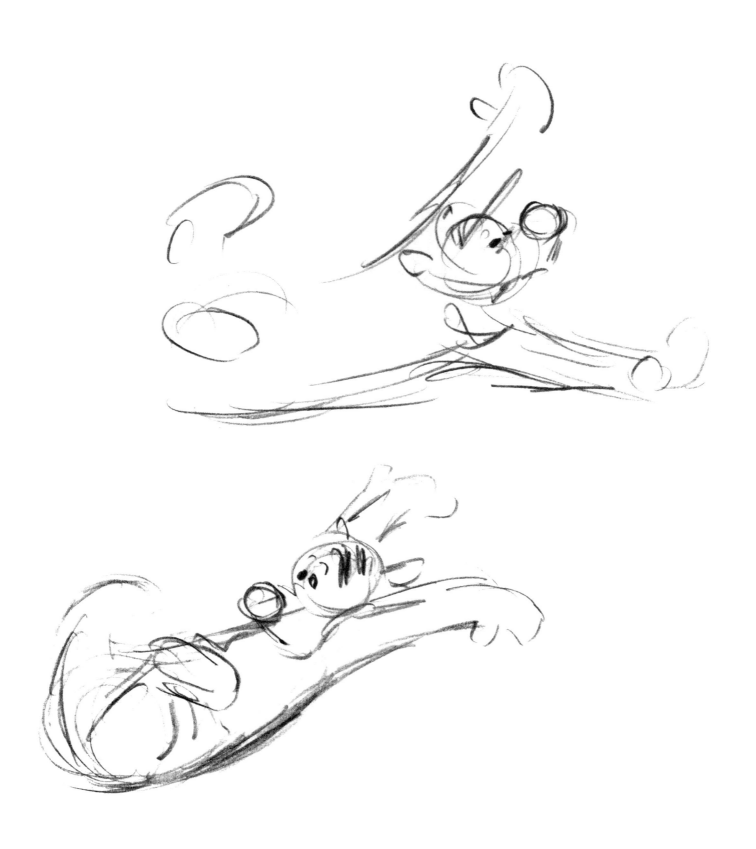

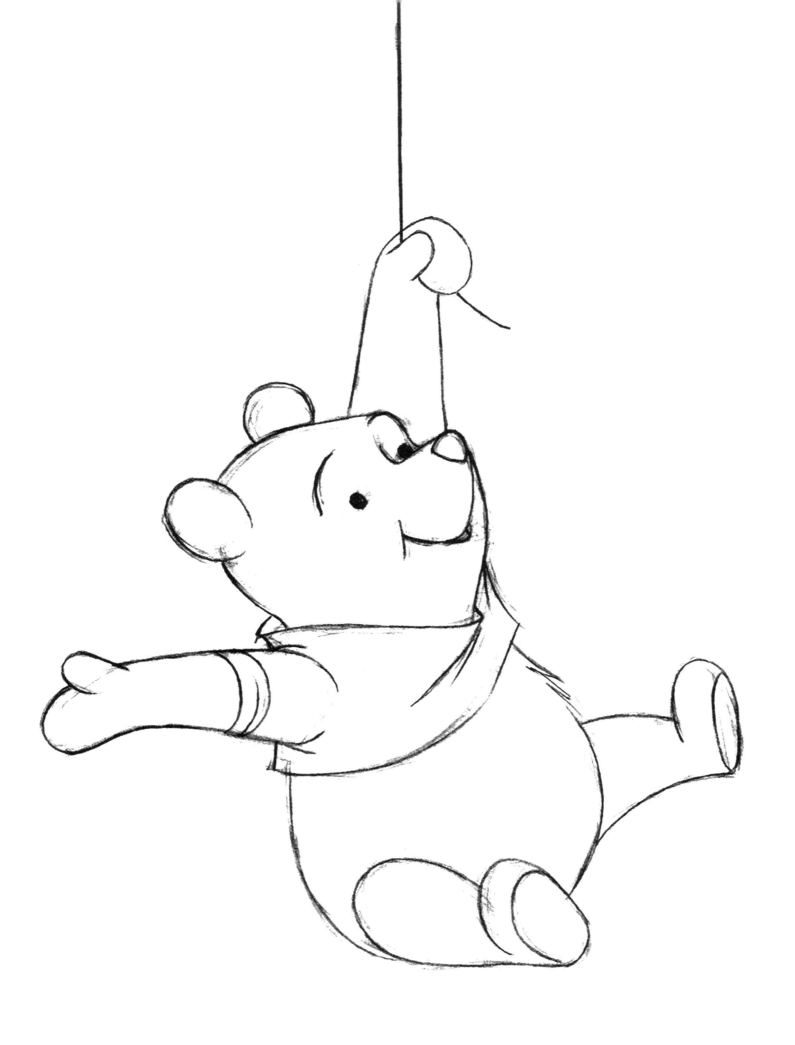

723

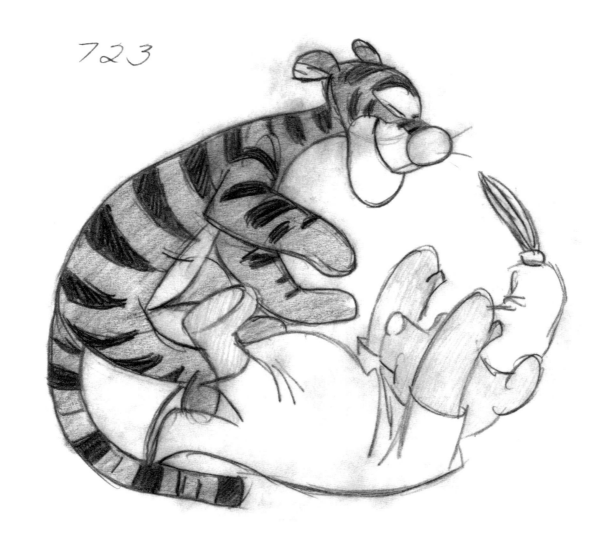

724

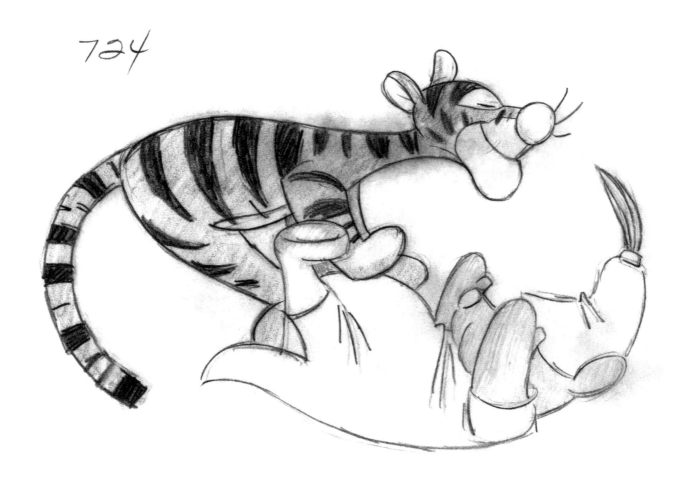

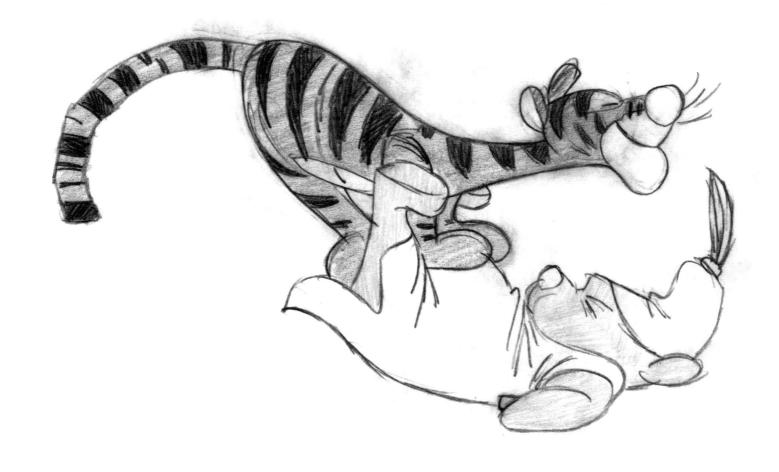

726

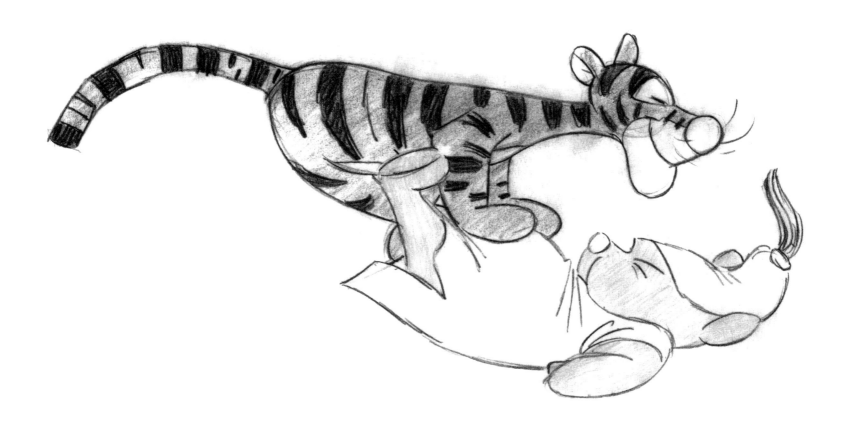

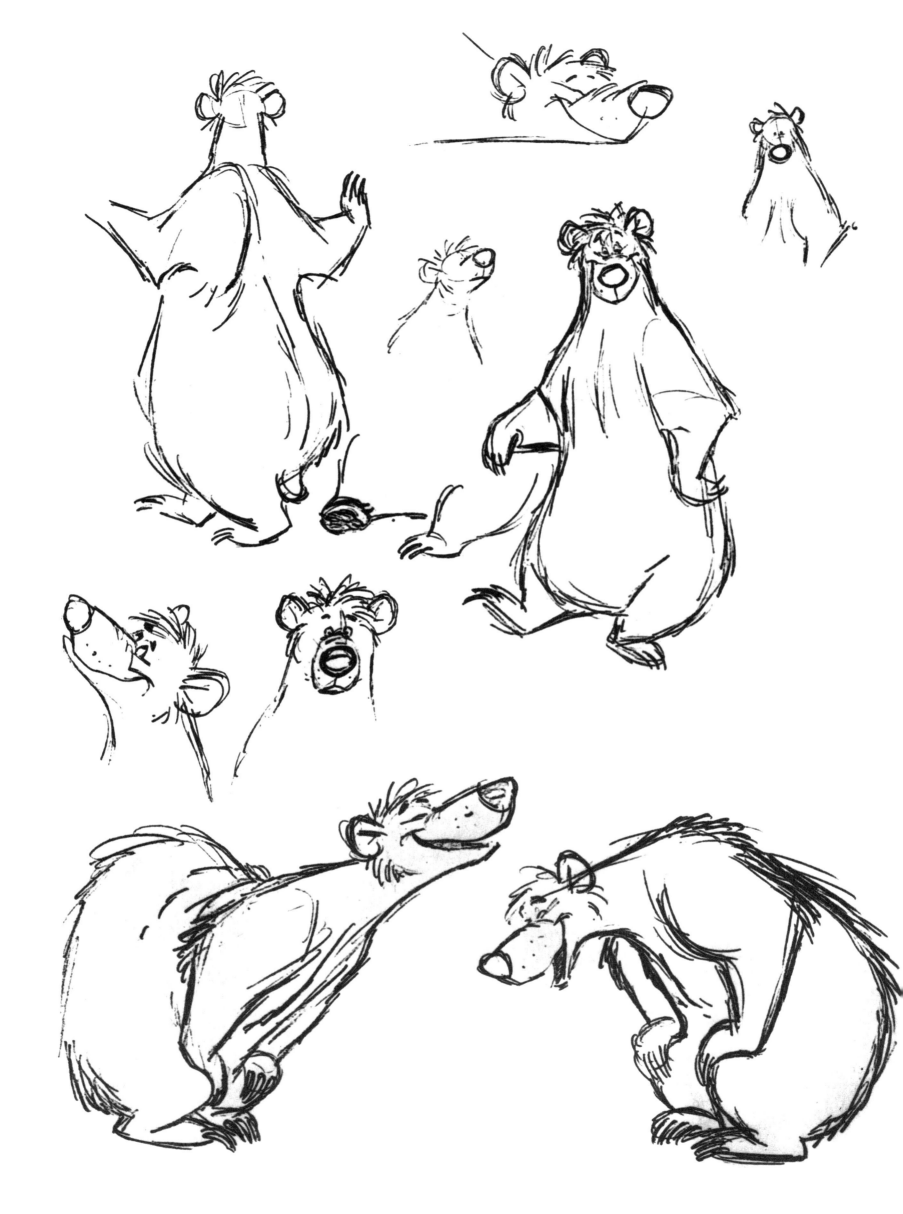

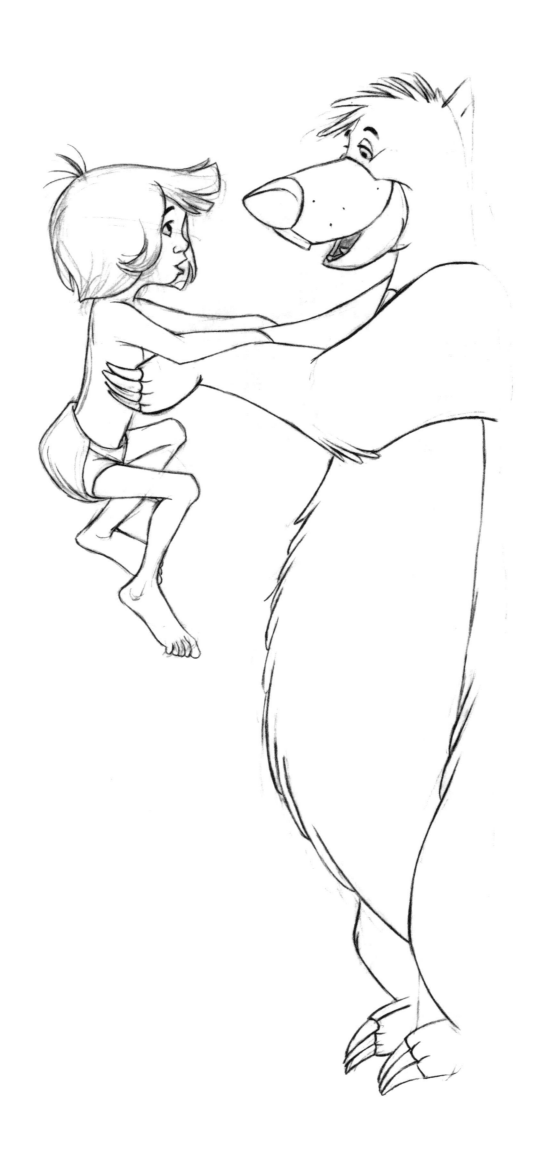

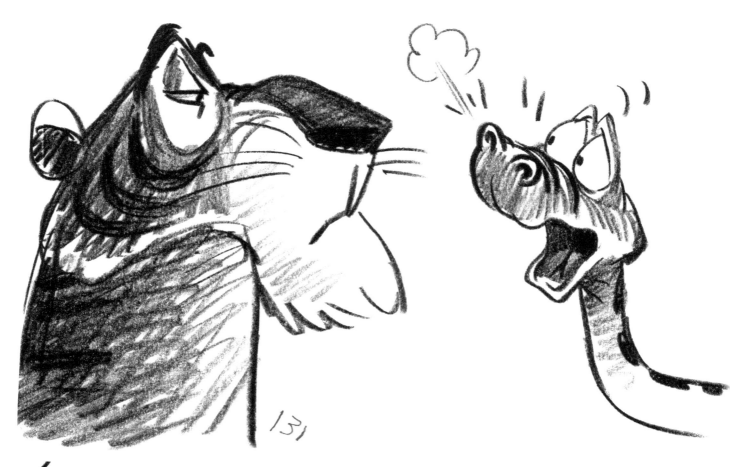

(FAKING SNORES) MY SINUSES -

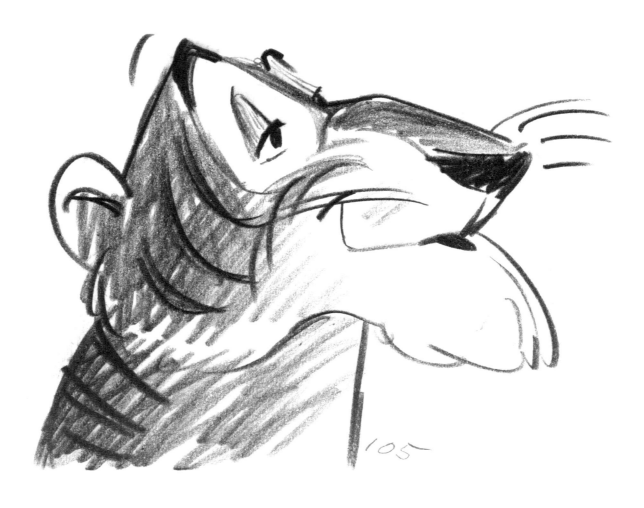

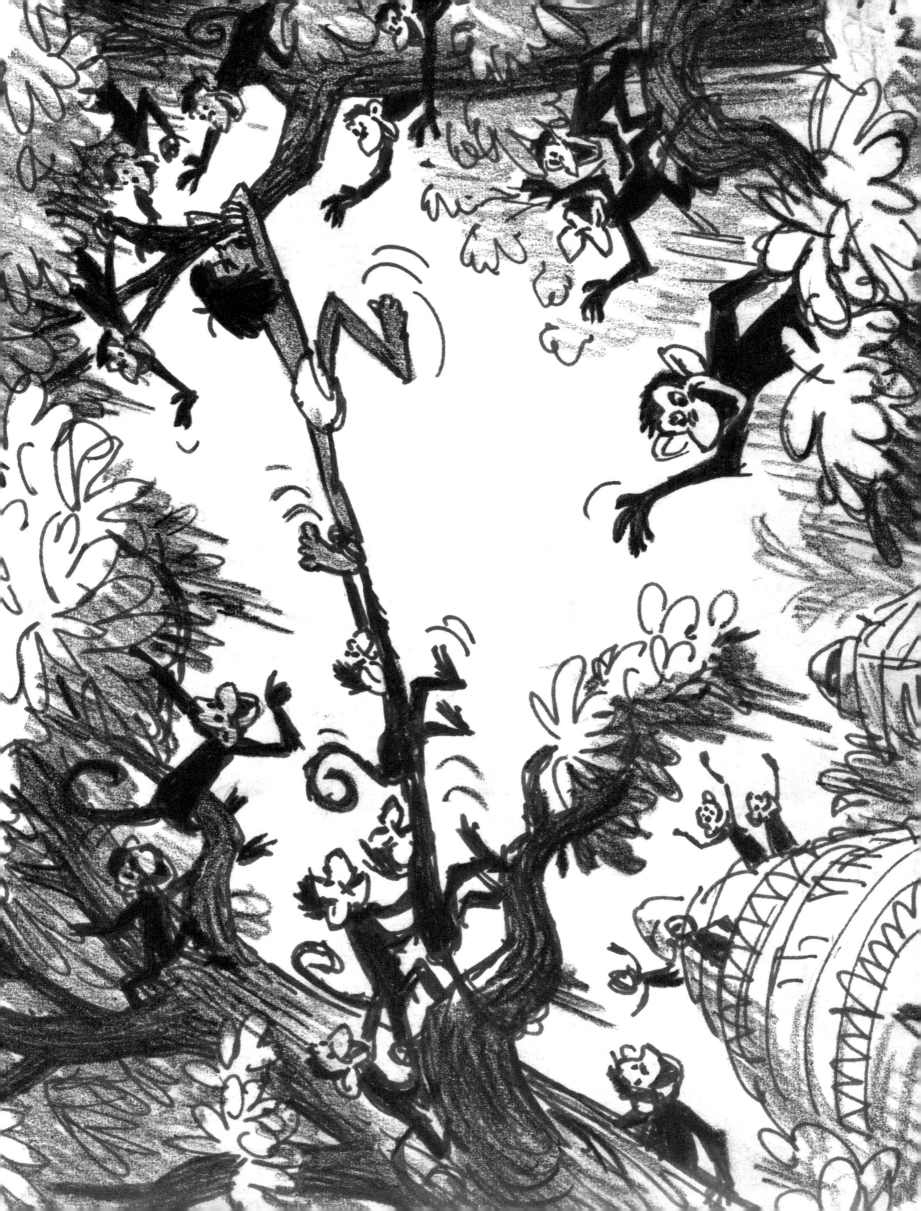

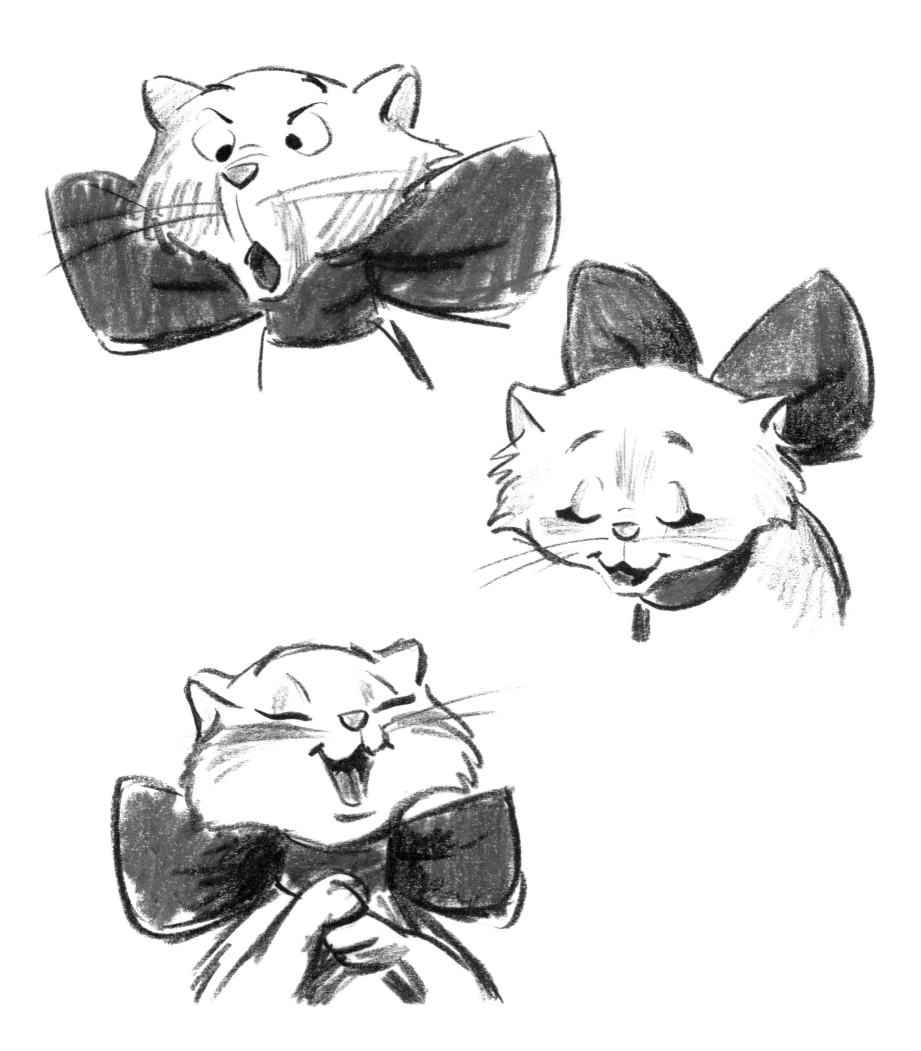

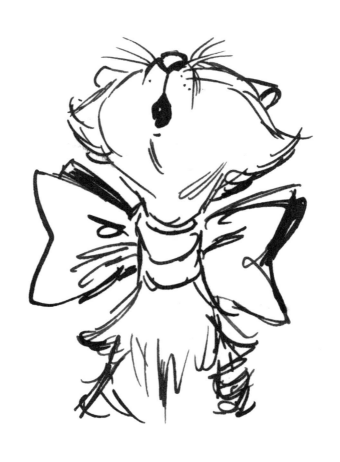
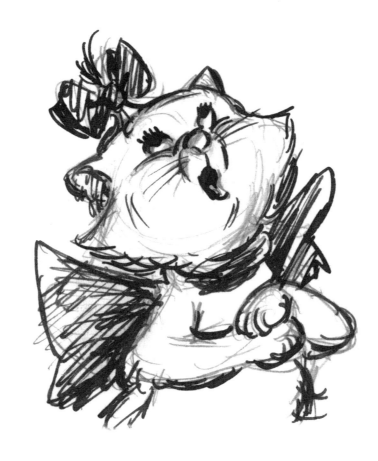

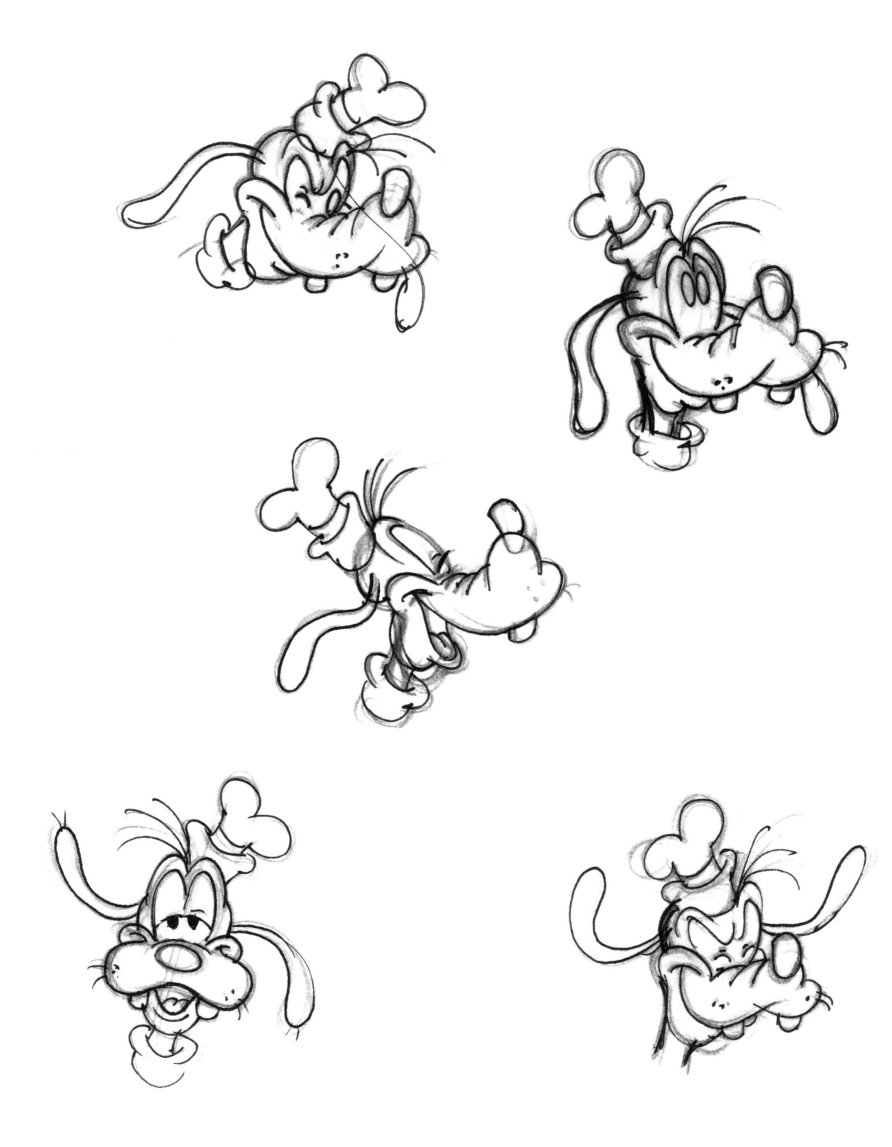

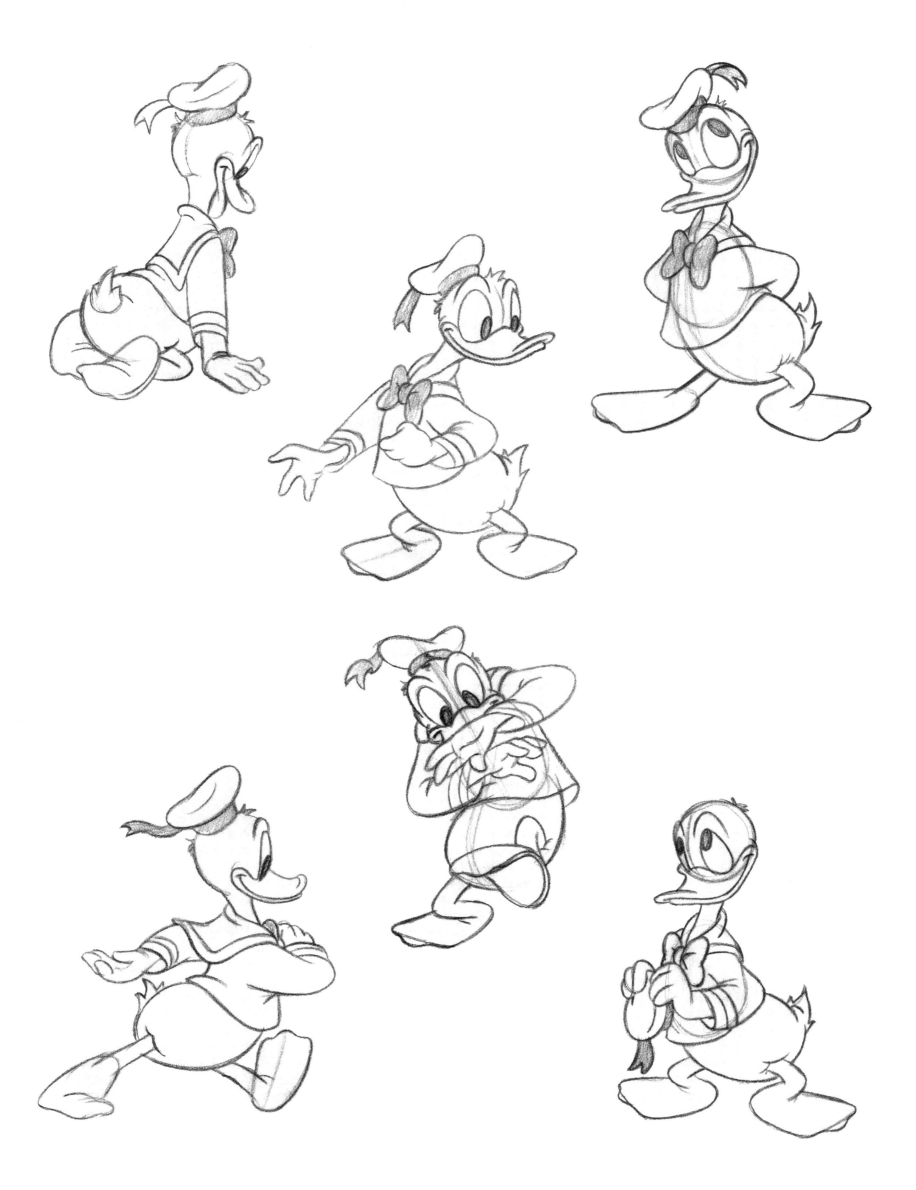

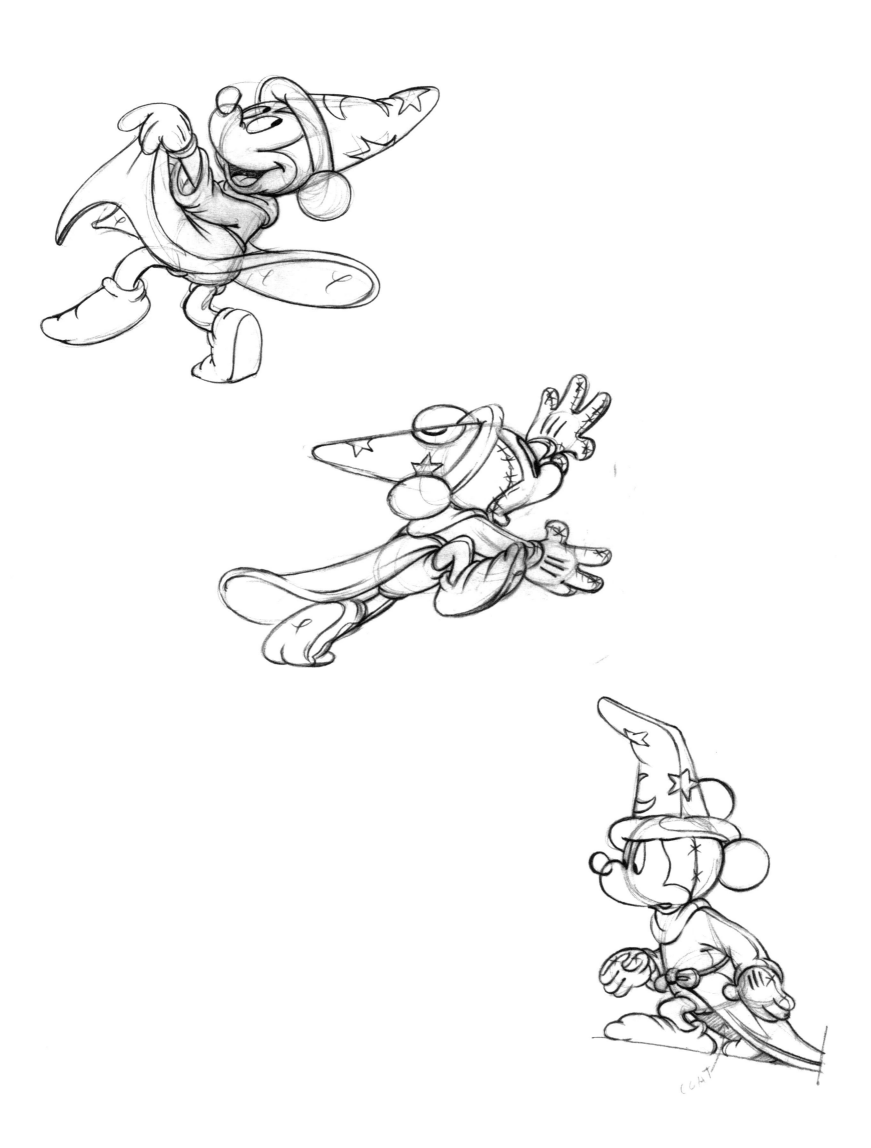

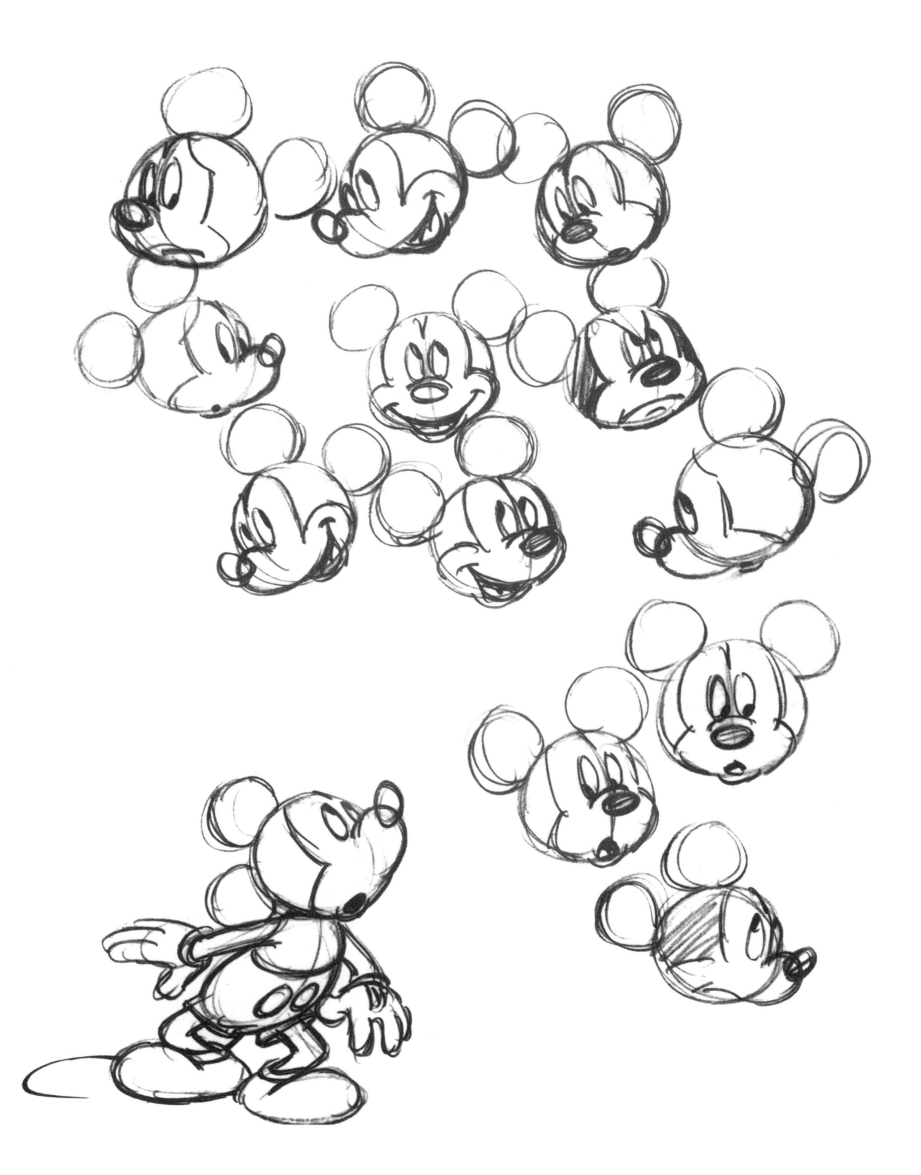

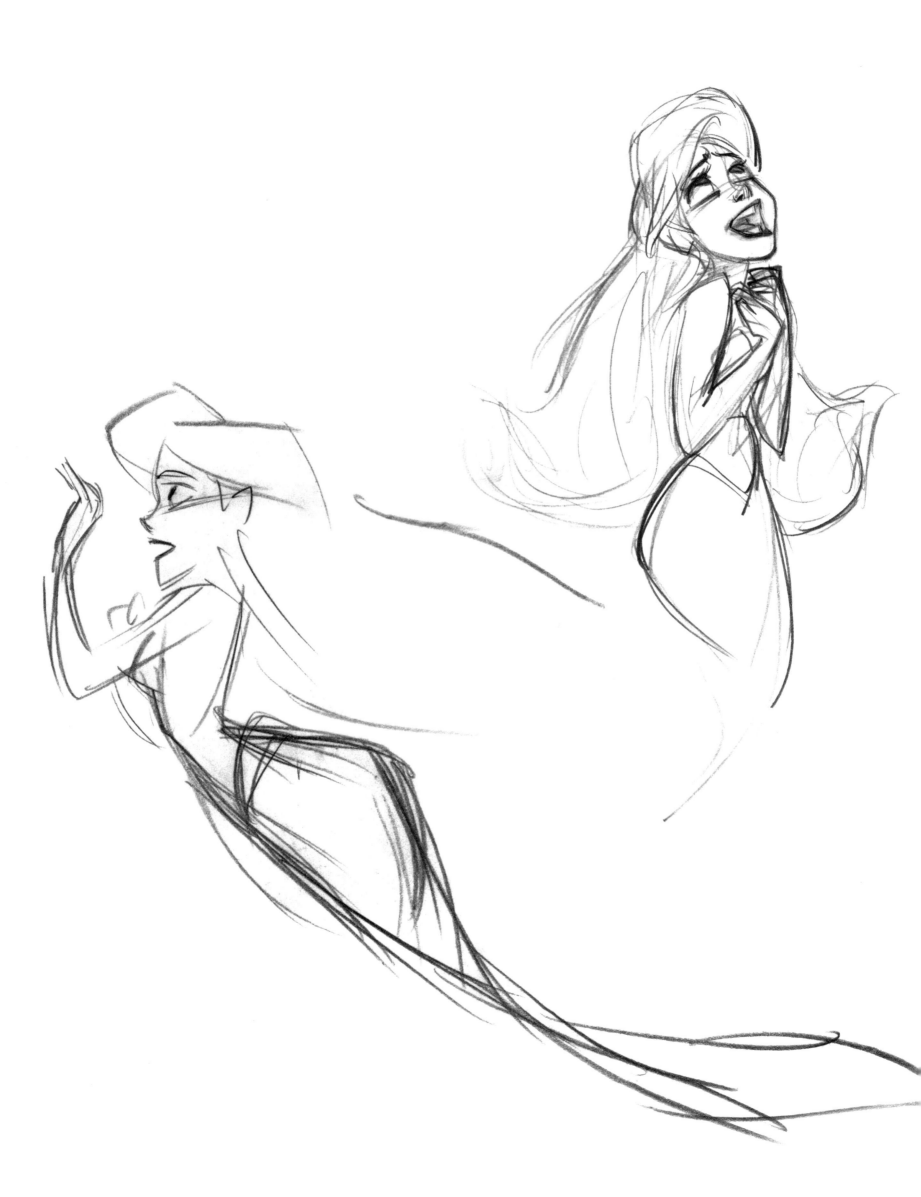

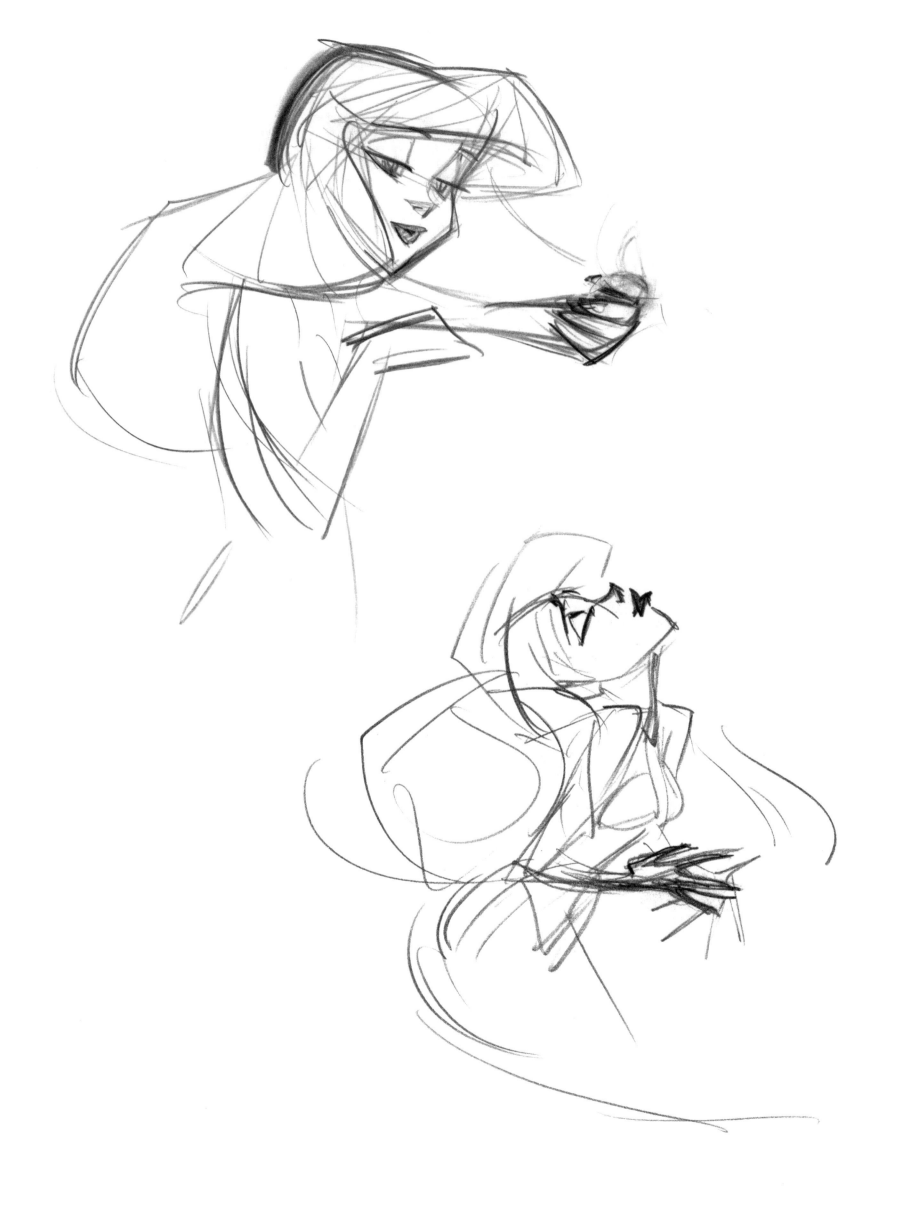

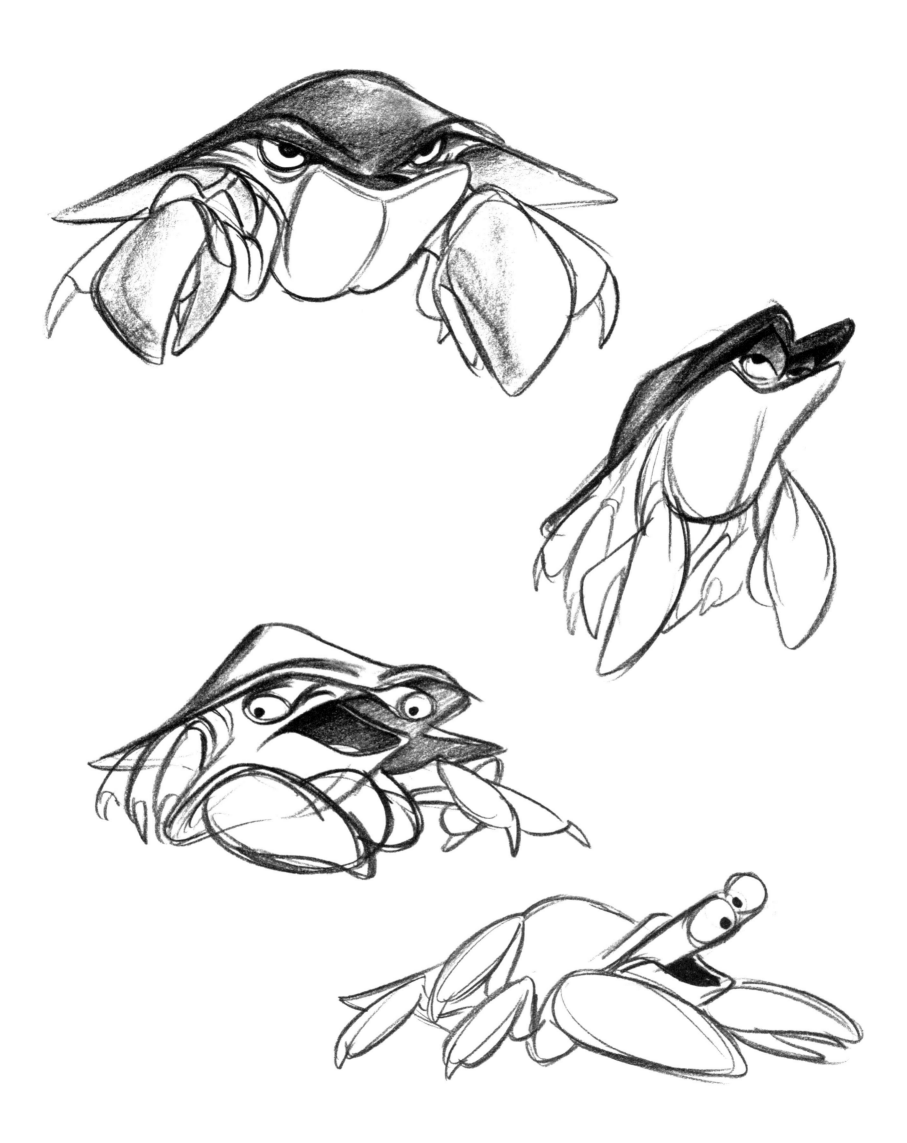

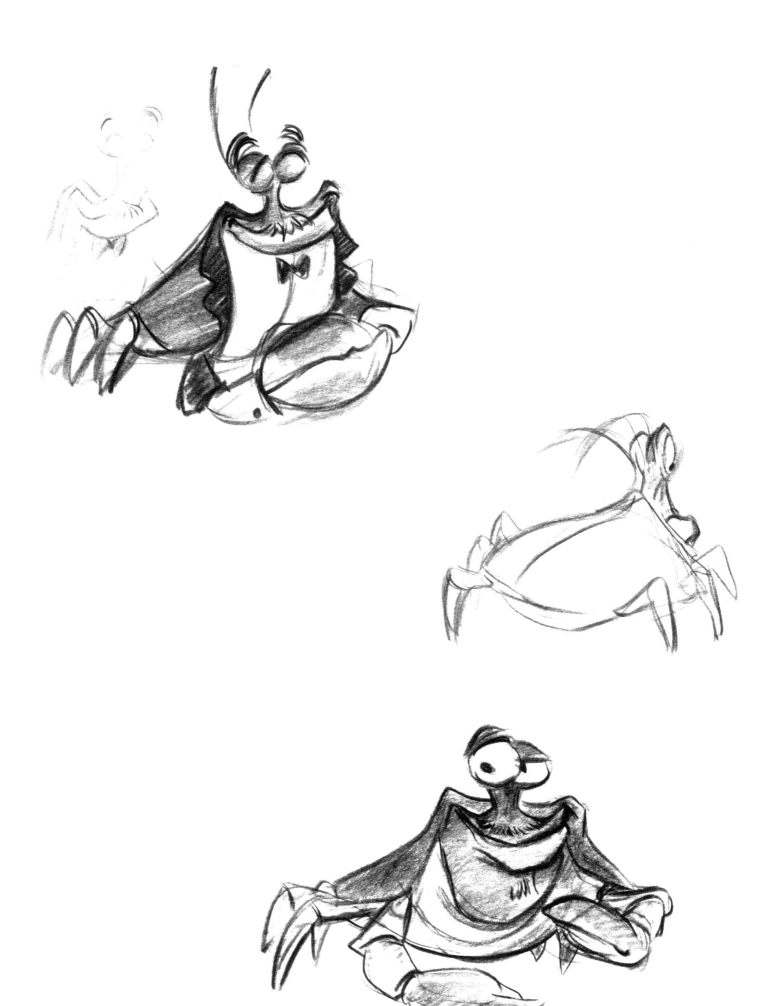

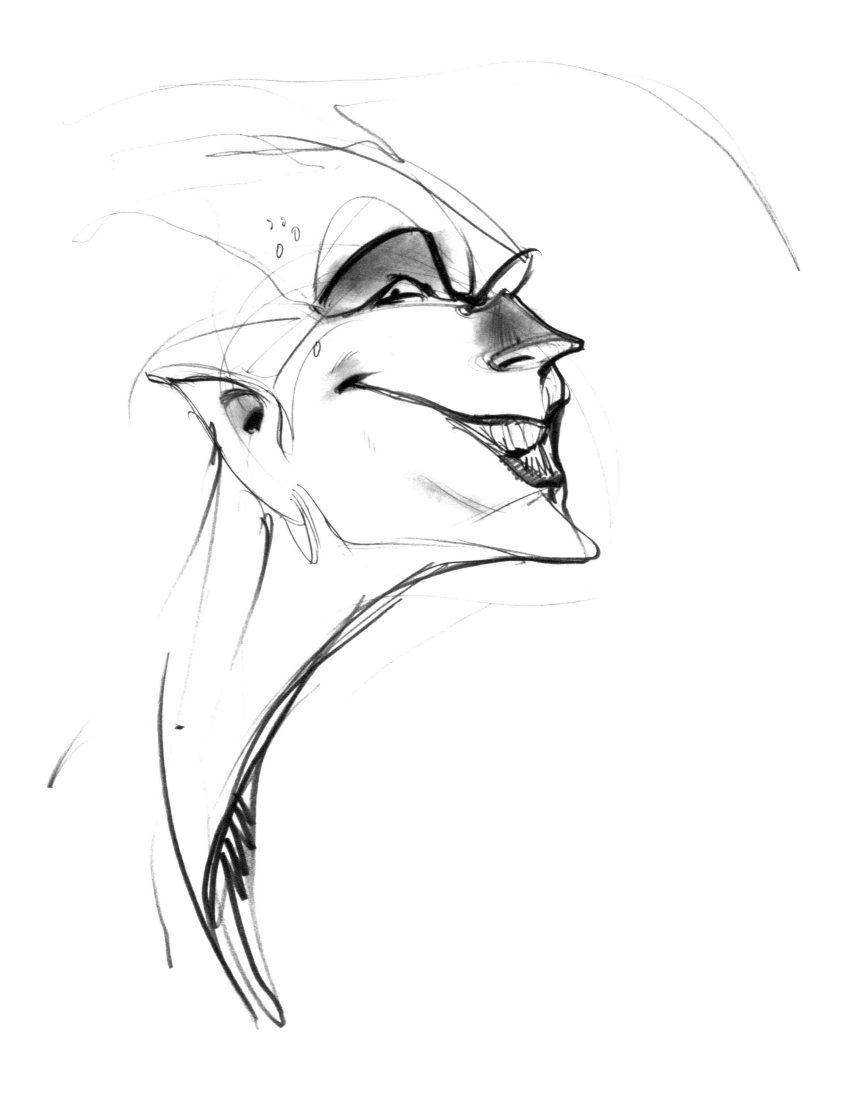

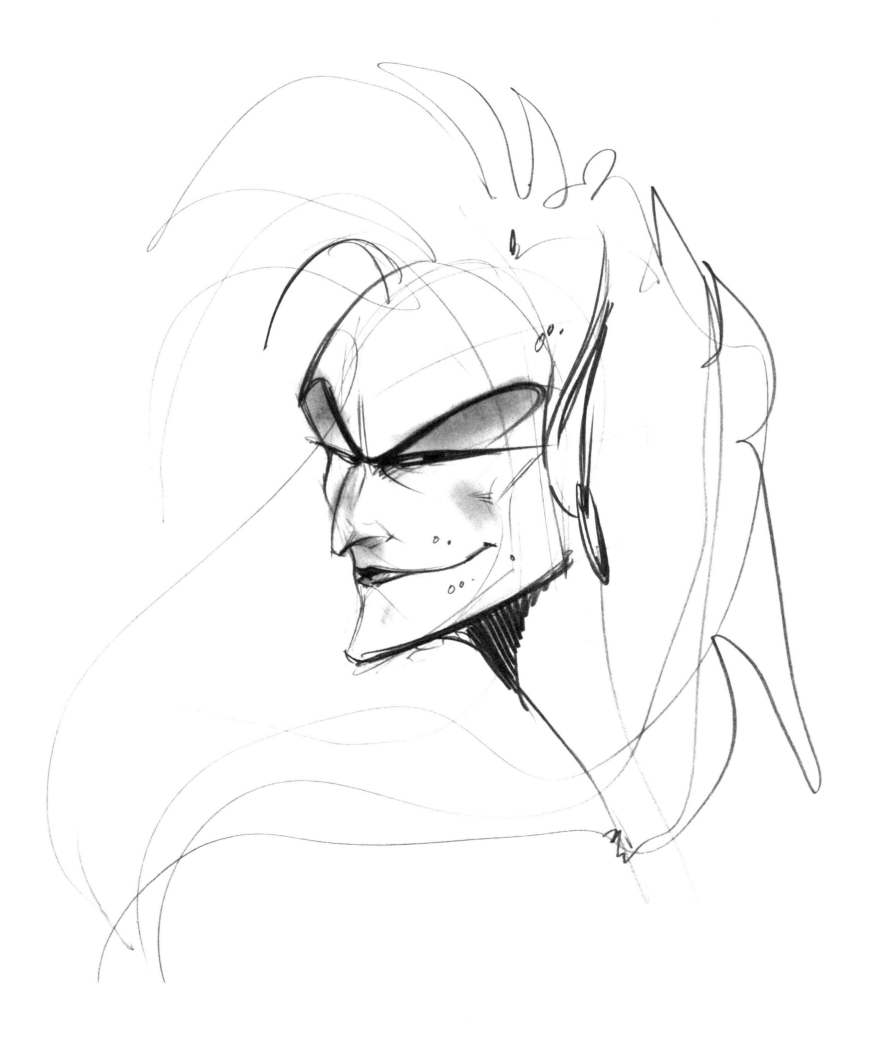

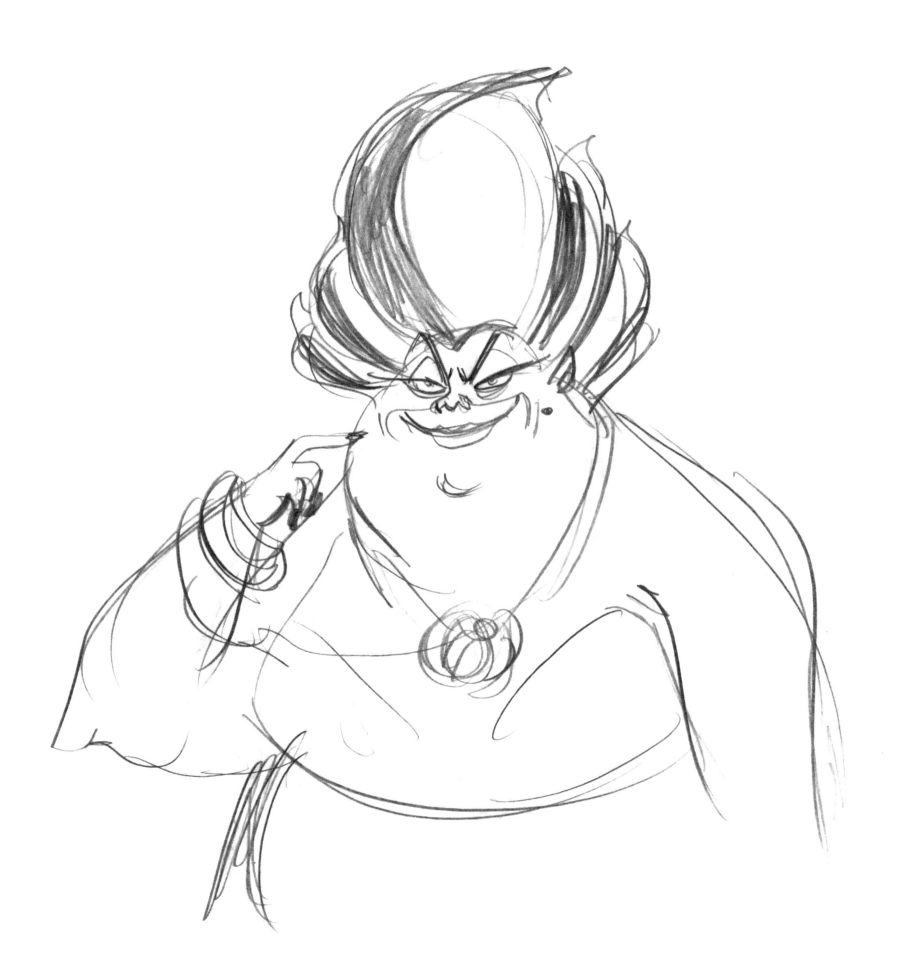

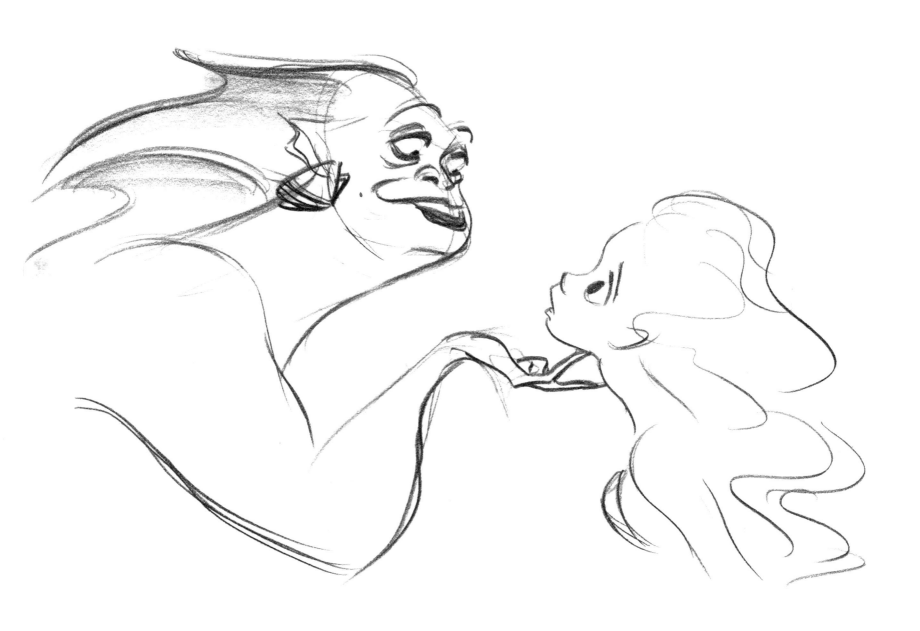

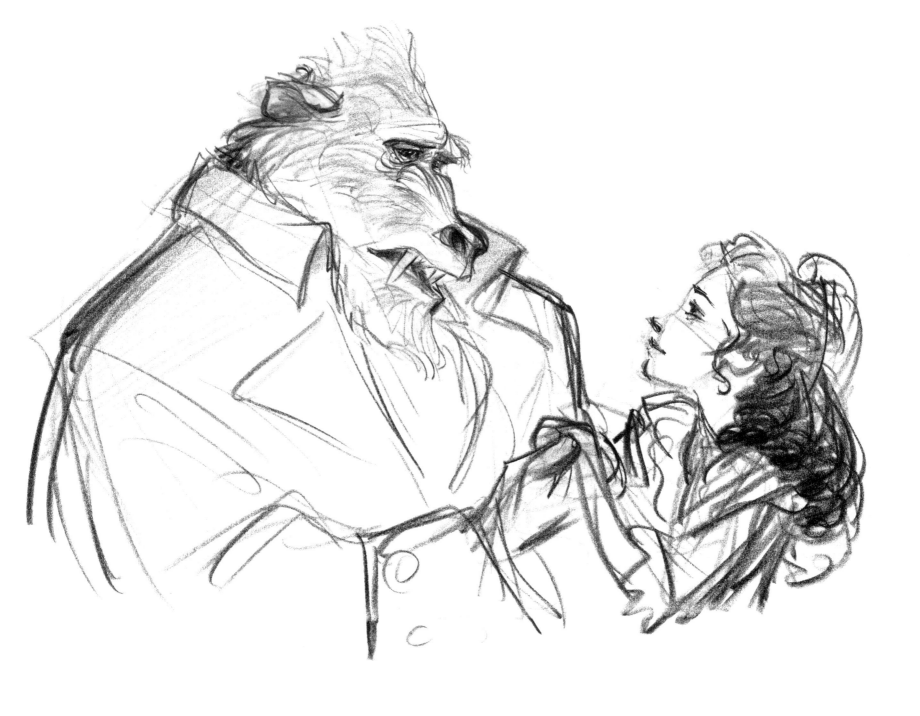

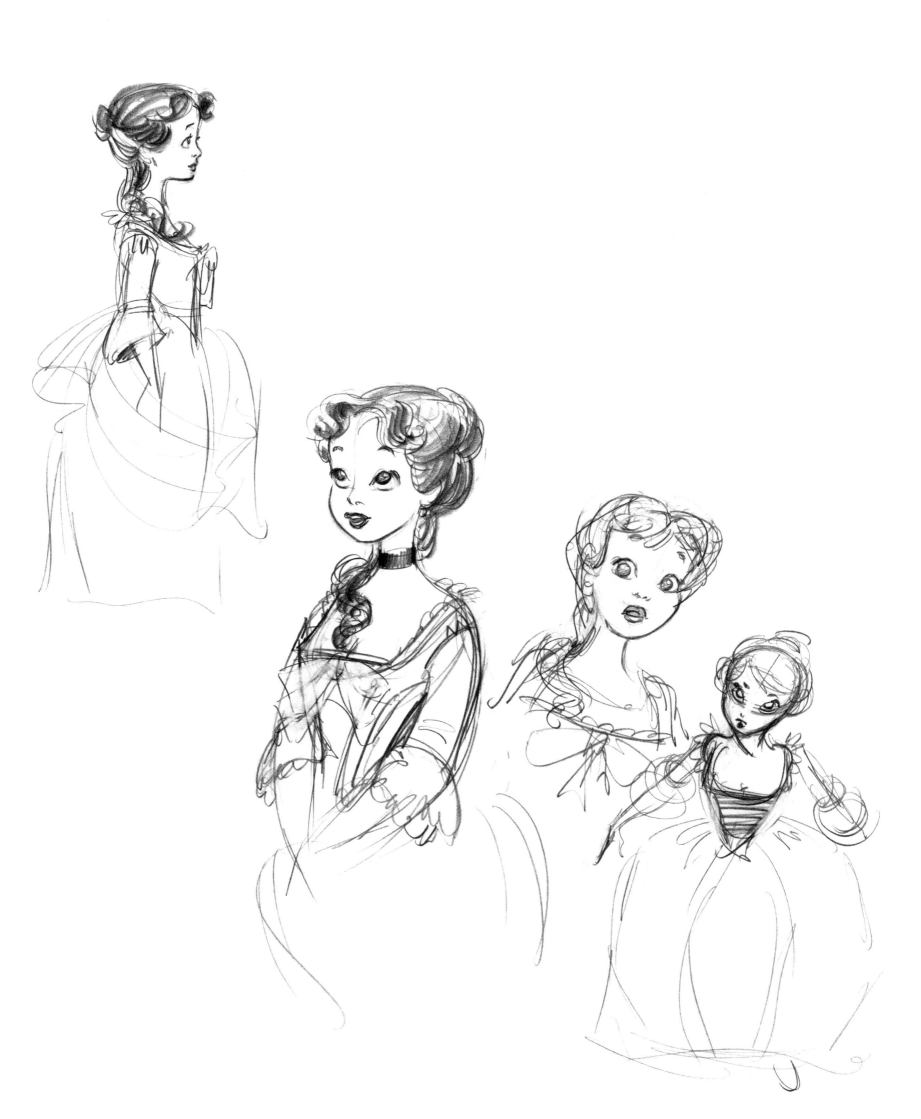

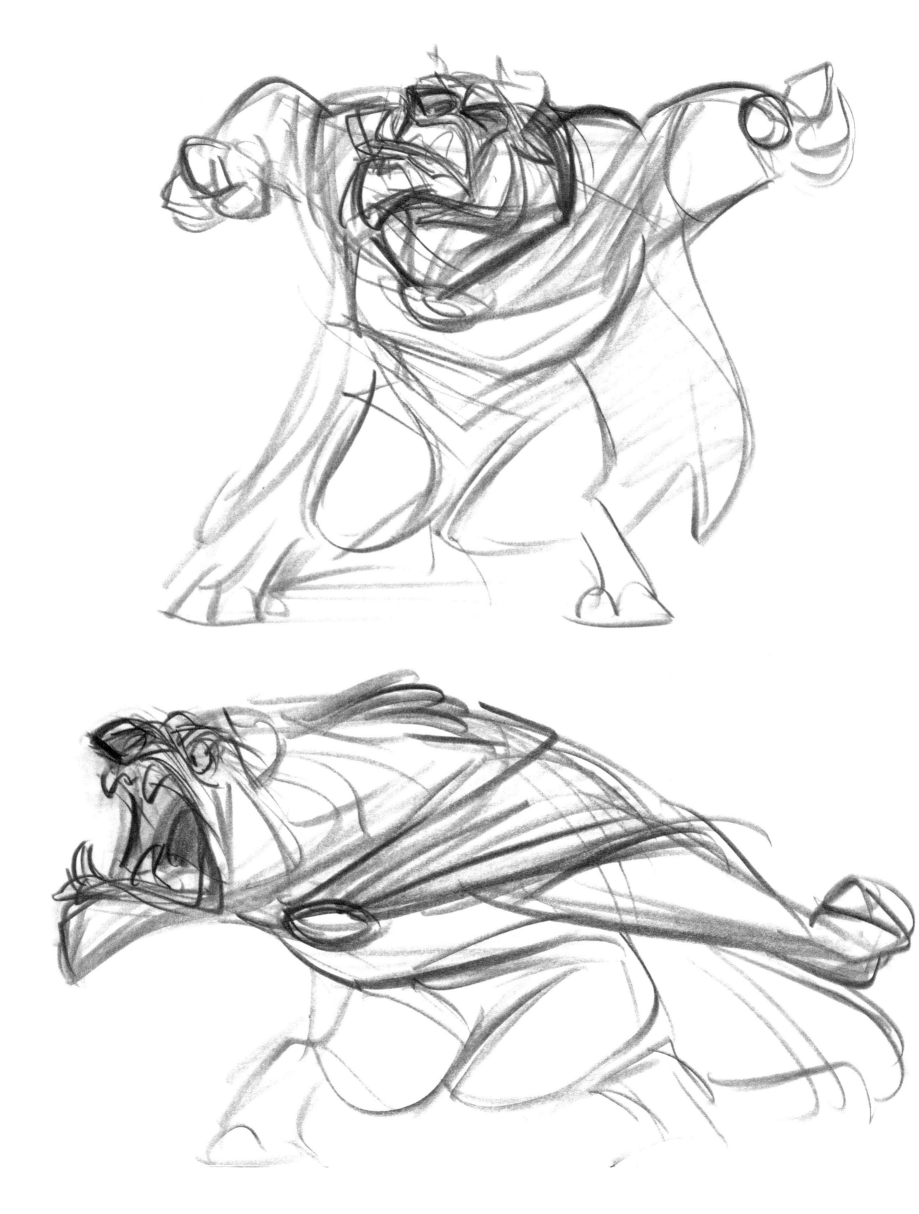

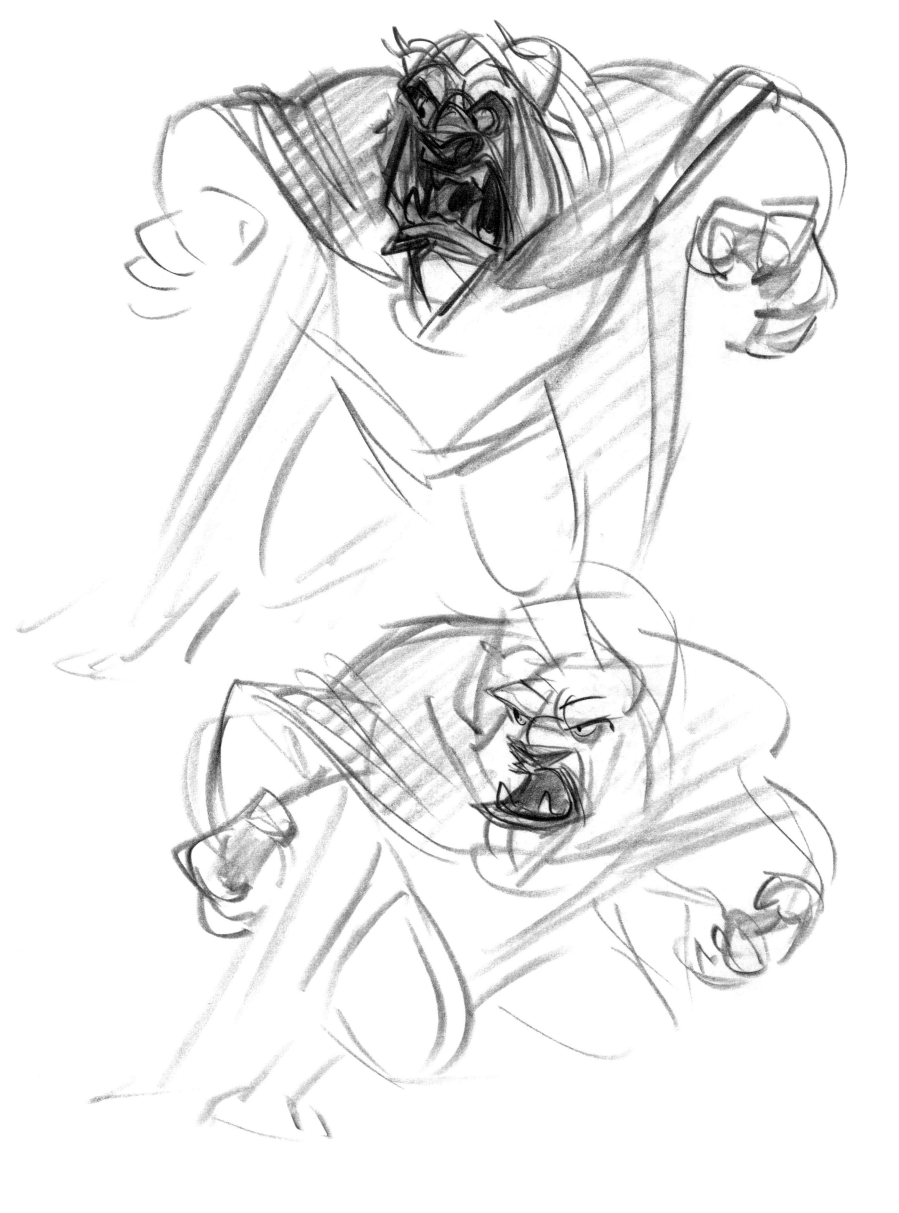

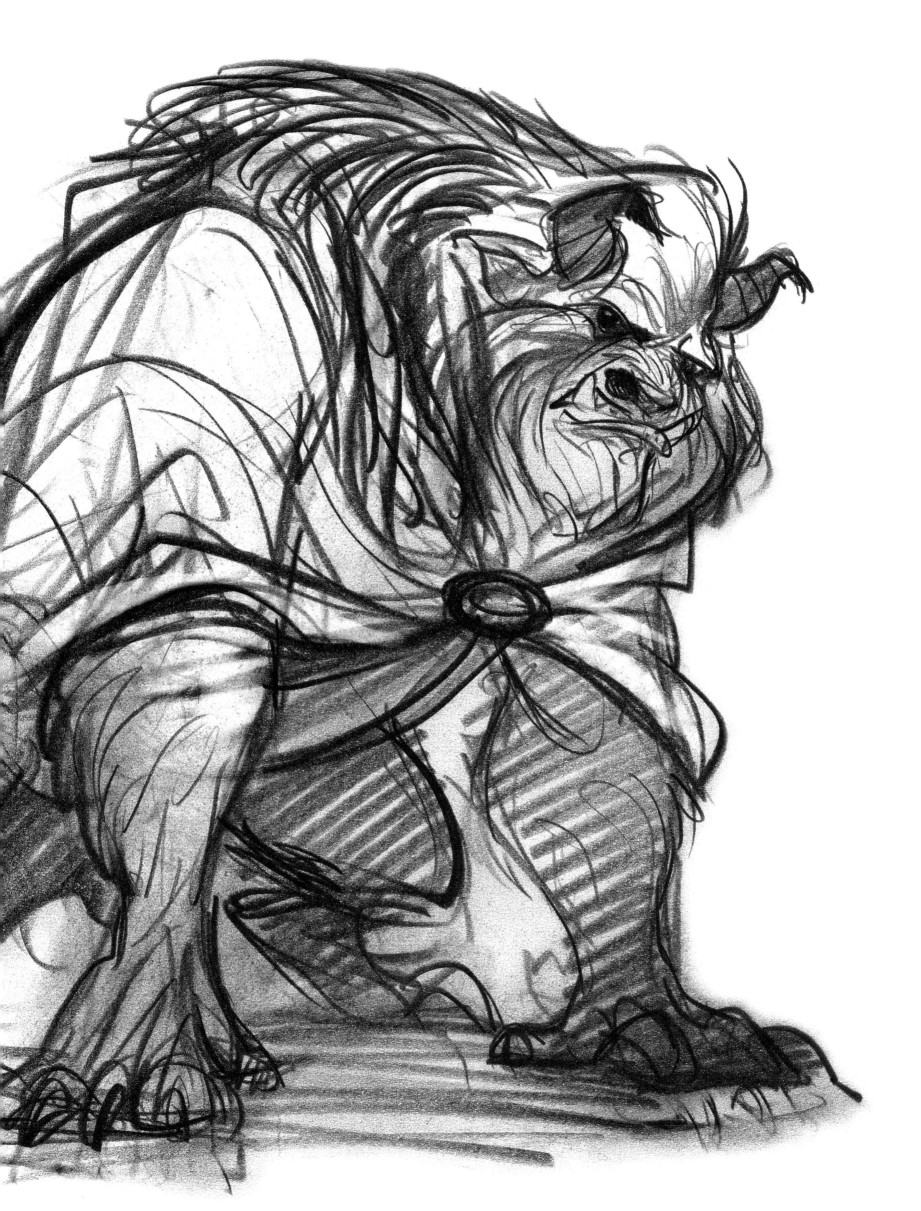

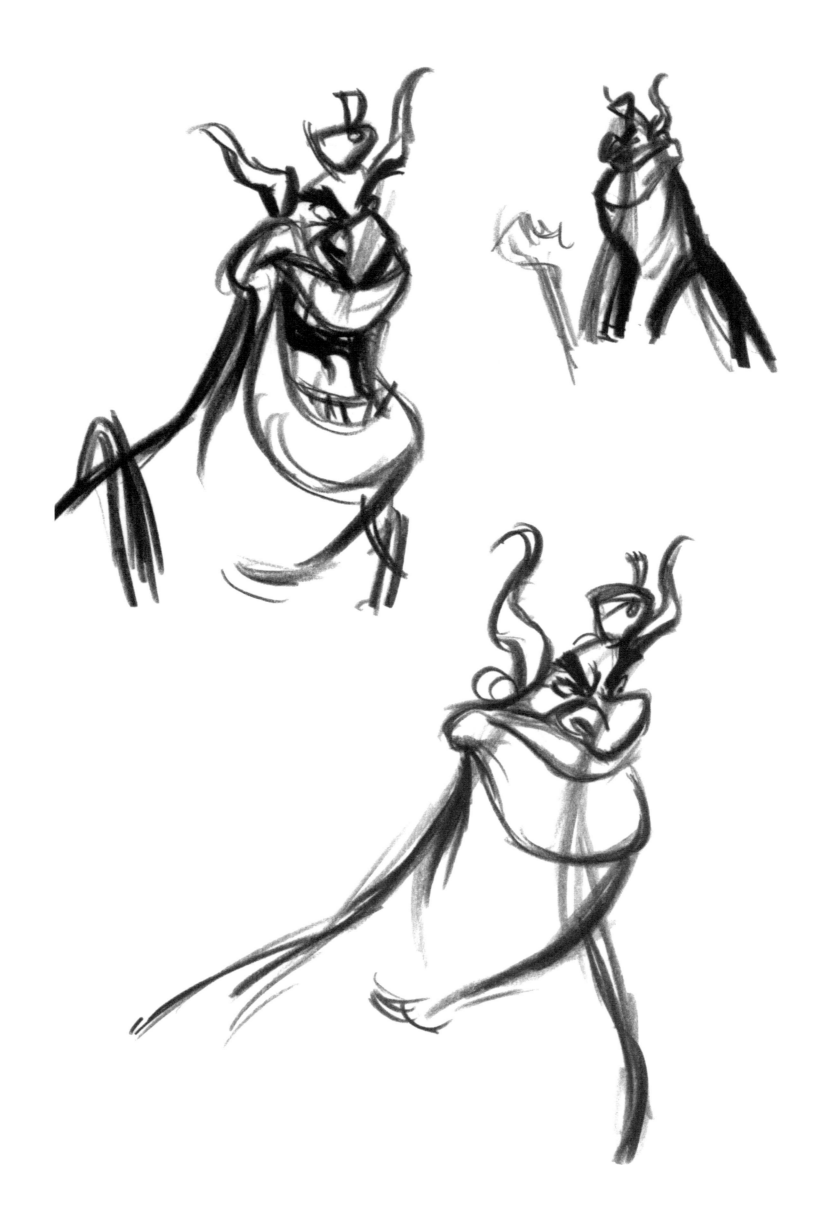

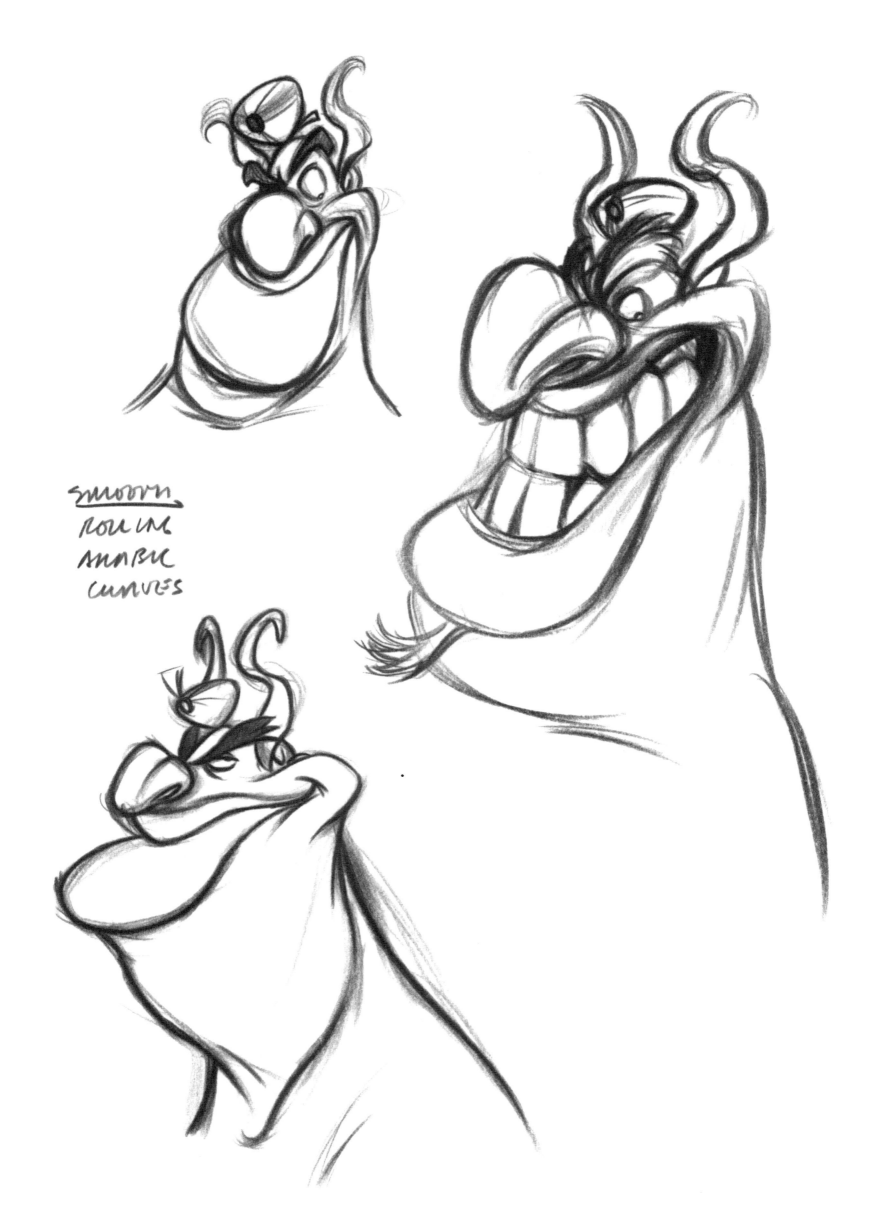

SMOOTH
ROLLING
AMIABLE
CURVES

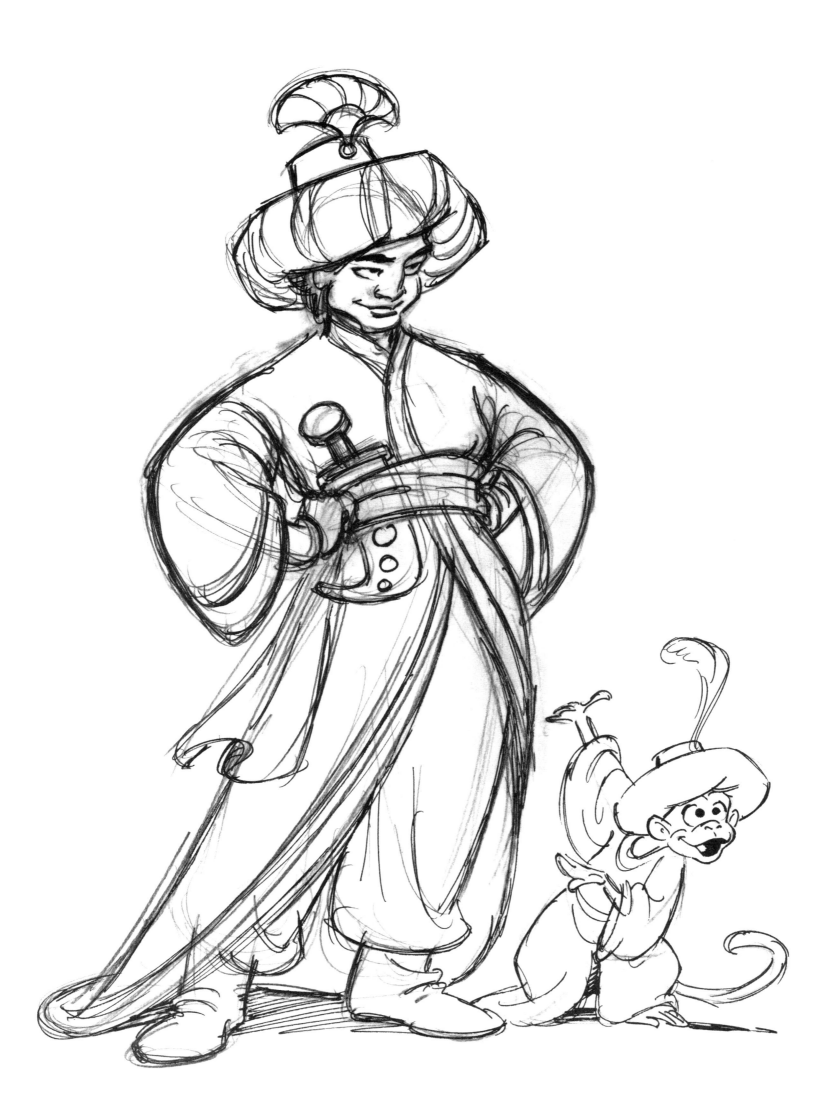

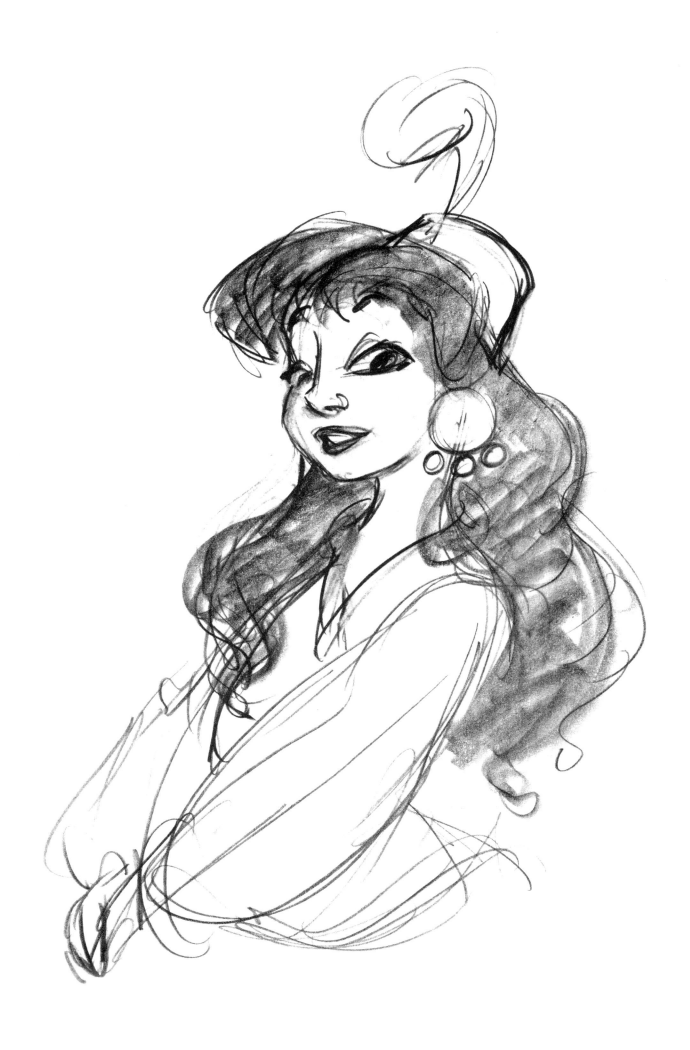

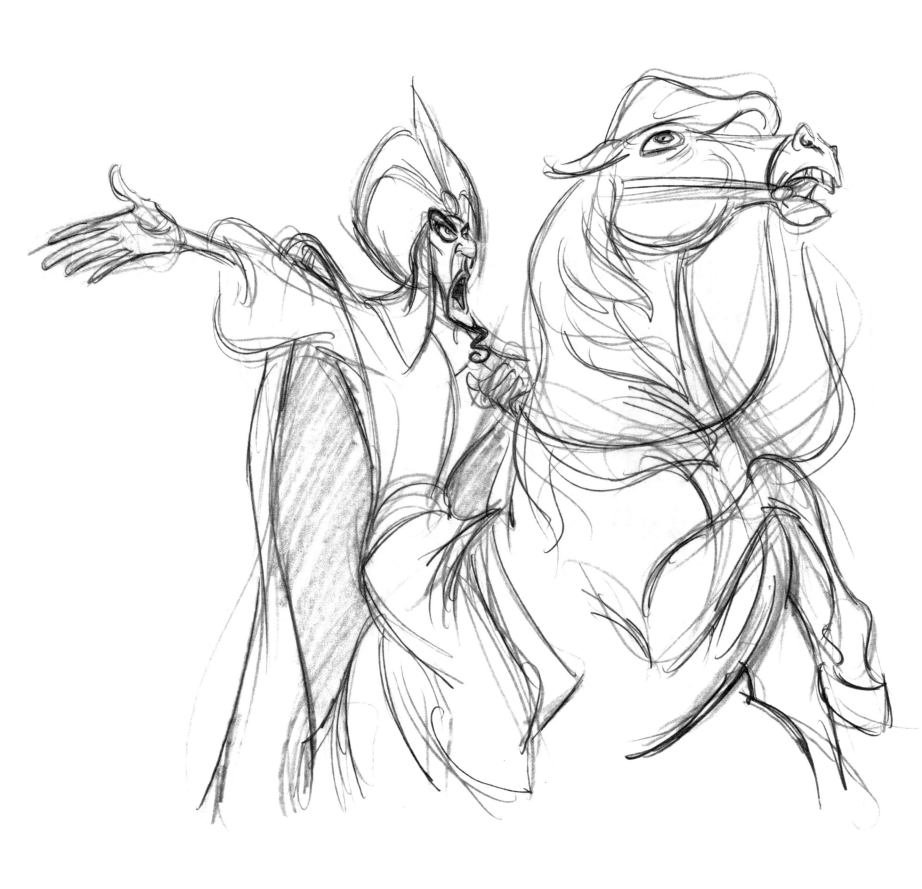

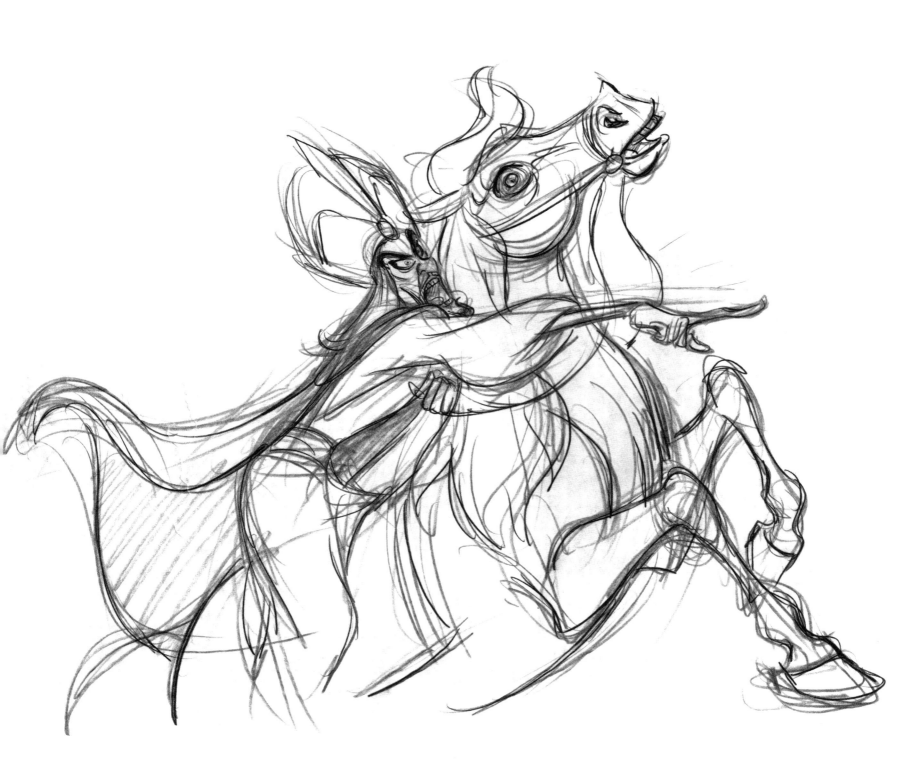

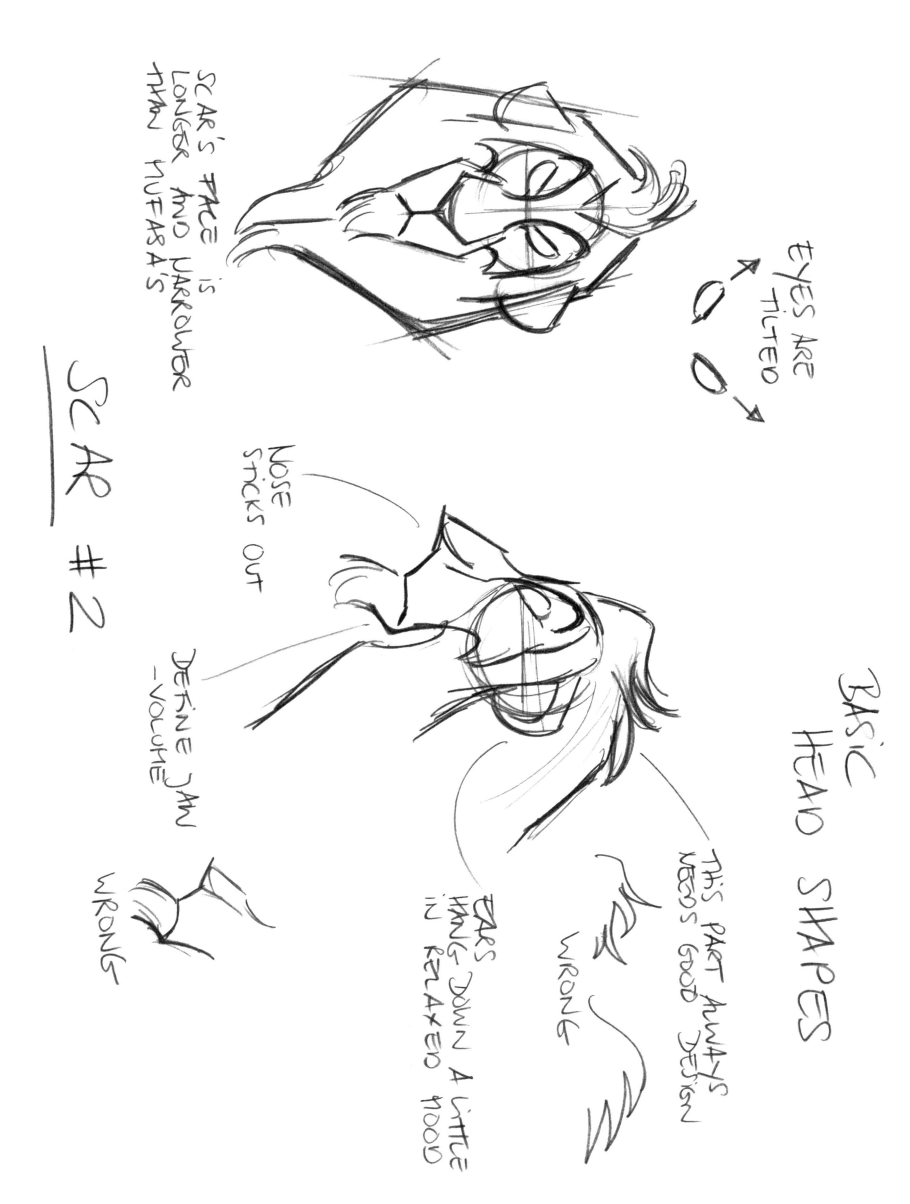

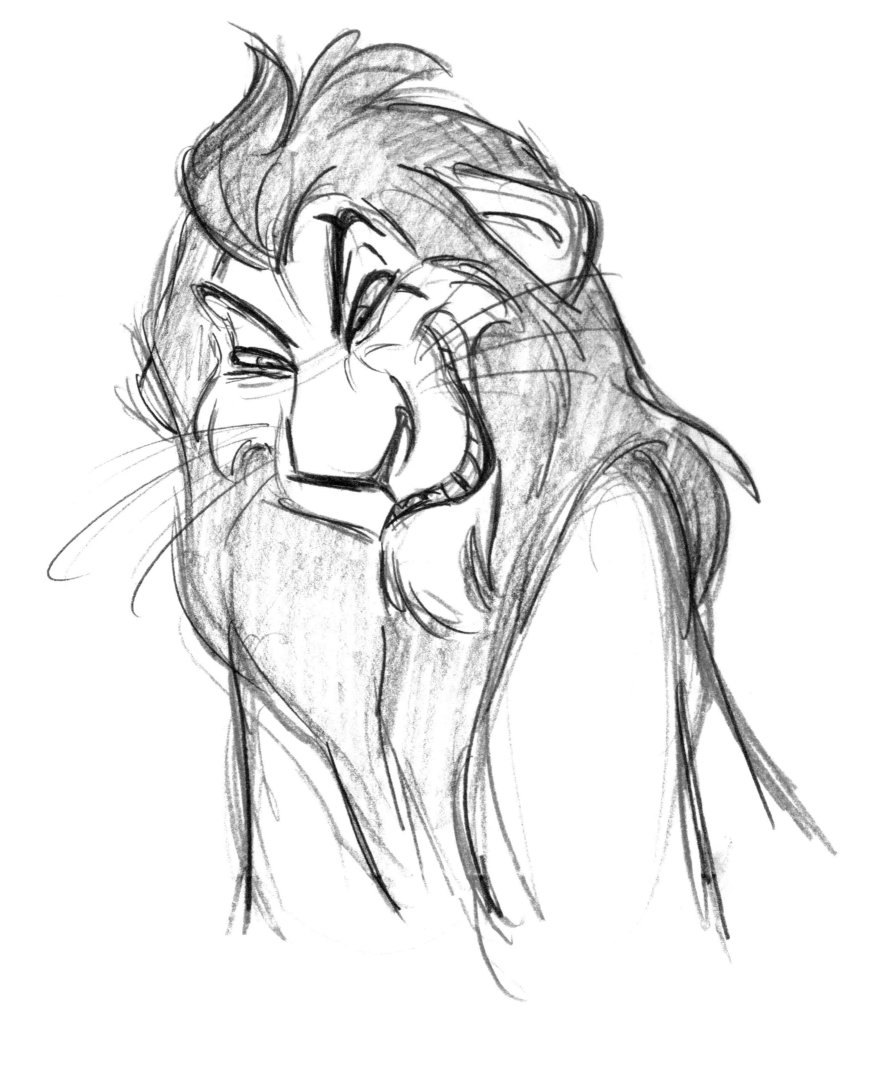

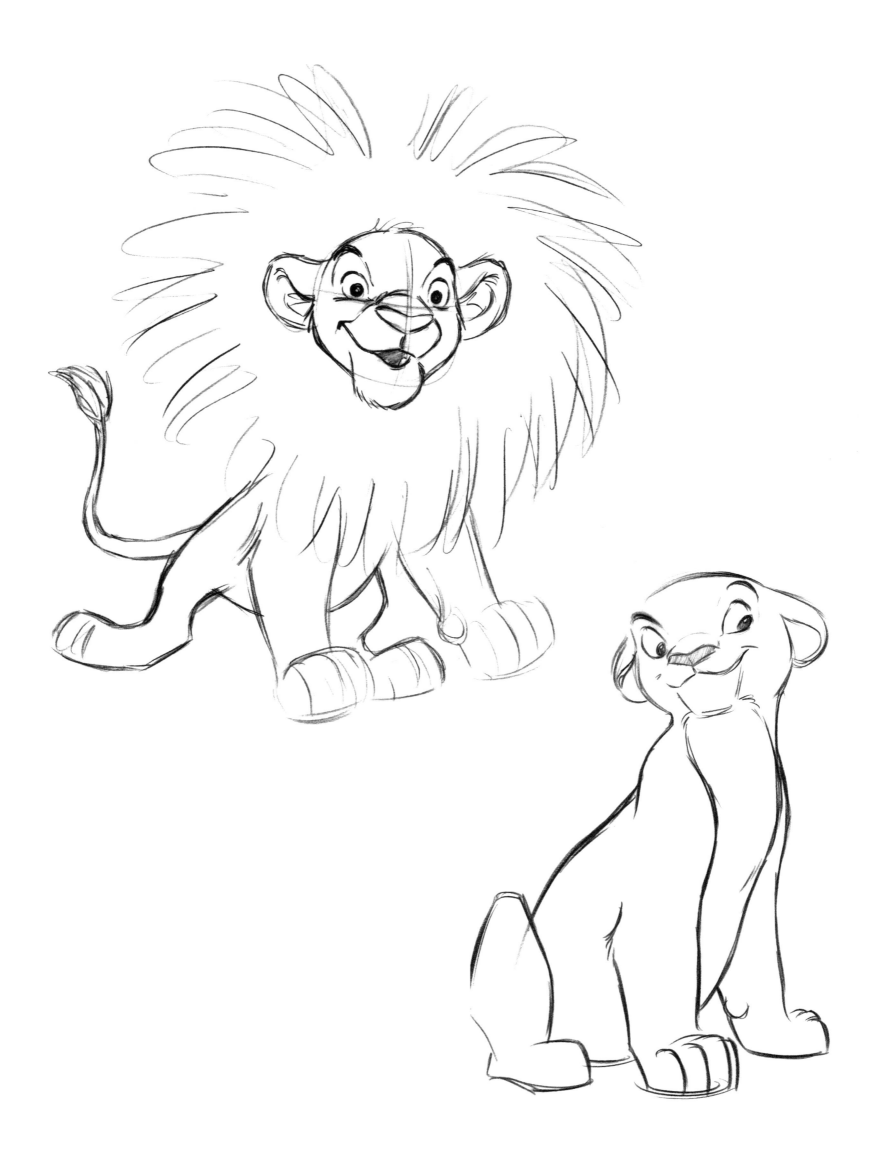

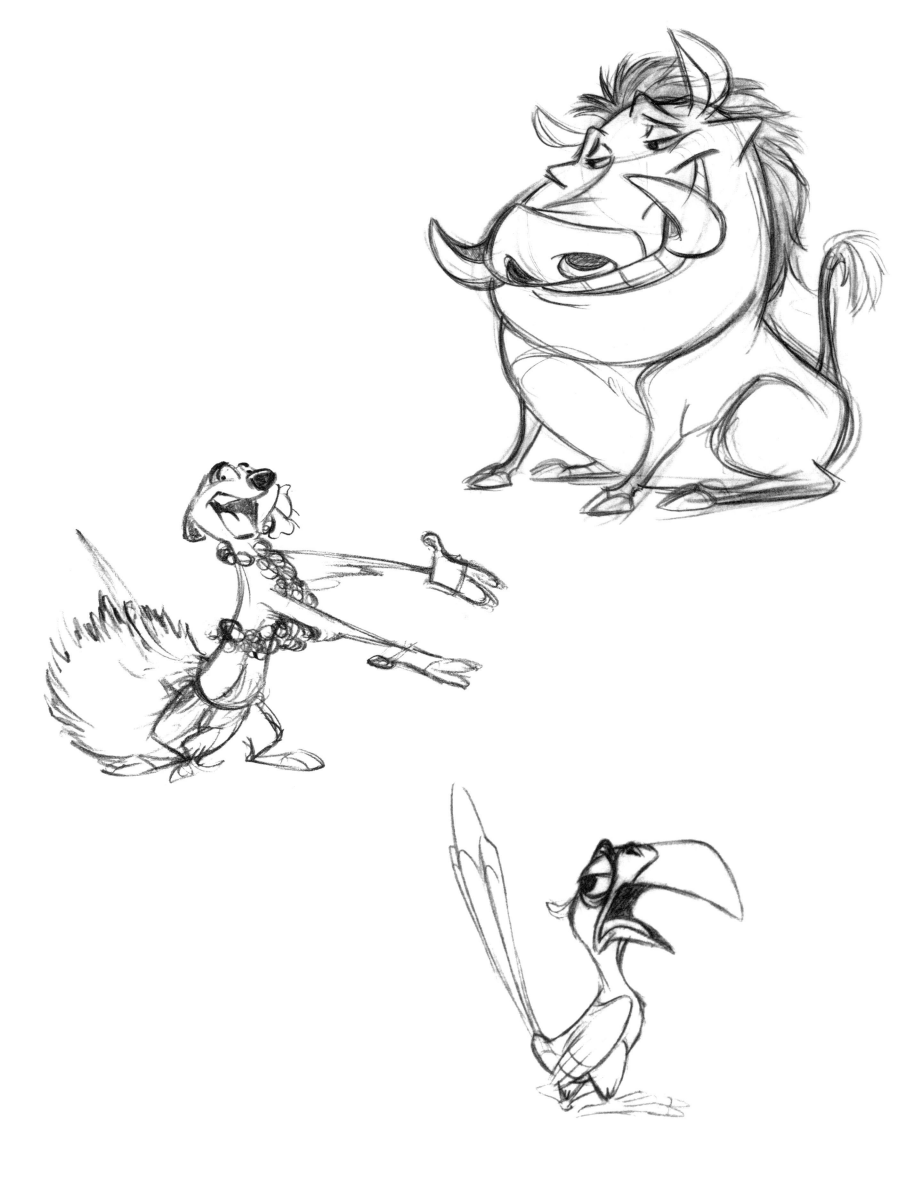

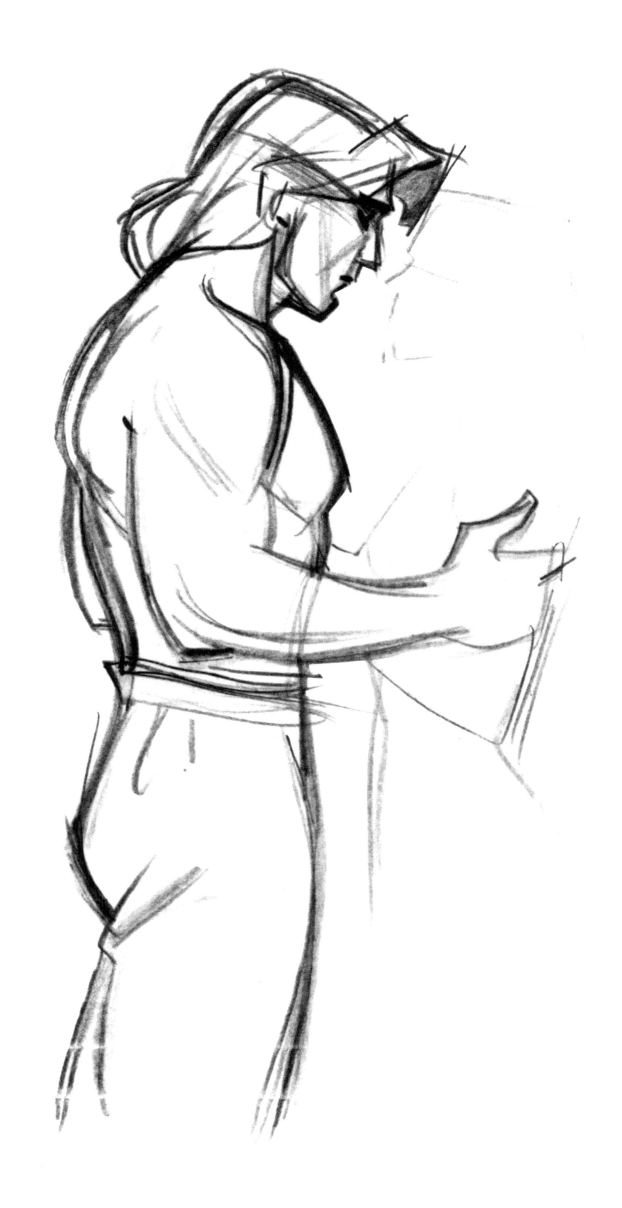

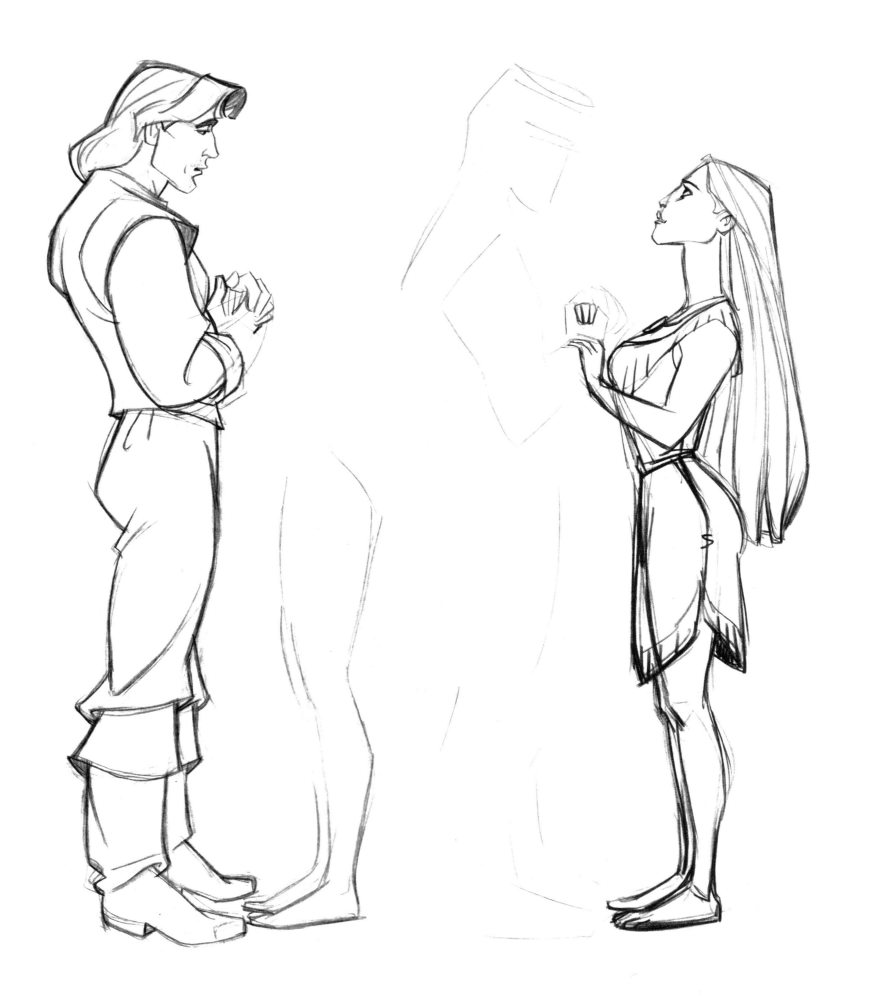

FOR SIZE COMPARISON CHART

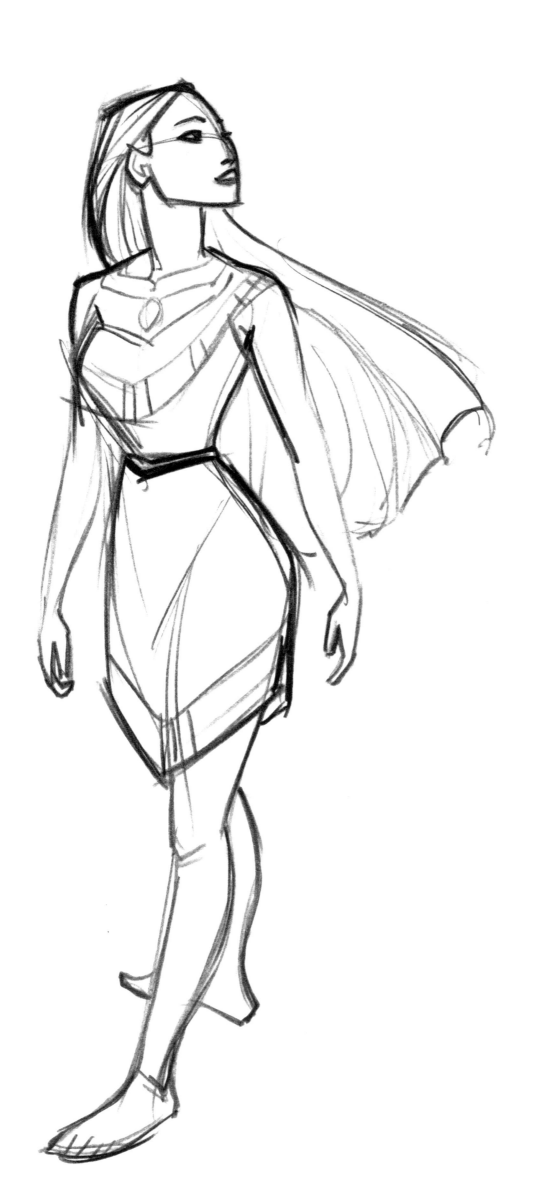

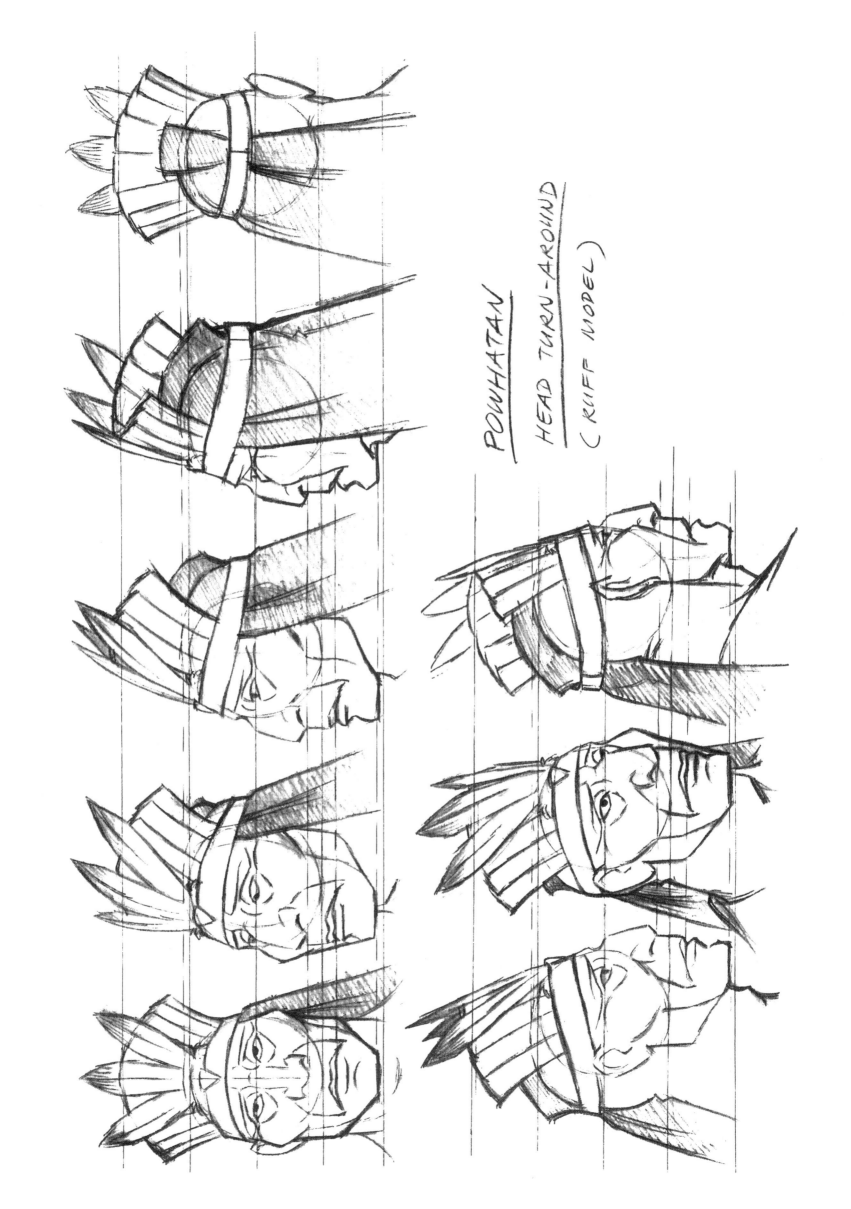

POWHATAN

HEAD TURN-AROUND

(KLIFF MODEL)

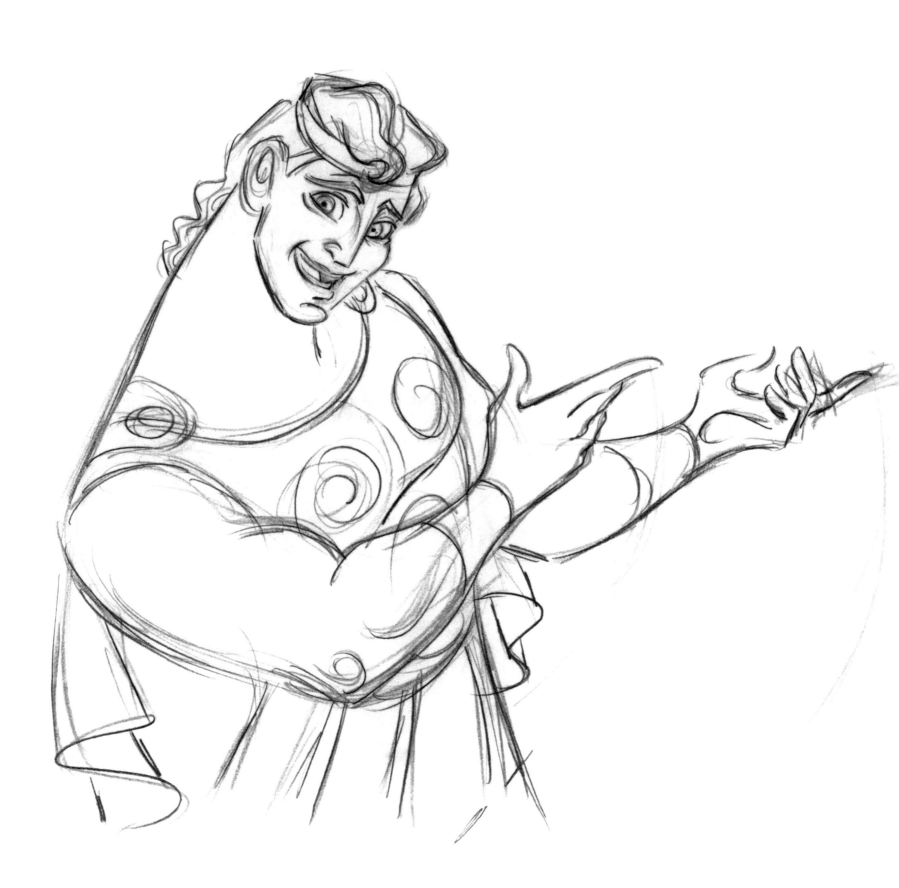

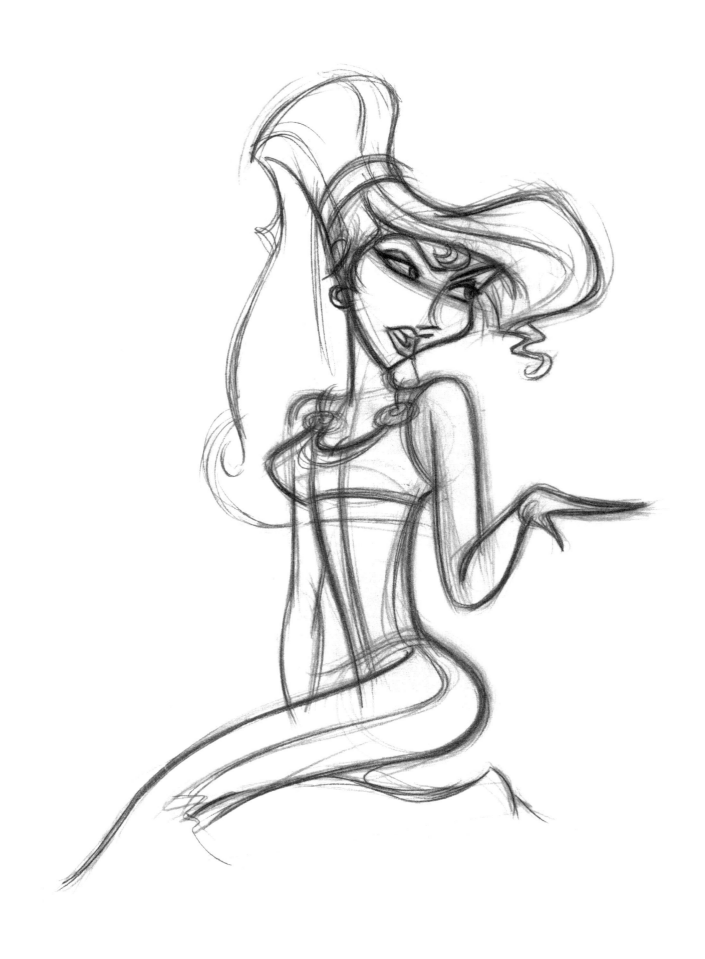

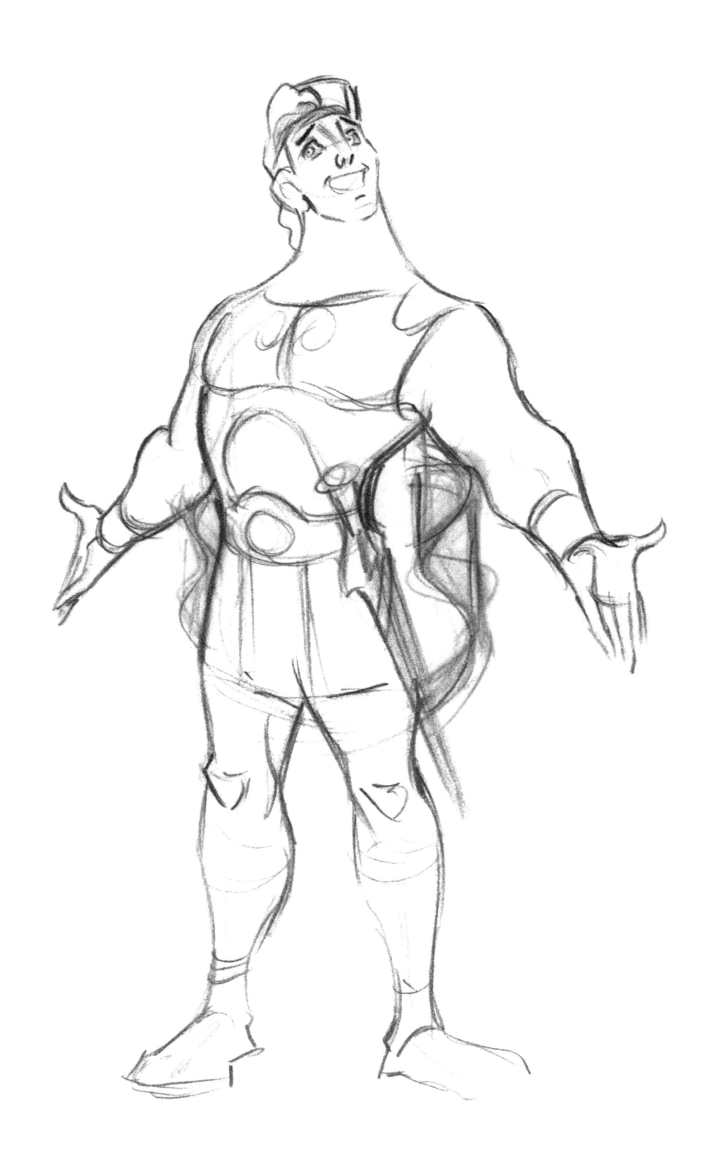

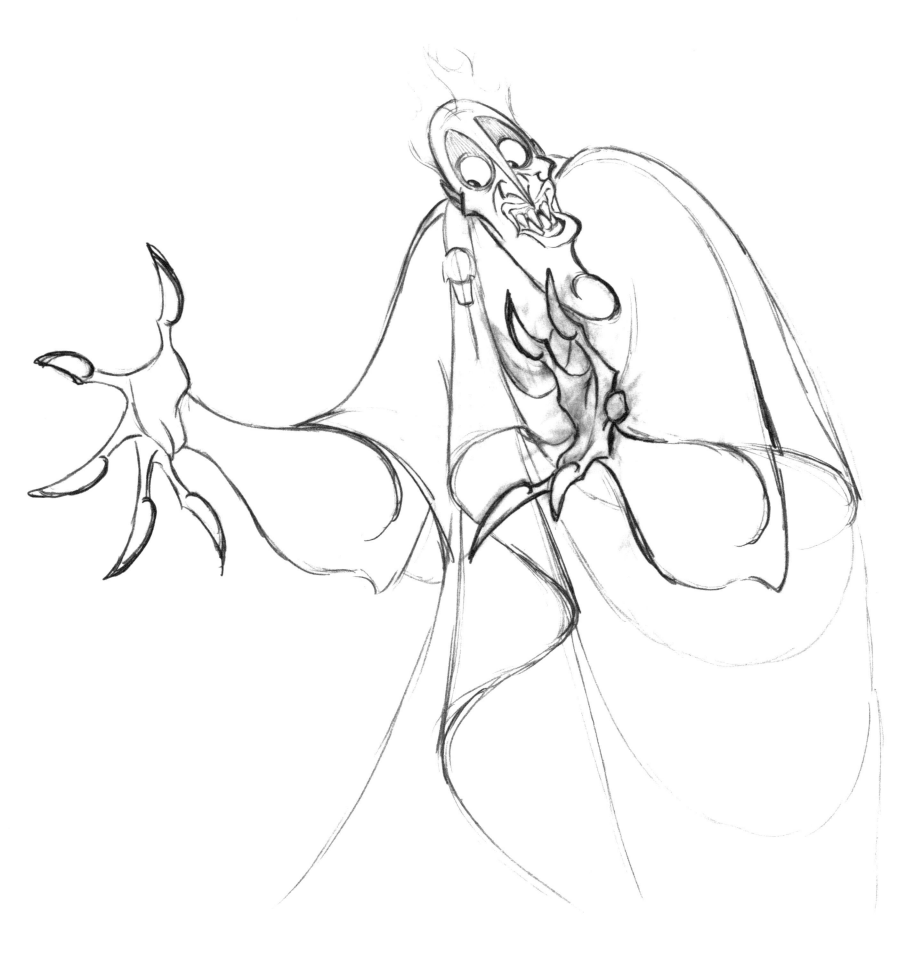

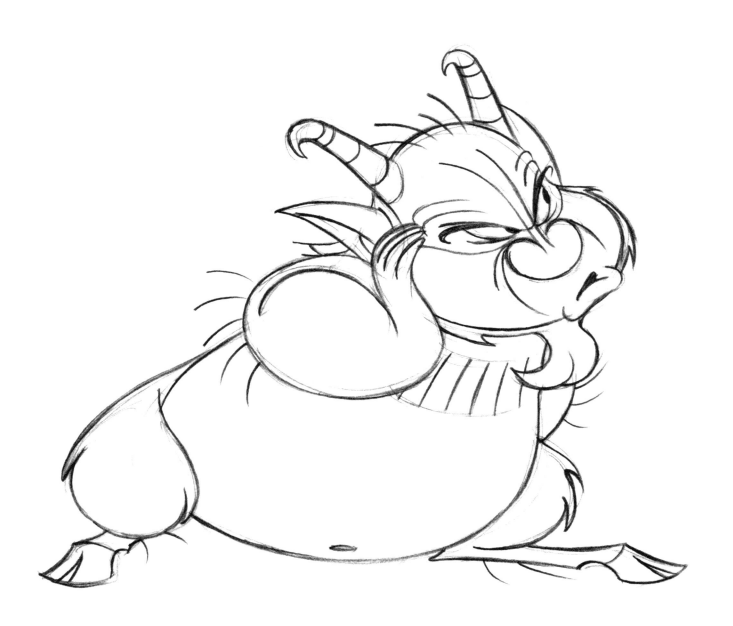

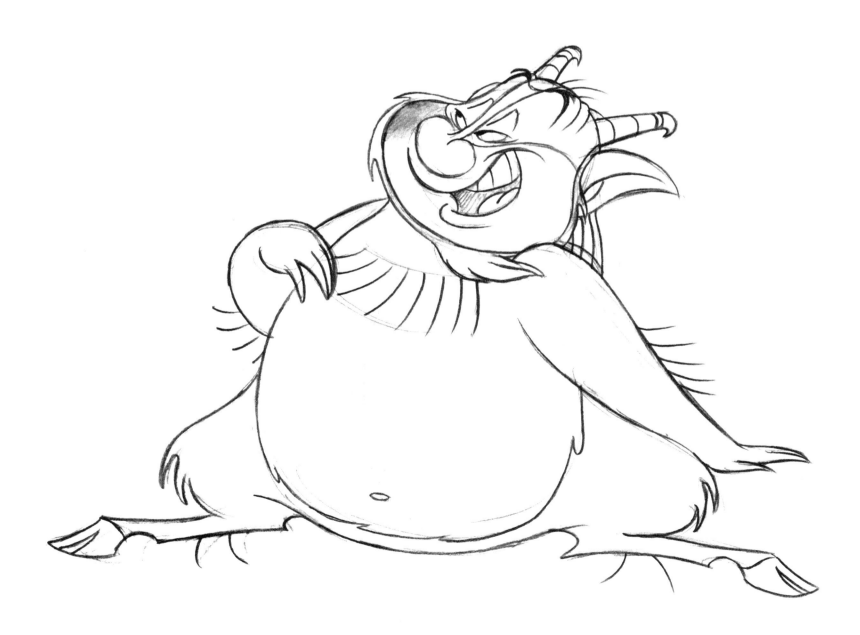

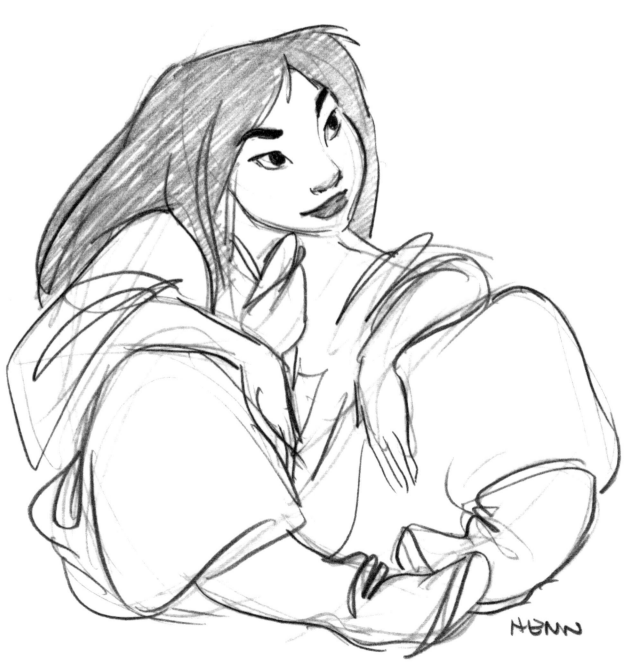

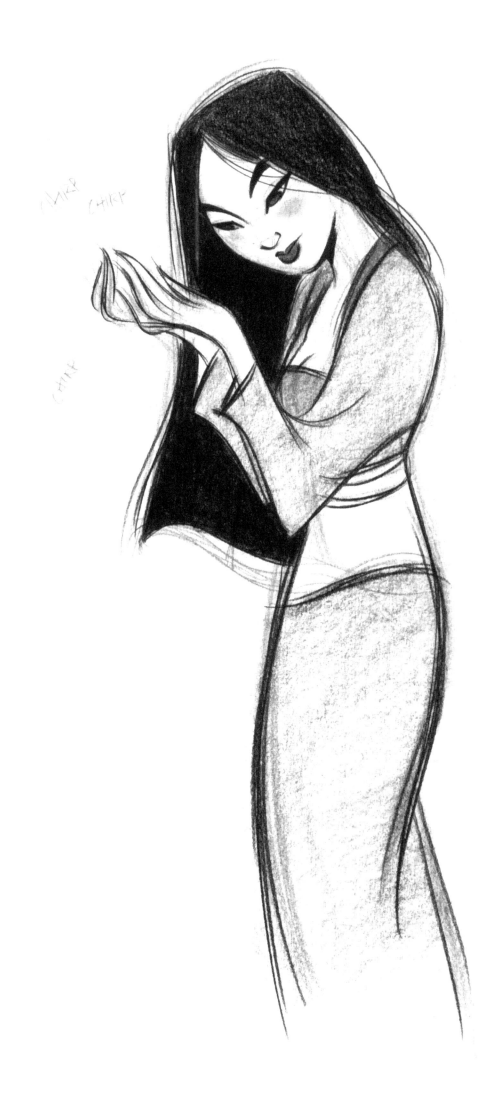

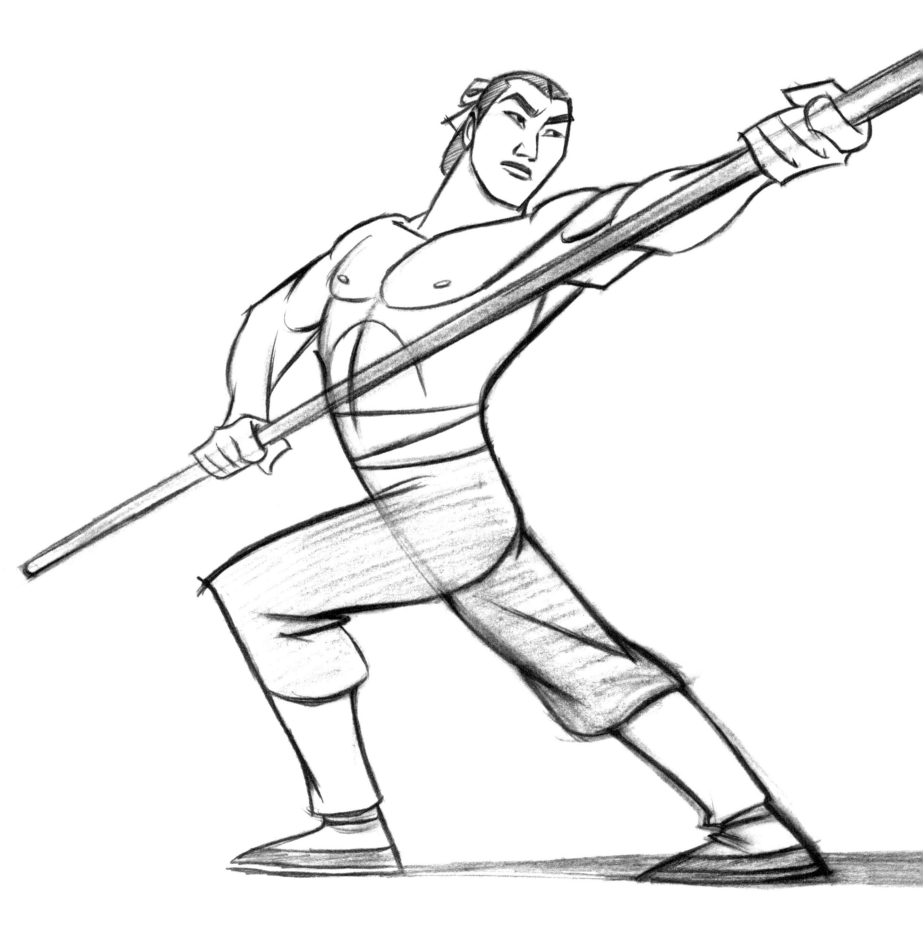

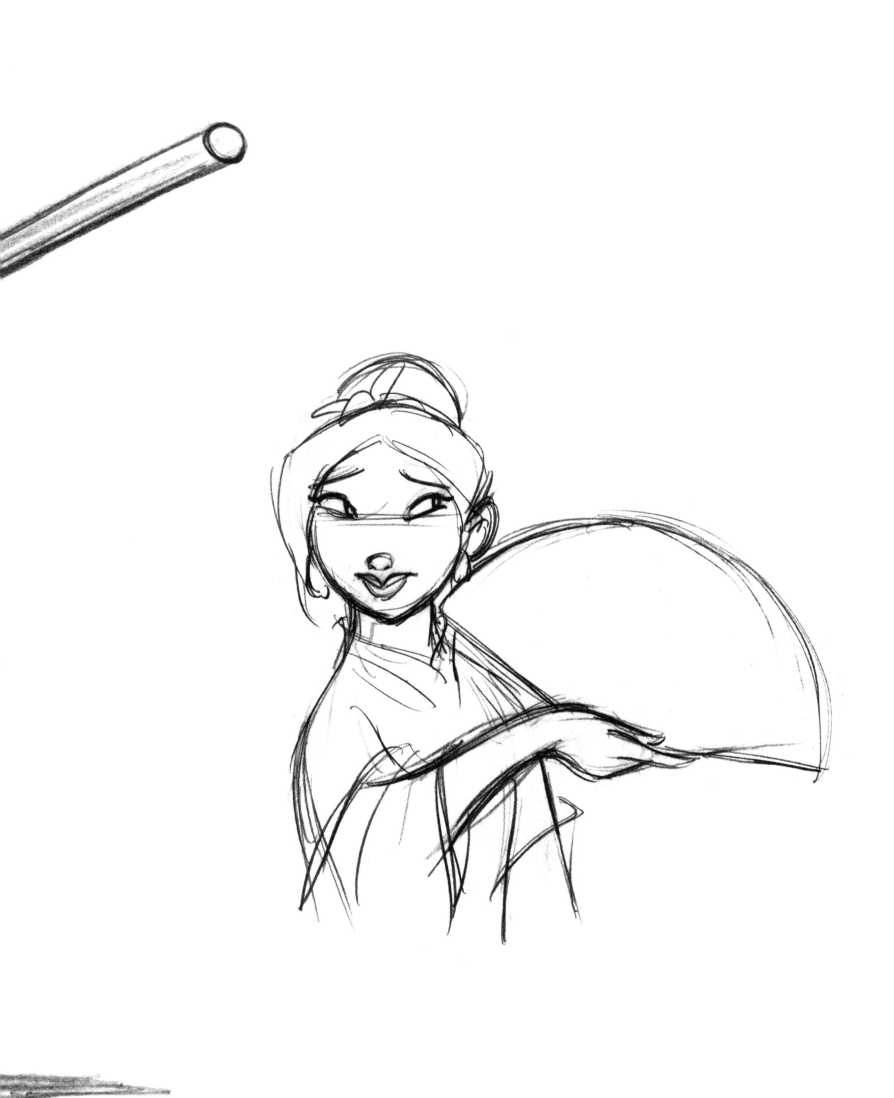

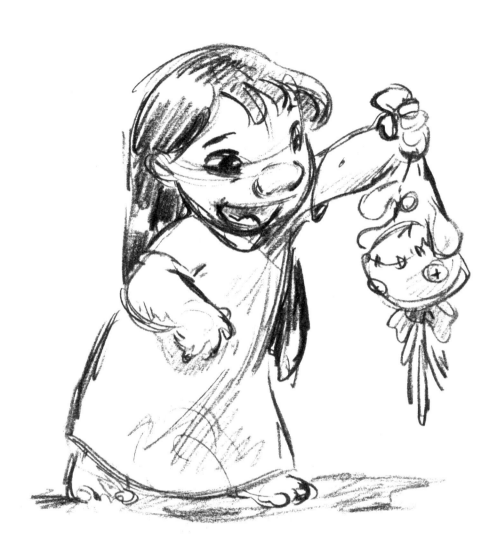

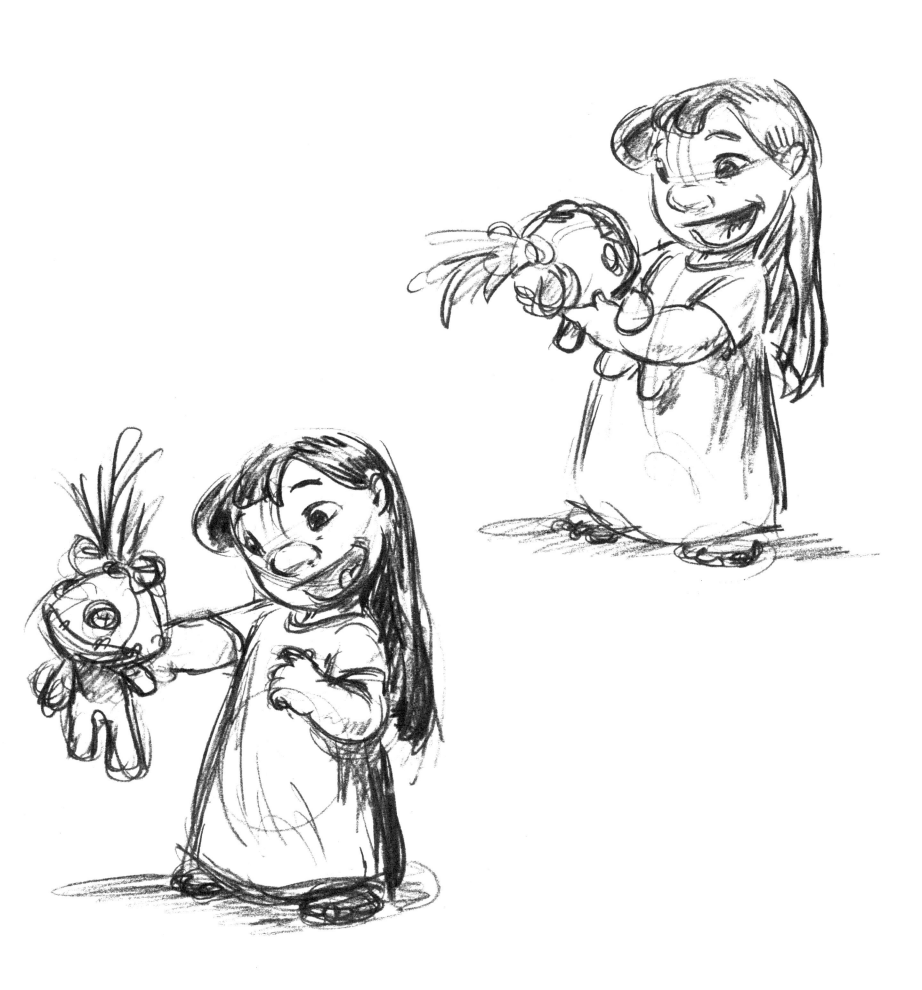

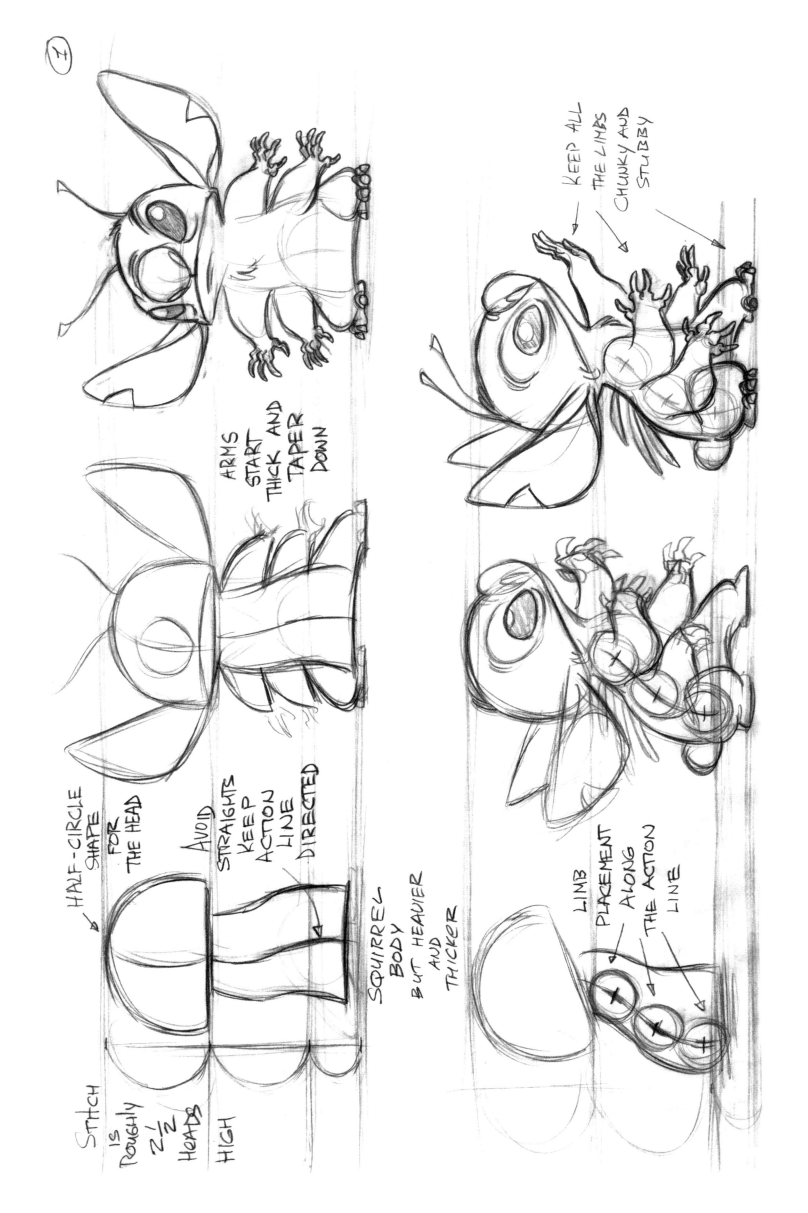

KEEP ALL THE LIMBS CHUNKY AND STUBBY

ARMS START THICK AND TAPER DOWN

HALF-CIRCLE SHAPE FOR THE HEAD

AVOID STRAIGHTS KEEP ACTION LINE DIRECTED

SQUIRREL BODY BUT HEAVIER AND THICKER

LIMB PLACEMENT ALONG THE ACTION LINE

STITCH IS ROUGHLY 2½ HEADS HIGH

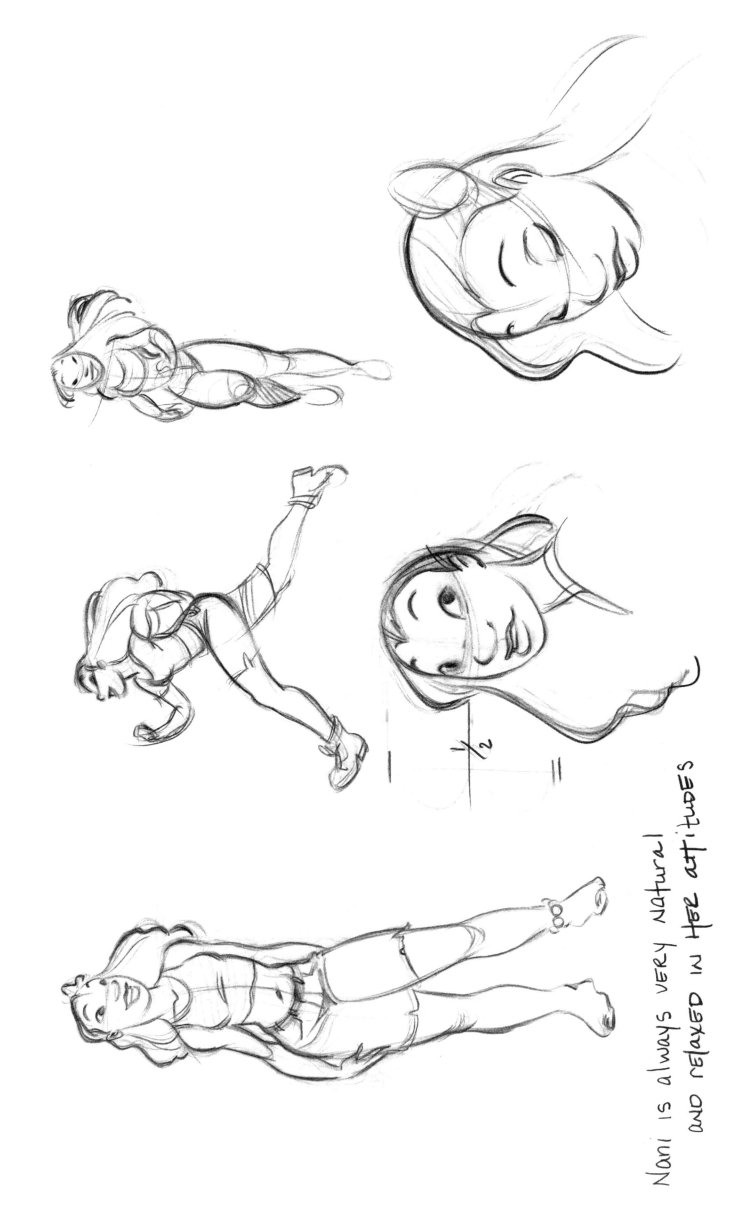

Nani is always very natural and relaxed in her attitudes

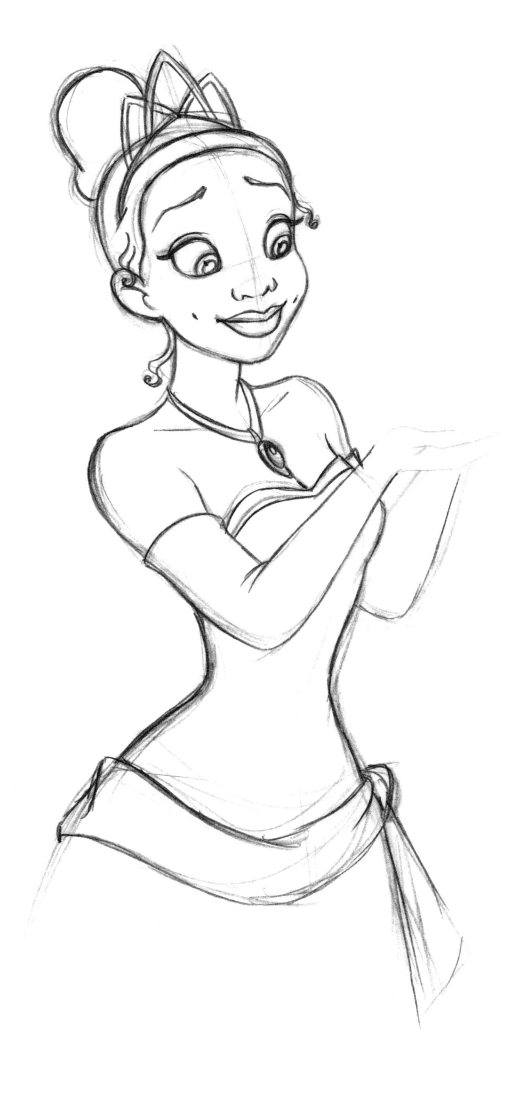

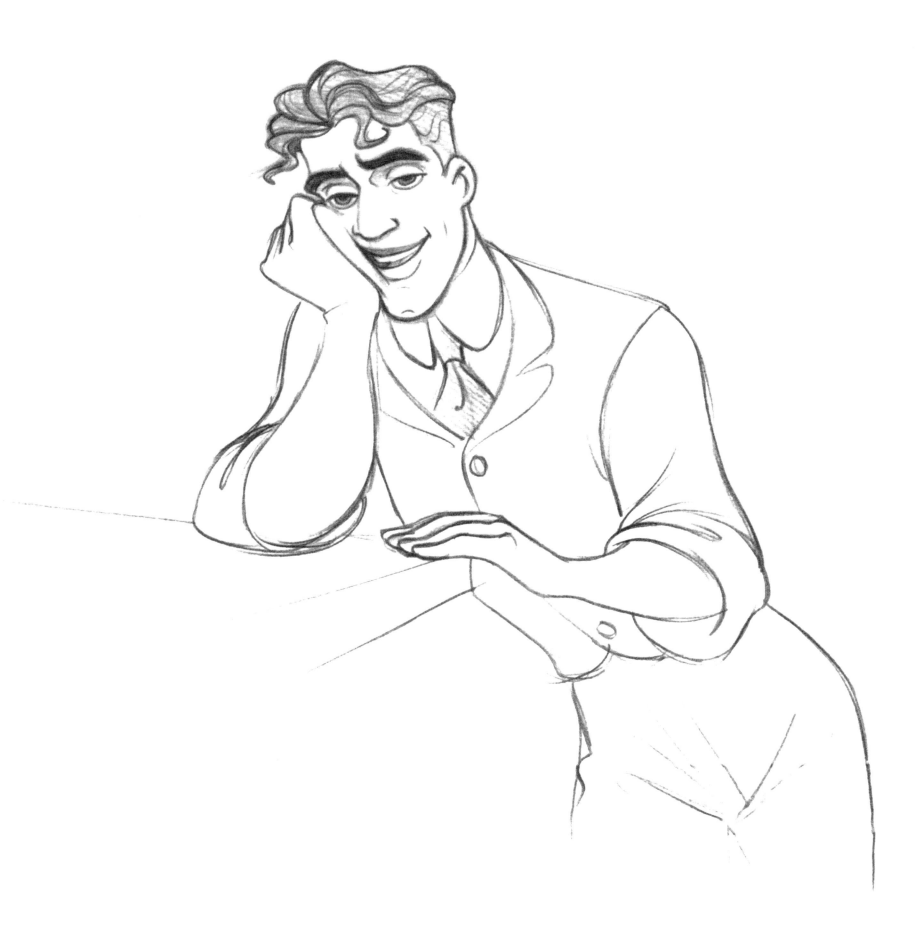

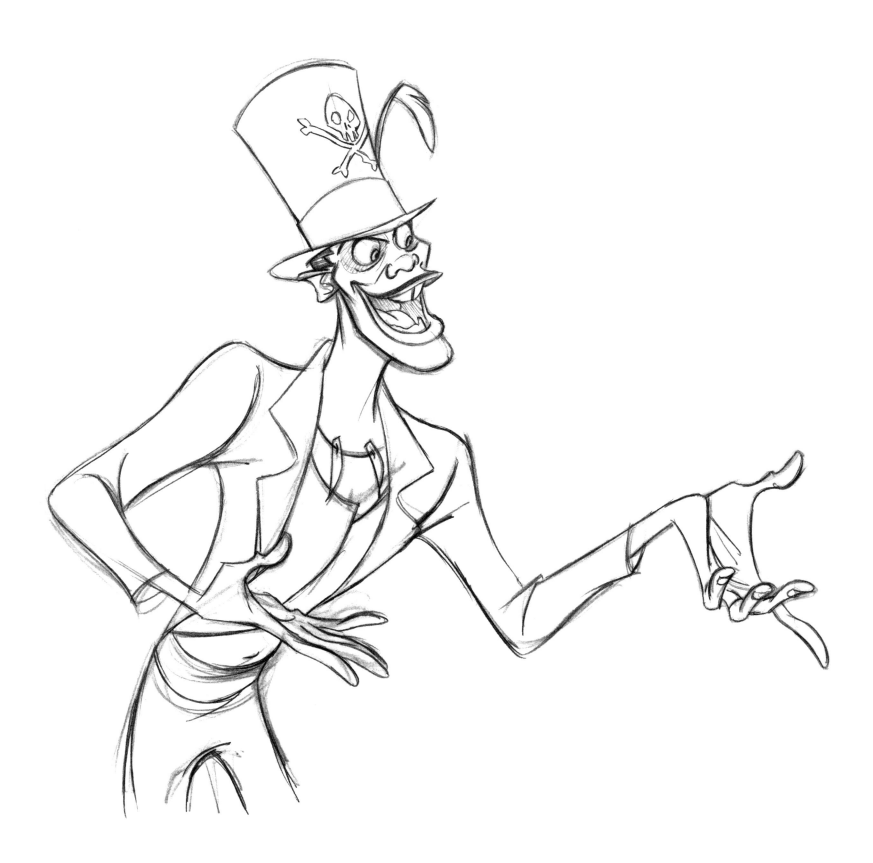

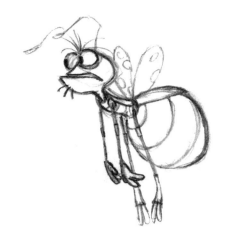
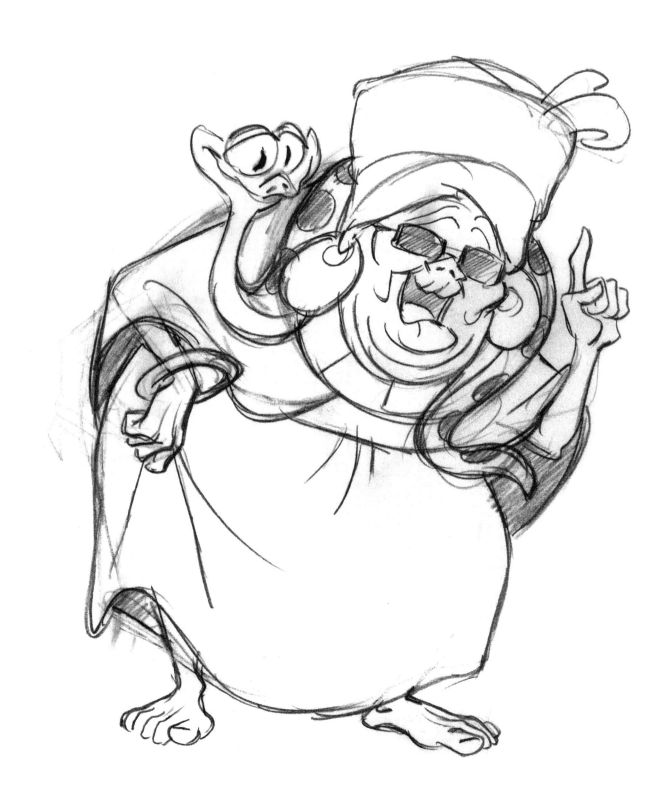

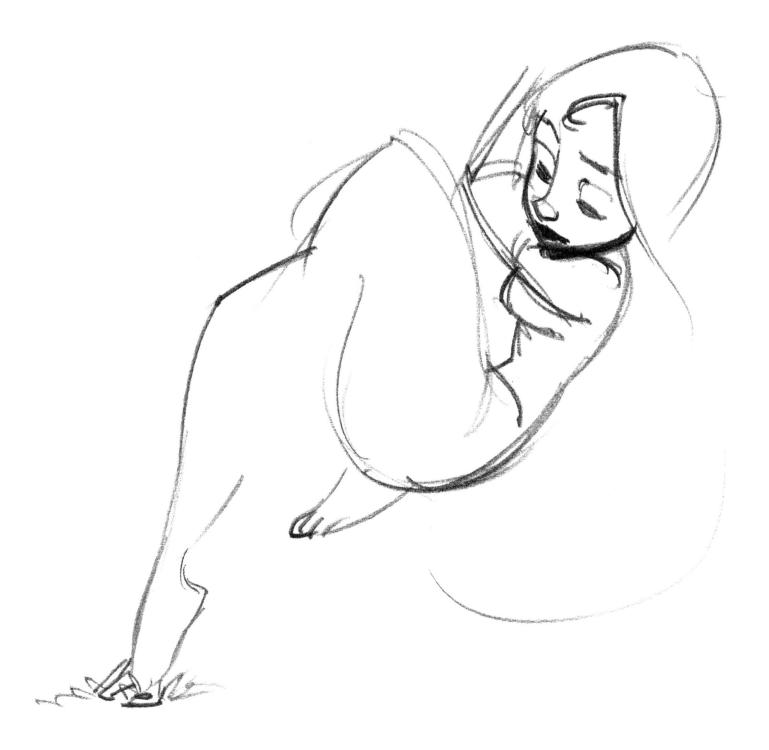

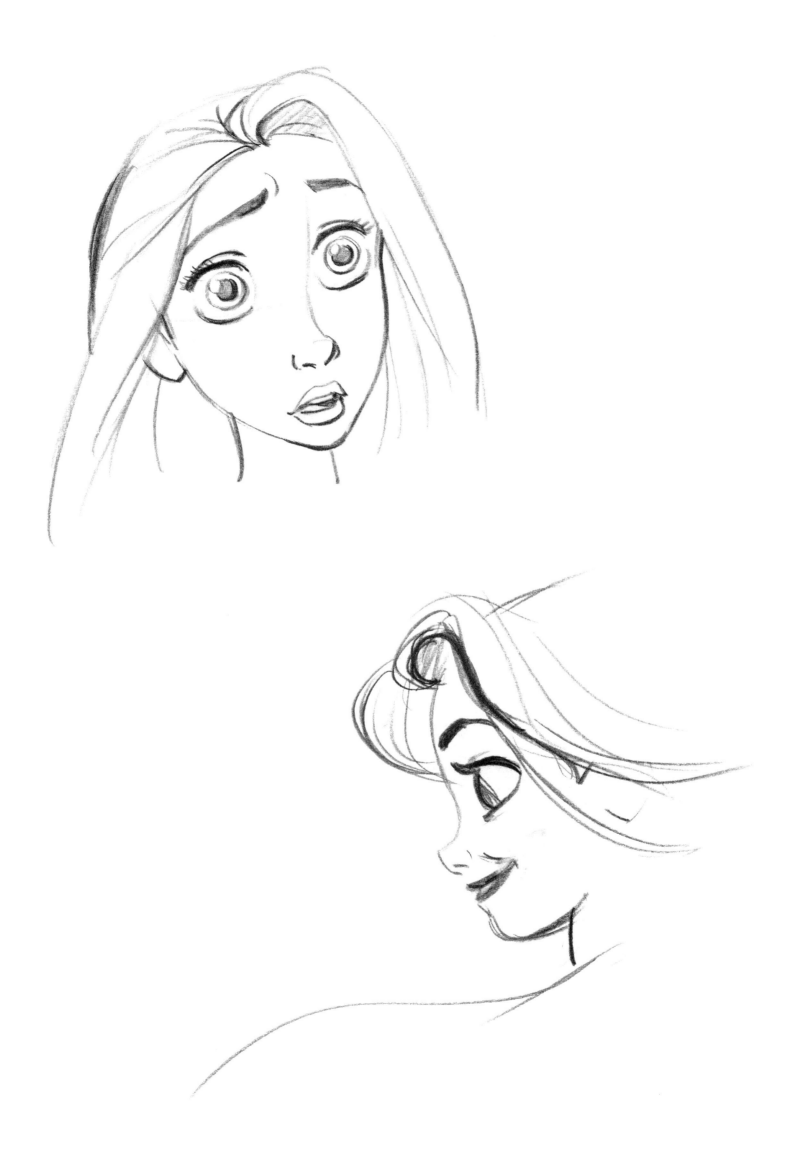

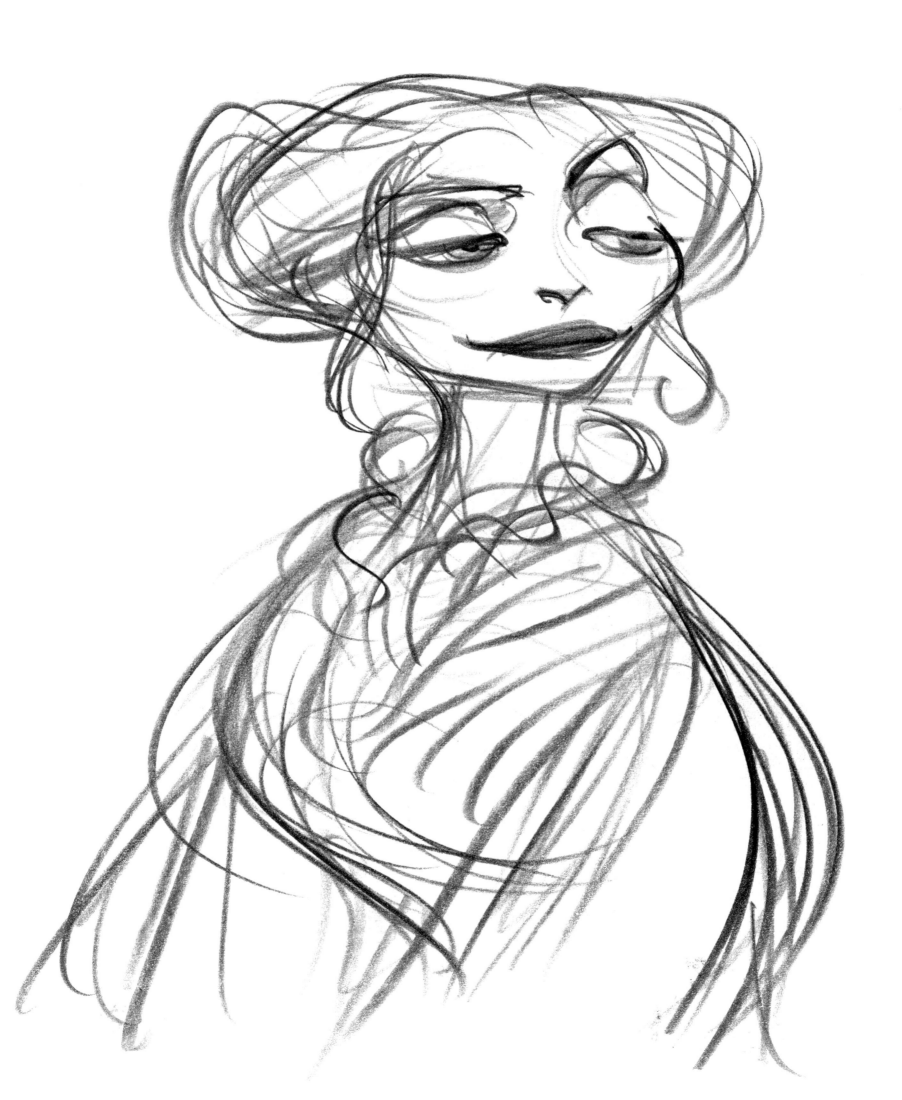

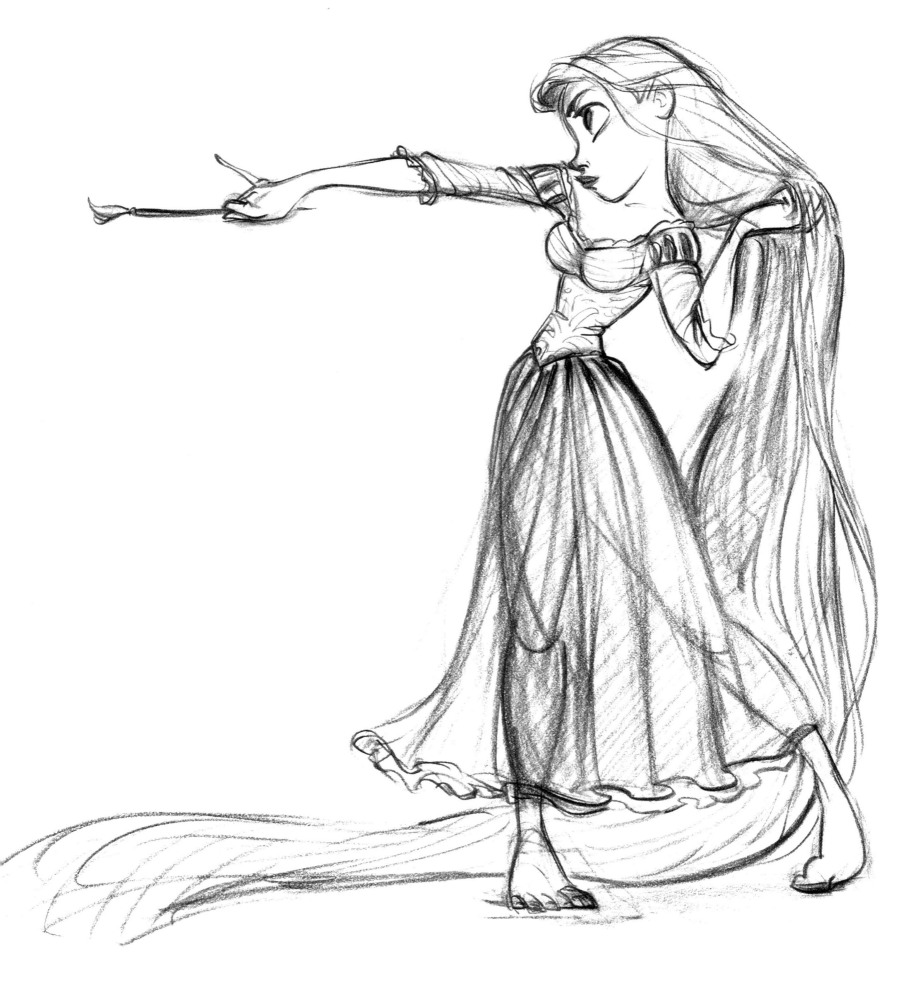

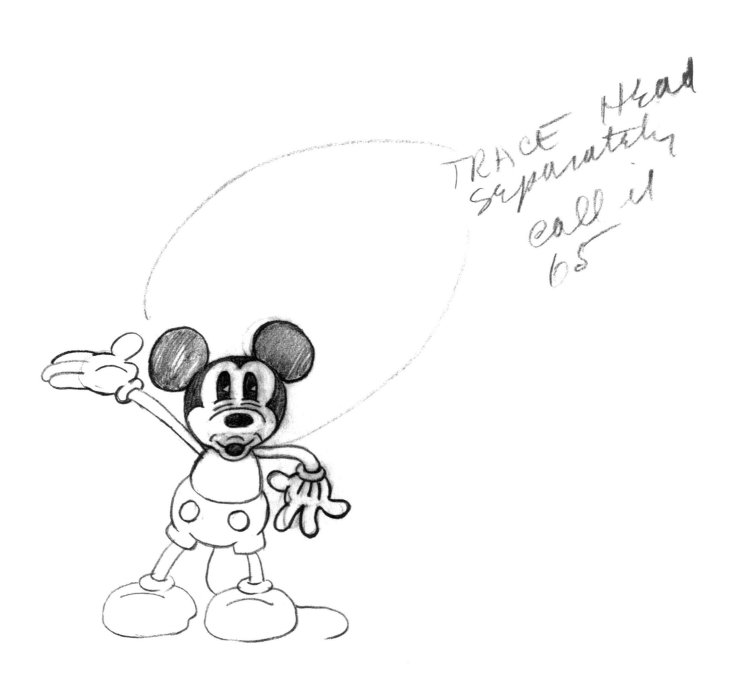

TRACE HEAD
separately
call it
65

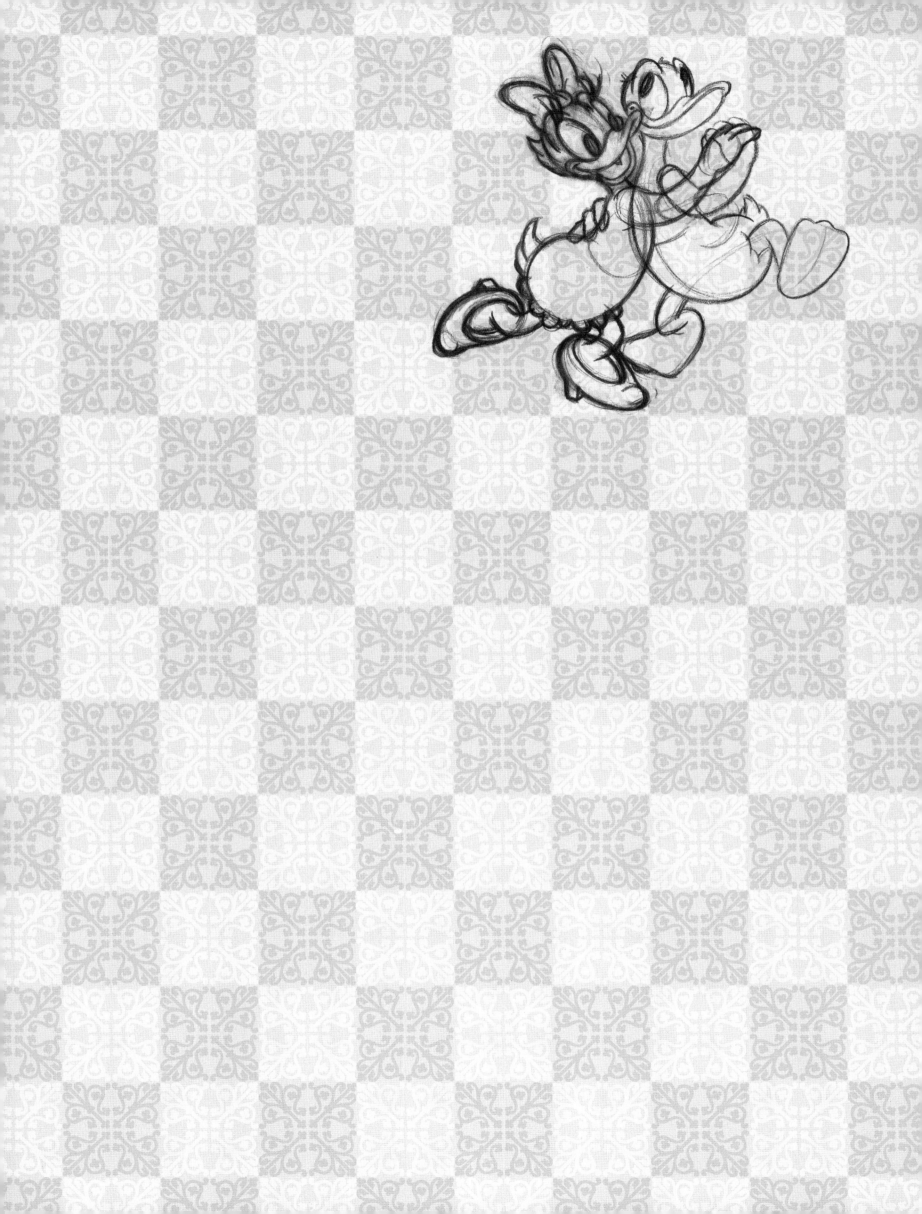

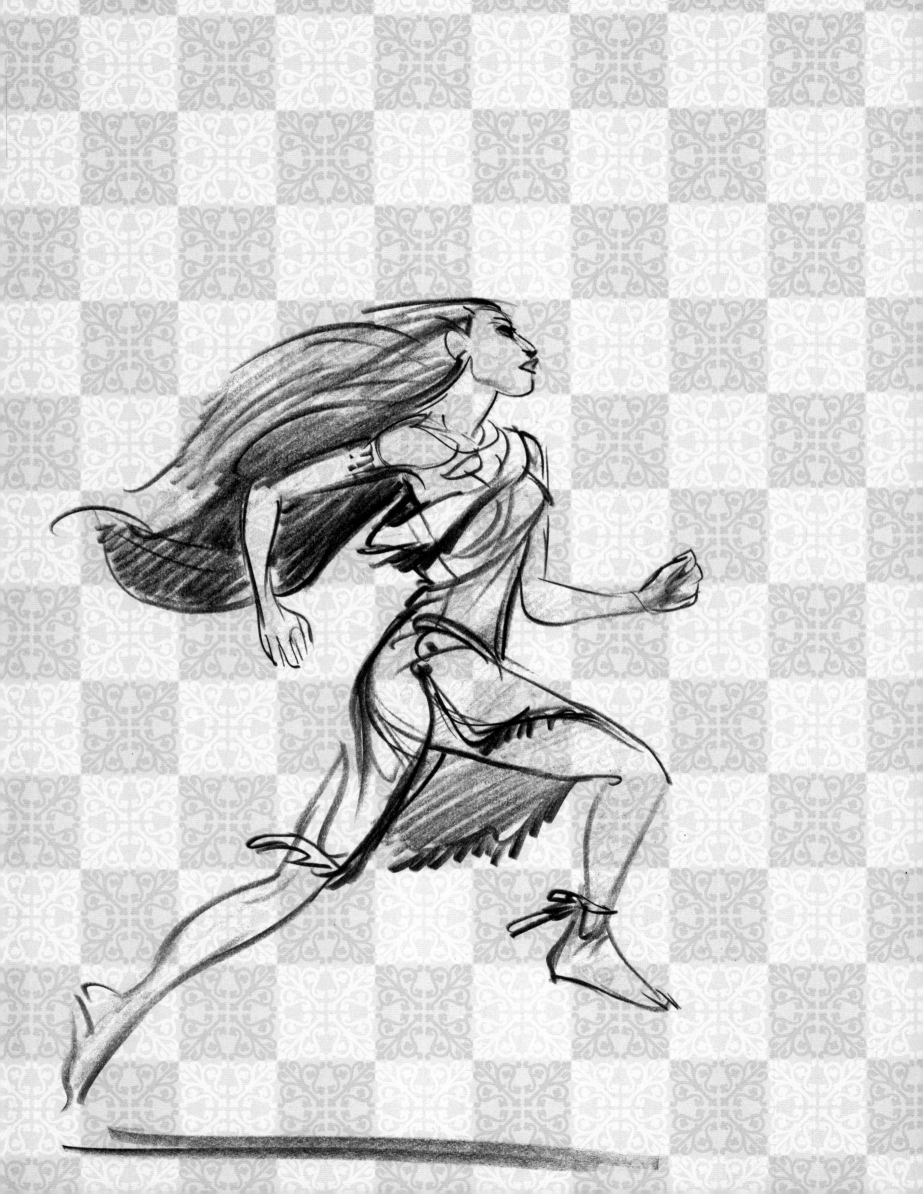